Félix Vallotton

The Nabi from Switzerland

Author:
Nathalia Brodskaïa

Layout:
Baseline Co. Ltd
232/17 Vo Thi Sau Street
4th Floor
District 3, Ho Chi Minh City
Vietnam

Library of Congress Cataloging-in-Publication Data

Brodskaia, N. V. (Natal'ia Valentinovna)
 Felix Vallotton : the Nabi from Switzerland / Nathalia Brodskaia. – [Revised edition].
 pages cm
 Includes bibliographical references and index.
 ISBN 978-1-78160-242-3
 1. Vallotton, Félix, 1865-1925–Criticism and interpretation. I. Title.
 ND853.V3B76 2014
 759.9494–dc23
 2013033100

© 2020 Confidential Concepts, worldwide, USA
© 2020 Parkstone Press International, New York, USA
Image-Bar www.image-bar.com

ISBN: 978-1-64699-321-5

Printed in

Nathalia Brodskaïa

Félix Vallotton

The Nabi from Switzerland

PARKSTONE®
INTERNATIONAL

F. VALLOTTON

Content

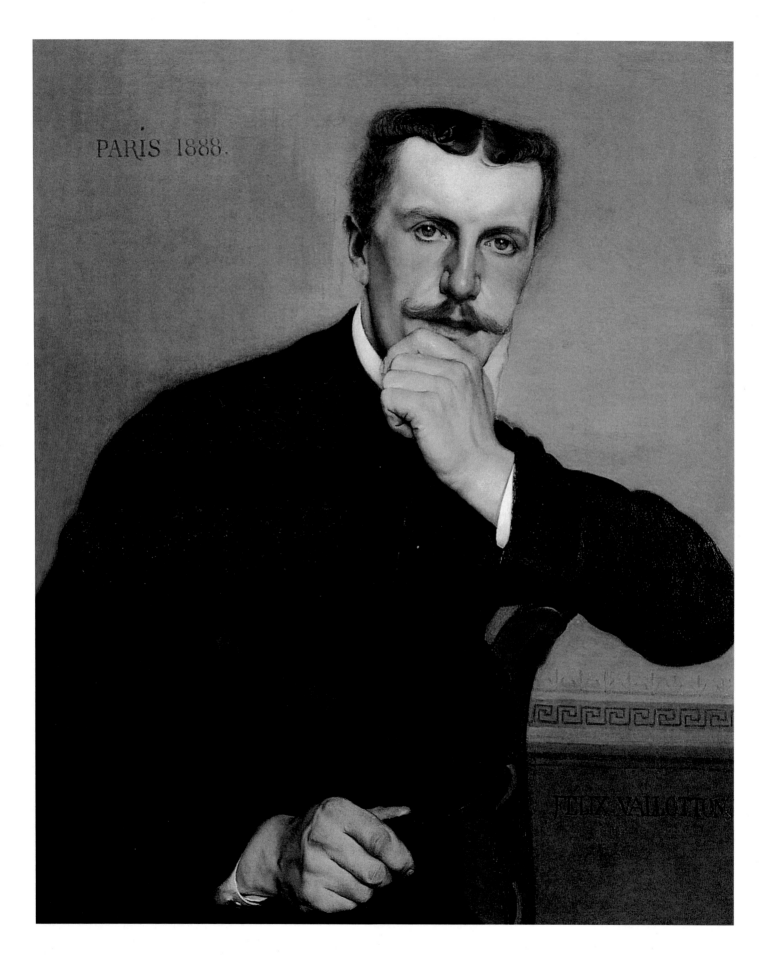

PARIS 1888.

FELIX VALLOTTON

Introduction

That very strange Vallotton – that was how Thadée Natanson, the publisher of *La Revue blanche* magazine, referred to the friend of his youth. In fact, Félix Vallotton did not bare his soul immediately, even to close friends. In the artistic milieu of Paris to which they both belonged, there were no ordinary people, but even among them, Vallotton stood out as being a most unusual individual. The reasons lay not so much in his character, which was indeed full of surprises, but in the phenomenon of his creative biography. Having fallen in love with painting, Vallotton suddenly abandoned it and became the greatest European engraver of the turn of the century.

Having devoted a total of only eight years to printmaking, he mastered that most forgotten of all the graphic arts – xylography. Despite his culture and intellectualism, and his membership of the group of Symbolists, Vallotton's works were easily understood, even by the man-in-the-street. In painting, he earned fame as a conservative and a Neo-Classicist, while contriving to keep up with both the latest trends and the most progressive understanding of colour.

Although he never had any intention of shocking the public, the artist nevertheless was given much attention in the press from the moment his creations made their first appearances at exhibitions in Paris. Vallotton's œuvre has not been overlooked by any of the most important critics and art historians. Claude Roger-Marx, Arsène Alexandre, Camille Mauclair, Félix Fénéon, and Gustave Geffroy wrote about his early works. As early as 1898, Julius Meier-Graefe had published a monograph on Vallotton the engraver, whereas his monograph on Renoir did not appear until 1912. He did not escape the attention of the authors of *La Revue blanche*, or of the Swiss critics for that matter. Louis Vauxcelles and Guillaume Apollinaire wrote about the artist at the beginning of the 20th century, even in far-away Russia (where there were already magnificent art collections of the Impressionists, Cézanne, Gauguin, and Van Gogh by the beginning of the 20th century), an individual treatise on Vallotton the engraver was published by N. Shchekatikhin as early as 1918.

Vallotton's legacy has not been forgotten even now in the 21st century. He has been recalled by Francis Jourdain, Pierre Courthion, and André Salmon, has been afforded an important place in 20th-century fine art by Charles Chassé, Gotthard Jedlicka, Florent Fels, and Élie Faure. Vallotton's works have been exhibited in many countries, and he has been the subject of various monographs, including a work by Hedy Hahnloser-Bühler, a Swiss collector of Vallotton's paintings. A catalogue of engravings and lithographs was compiled by a nephew of the artist, Maxime Vallotton, and the art critic, Charles Goerg. Three volumes of documents "on the biography and history of the work" published by Gilbert Guisan and Doris Jakubec have made it possible to examine the life and œuvre of "that very strange Vallotton" properly. The details of the artist's hard life, contacts with friends, intimate relationships, the creative process, and his dealings with his patrons are assembled, fragment by fragment, in excerpts from his letters and diary and in painstaking commentaries. While acknowledging gratitude

Portrait of the Artist's Brother with Hat, 1888.
Oil on canvas, 76 x 61 cm.
Private collection, Galerie Vallotton, Lausanne. (p. 6)

The Visit or *The Top Hat, Interior*, 1887.
Oil on canvas, 33.5 x 24.5 cm.
Musée d'art moderne André Malraux, Le Havre.

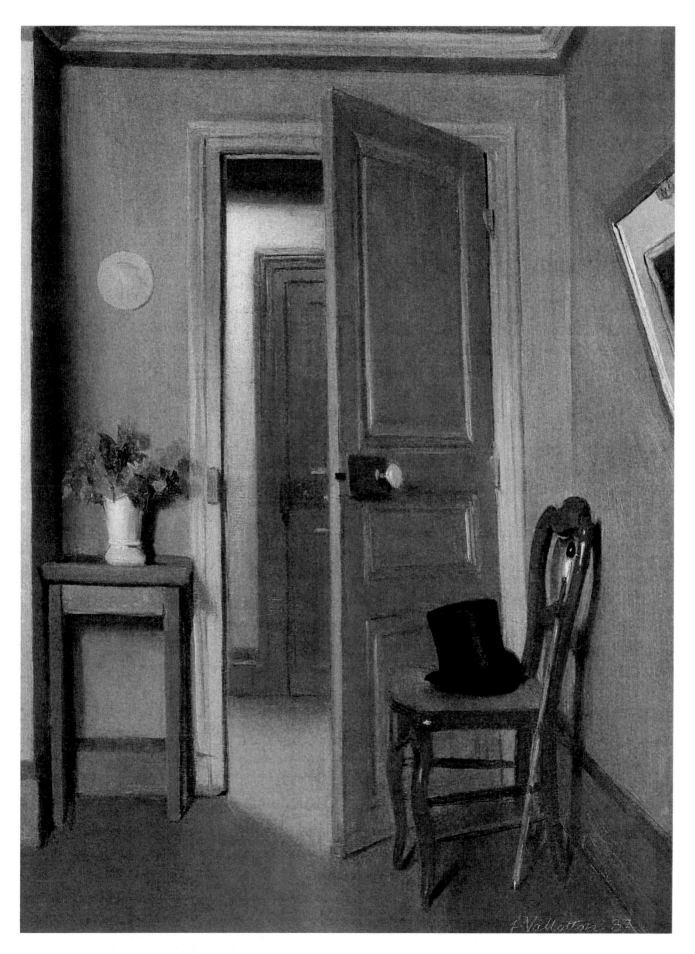

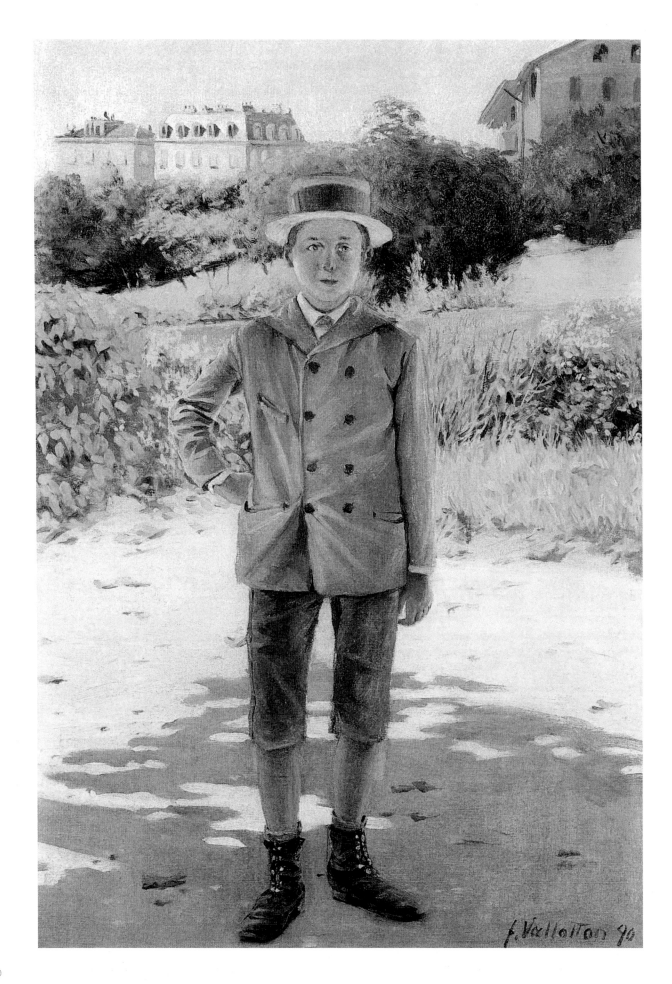

for that work, we offer yet another essay on the artist, in the hope that it will help the reader penetrate the world of his art in some measure.

This is the story of Félix Vallotton, who was born in the pretty town of Lausanne, on the shores of Lake Geneva, and who became famous as an engraver and artist in Paris, lived sixty years to the day, and maintained his Swiss identity throughout.

As your train emerges from the tunnel, the blue lake, as lovely as the sea, unfolds to your view. From the swathe of mist between the water and the sky, the snow-covered mountains emerge. The nearby bank is patch-worked with the irregular rectangles of the vineyards, which soon give way to the houses of Lausanne running up the slope. It is difficult to imagine anywhere on earth that is prettier than Lake Geneva. In the 18th century, this area was visited by the Russian historian and writer, Nikolay Karamzin, who dedicated these words to Lake Geneva:

> "Whether I shall see you again in my lifetime, I do not know; but if fire-
> breathing volcanoes do not turn your beauty into dust – if the ground
> does not open up before you, dry up this sparkling lake and swallow
> its shores – you will always be a source of wonder for the mortals!"

In the mid-19th century, the young Lev Tolstoy wrote on the banks of Lake Geneva:

> "Its beauty blinded me, and immediately struck me with the force of
> the unexpected. In that very instant I wanted to love…, life became
> a joy to me, and I wanted to live forever and ever…"

Nevertheless, for anyone who was born there, the bewitching beauty of this area sometimes acquired a fateful tinge. The Lausanne writer Charles-Ferdinand Ramuz told of the deceptive nature of the mountains and the constant need for vigilance in man, who was so insignificant in their stern world. The titles of his novels speak for themselves: *Great Fear in the Mountains* and *If the Sun Never Rose*. The sensation of diffidence, as well as the insignificance of man's efforts in his struggle against the great and fearless elements, leads not only to melancholy, but also to depression and despair. Jean-Pierre Schlunegger, the delicate and sensitive poet from Vevey, committed suicide by hurling himself from the elegantly curved arch of a bridge among the cliffs surrounding the lake. There is something in the nature of this area that gives birth to characters that are strange and tragic, closed and resistant to any attempt at comprehension.

"Between a country and its people there is kinship," said the Romanticist writer Juste Olivier, who dedicated his two-volume work *The Canton of Vaud* (1837-1841) to his country. No-one has gained a better understanding of the intricacies of a life which has moulded "a generation of ploughmen, herdsmen, and vine-growers" than he has. Olivier continued:

Portrait of Young Delisle, 1890.
Oil on canvas, 46 x 33 cm.
Private collection.

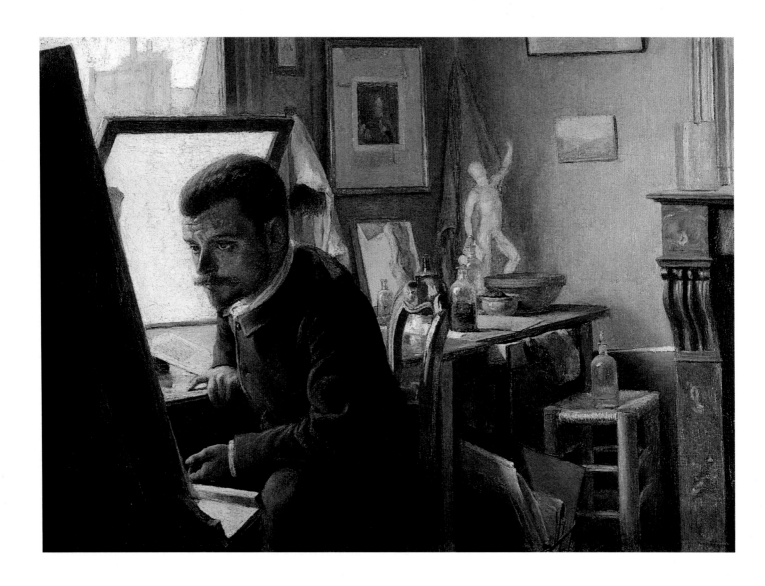

"Our life is not noisy and not dazzling, but even if there is nothing ostentatious in it, there is also no deception or false modesty about it: it possesses sincerity and truth; strength, boldness, patience, truthfulness, a feeling of our own dignity and individuality, a strange aversion to affectation and excessively free gestures, a democratic and natural instinct, simplicity, very true sound and really natural colour; it contains nothing forced, and in the final analysis it possesses a special, if almost imperceptible originality, the basic feature of which could not be erased by civilisation – that is our quiet independence."

Felix Jasinski in his Printmaking Studio, 1887.
Oil on canvas.
Private collection.

July 14, Etretat, 1889.
Oil on cardboard, 47 x 60 cm.
Private collection.

And not one man of words, music, or art whose fate is connected to Lake Geneva has been able to escape the influence of the nature of the country and its way of life, to a greater or lesser extent. It was here, on the shores of the Geneva, that the artist Félix Vallotton was born on 28 December 1865.

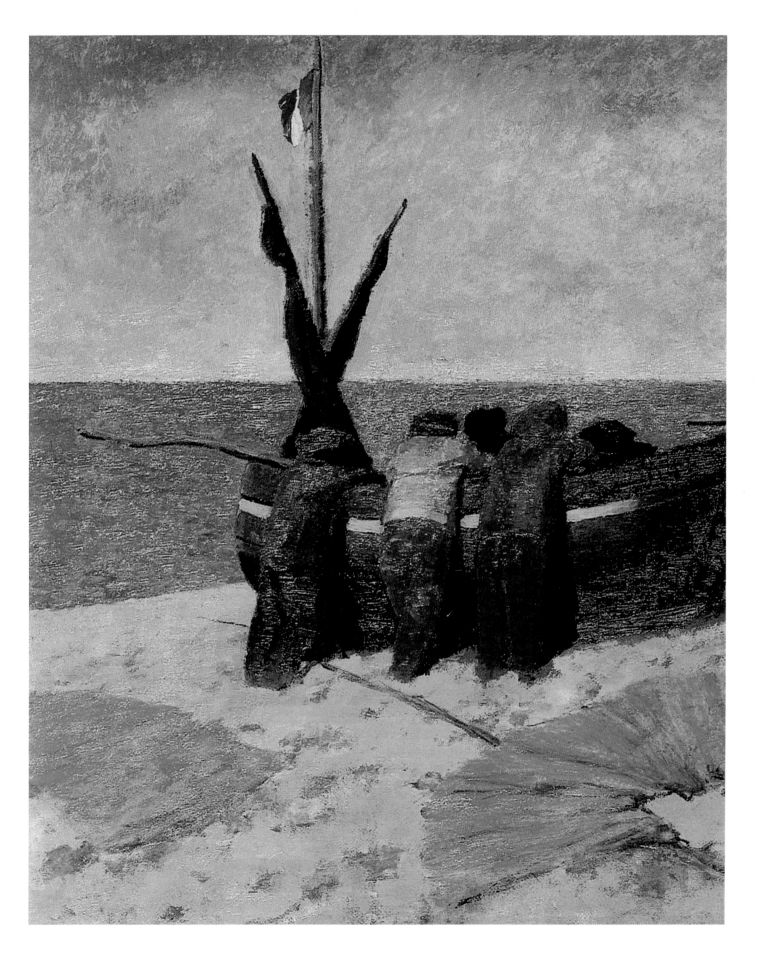

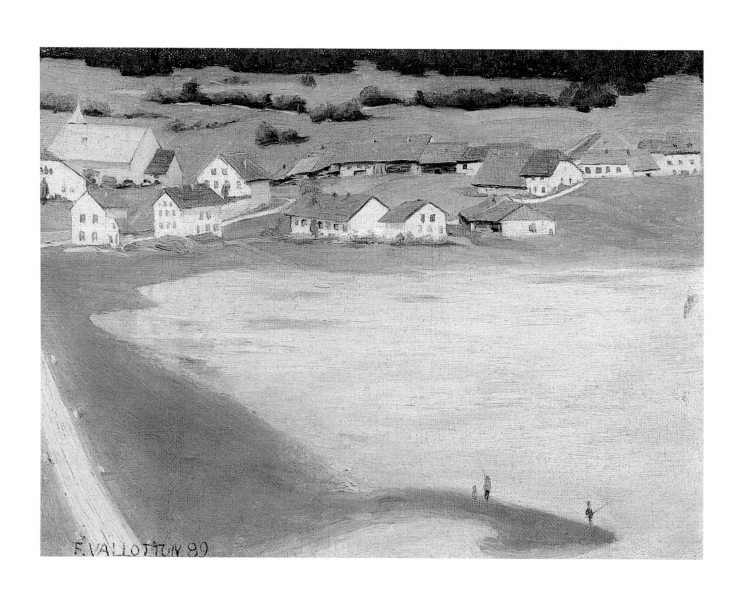

Les Charbonnières, 1889. Oil on canvas 24.5 x 32.5 cm. Musée cantonal des Beaux-Arts, Lausanne.

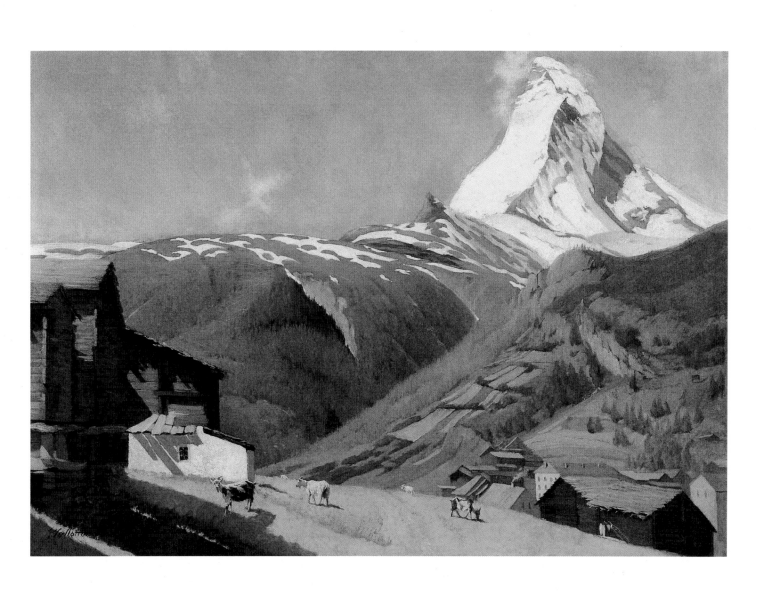

View of Zermatt, 1889. Oil on canvas, 73 x 105 cm. Private collection, Switzerland.

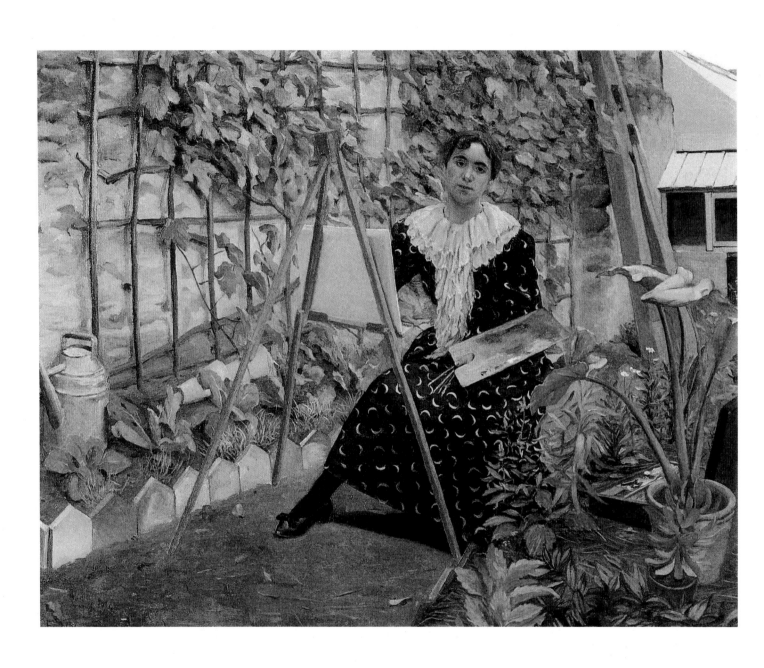

Young Girl Painting, 1892. Oil on canvas, mounted on wood, 32.5 x 41 cm. Josefowitz Collection, Lausanne.

A Talented Artist

The Vallotton ancestors came from the little town of Vallorbe in the canton of Vaud. The artist's father, Adrien Vallotton, owned a chandlery and grocery shop in Lausanne, and later a small chocolate factory. The family lived on the narrow town hall square, the Place de la Pelouse (Meadow). The name of the square, just like the well-preserved ornamental pool here, is reminiscent of the age-old occupation – cattle farming – of the local residents, who built the reservoirs as watering-places for their cattle. In the centre of the pool there is an ancient painted stone sculpture representing justice. A steep flight of steps runs from the square up to the Notre Dame cathedral. It was here, in the very centre of Lausanne, that the future artist was born, and spent his childhood and youth; and the view of the blue lake from the square beside the cathedral remained in his memory forever, and found its way into his art.

Maxime Vallotton, the artist's nephew, recounted that Félix was a delicate and sensitive child. The Franco-Prussian War and the smallpox epidemic, from which so many people suffered, including his father, made an enormous impression on him. In 1875, the boy was sent to a high school where the teachers inevitably noticed his aptitude for literature and drawing. The story is still told in the family of how, one day, during a boring lesson, Félix drew a portrait of his teacher. Astounded by the likeness, the teacher not only refrained from punishing him, but even kept the drawing for himself.

His Training

When attending evening classes in drawing, Félix fell into the hands of an attentive mentor – the artist, Jean Samson Guignard. After completing his studies in Lausanne, Vallotton persuaded his father to allow him to study painting in Paris, and they both went there in 1882. After booking in to the Hotel de Russie, they had a look round the city in which Félix would spend the rest of his life. The Académie Julian was in the suburb of Saint-Denis. It was an art school founded by Rodolphe Julian, a former artist's model, with a teaching staff which included the most famous professors in Paris who regularly won all the top artistic prizes. Adrien Vallotton left his son at the Académie Julian to master the rudiments of the craft, under the guidance of Jules Lefebvre, Gustave Boulanger, and Guillaume Bouguereau. Although Félix had passed the examinations for l'École des Beaux-Arts at the same time, Vallotton preferred the Académie Julian, as its classical system accorded with his ideas of real art and its adherence to naturalism with tastes developed under the influence of paintings by Vaudois artists. His life acquired a monotonous and exhausting rhythm. In a letter to his brother soon after his arrival in Paris:

> "So far I have not seen much apart from some museums. The botanical gardens, which did not make much impression on me, one or two

The Seamstress, 1891.
Oil on canvas, 32 x 40 cm.
Private collection, Lausanne.

The Patient, 1892.
Oil on canvas, 74 x 100 cm.
Josefowitz Collection, Lausanne.
(pp. 20-21)

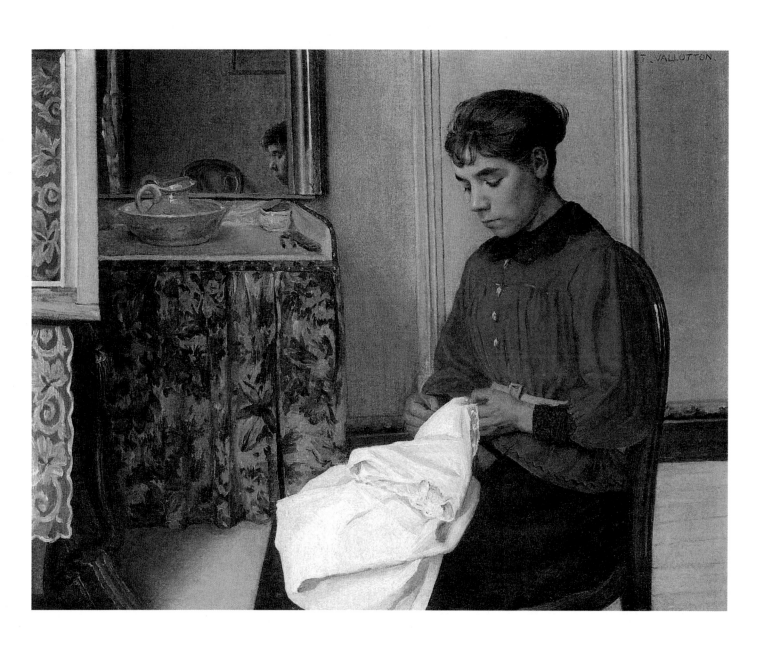

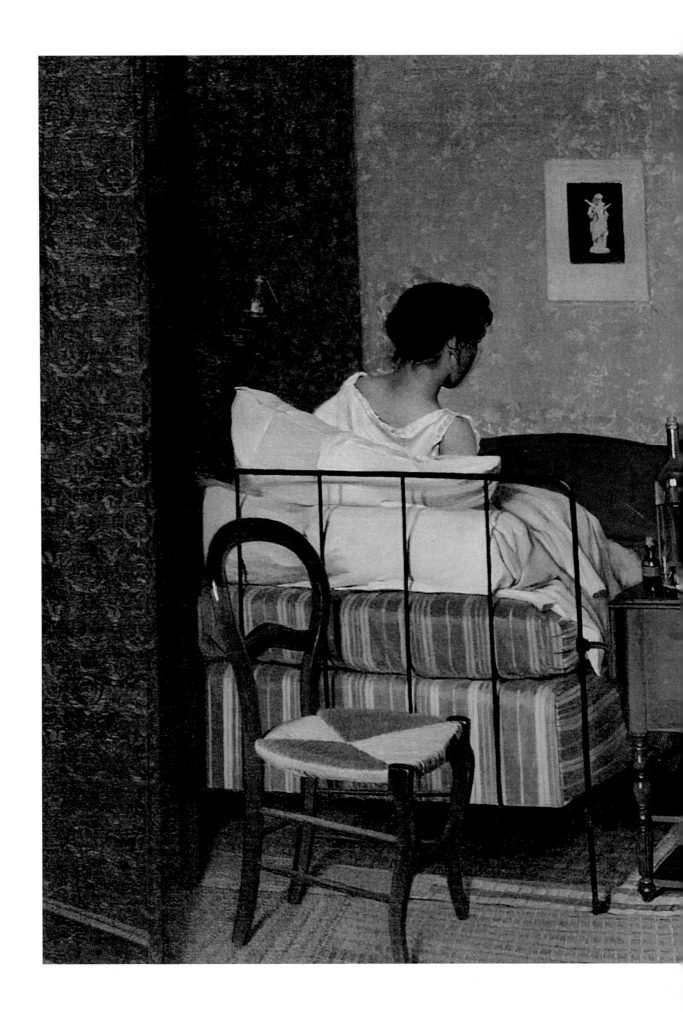

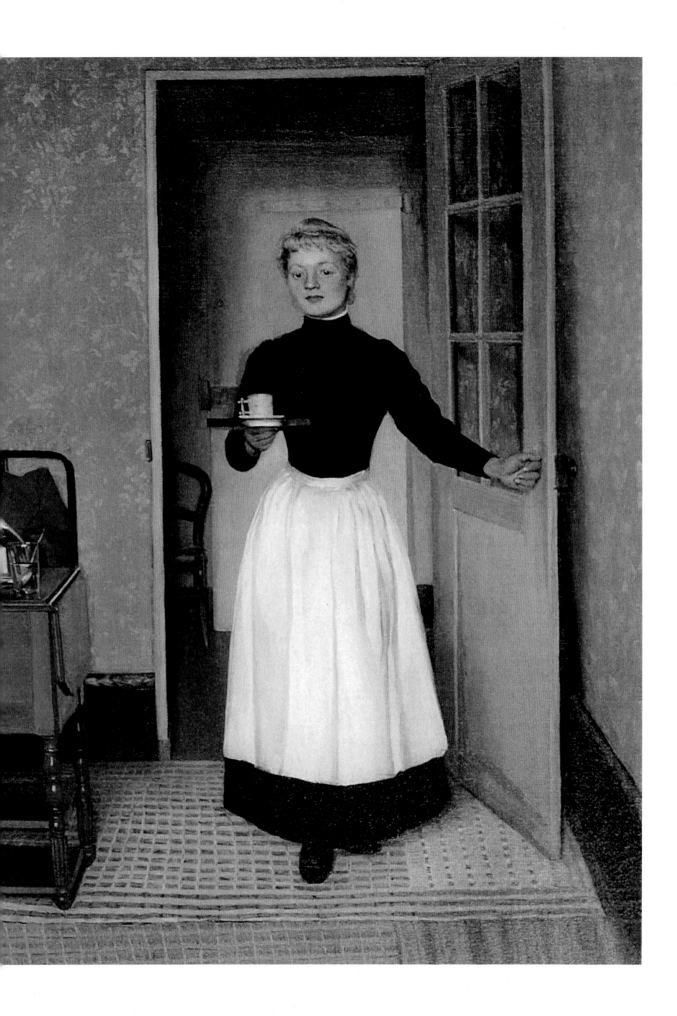

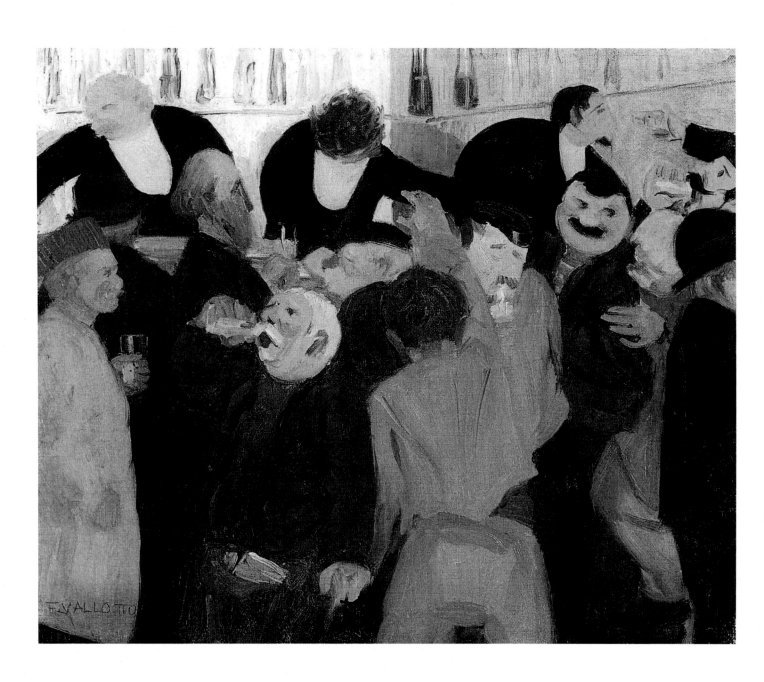

theatres which I visited with father, the Panthéon, which is magnificent and which affords a marvellous view on a fine day. Every day, I follow the very same route and see the very same things: the Louvre, which I cut through, the Magasins du Louvre, the Place des Victoires and the Bourse … The professor is pleased with me, but I am not pleased with myself, and sometimes feel sad … My heart sinks when I think of what I am about to study, and realise that I am nothing compared with the great artists who startled the world at the age of fifteen…"

Fellow students respected Vallotton for his seriousness and restraint; his professors considered him a model student and dreamt of his winning the Prix de Rome. In 1884, when Adrien Vallotton asked Lefebvre what he thought of his son's abilities, the professor replied:

"Monsieur, I hold your son in high esteem, and have only had occasion to compliment him up till now. I think that, if I had such a son, I would not be worried about his future at all, and would unhesitatingly be prepared, within the bounds of possibility, to make sacrifices over and over again, in order to help him. He is clever, hardworking, and well brought up. I can reproach him with only one thing – a certain constraint in his work, which sometimes paralyses his efforts. I am convinced that this reticence will disappear when he realises that his family believes in him and supports him … It was also very hard for me in the beginning, and I had to undergo many severe trials. Indeed, that is why I am so interested now in those who are prepared to work – your son is one of those, and, I repeat, he will bring you fame."

The reticent student turned out to be more farsighted than anyone would have thought possible. He absorbed his teachers' abilities to perfection in mastering his craft – accuracy of drawing, skill in lending beauty to his treatment of light and shade in his models, and the art of composition. Yet this did not stop him from adopting a critical attitude towards their work. He was able to treat his professors' weaknesses ironically, but indulgently. In 1891, when reviewing the Paris exhibitions for the *Lausanne Gazette*, he wrote that "Professor Bouguereau uses his indomitable energy and enormous diligence in the service of bad taste". As for Jules Lefebvre, his good relations with his former student did not stop Vallotton from remarking in 1895: "Monsieur Lefebvre always draws faultlessly, but he has never thought of anything, and has never managed to become interested in anything…" His observations during his student years laid the foundation for his satirical cartoon portraits of artists from the great salons on the Champs Elysées and the Champ de Mars, among whom were both Bouguereau and Lefebvre. However, this was to happen much later, in 1896,

The Bistro, c. 1895.
Oil on canvas, 22 x 27 cm.
Private collection.

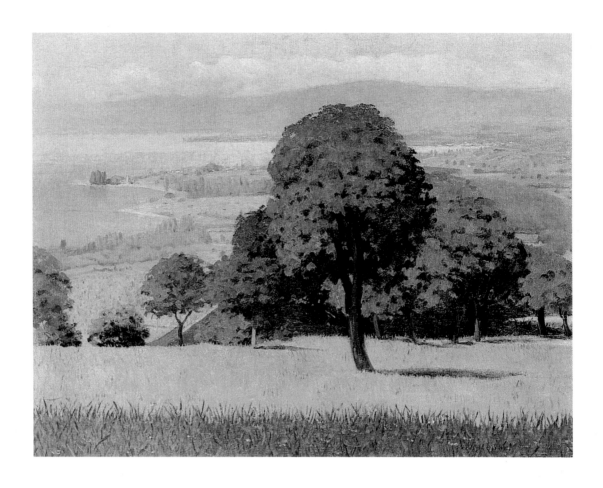

twelve years after Lefebvre's letter to Vallotton's father. In the mid-1880s, Vallotton still thought of himself as a student.

It would be an understatement to say that the Académie Julian only gave Vallotton the technique and skills of the trade in his painting – it also provided him with contacts which would prove important for both his profession and his broader life. Above all, it was probably there that he met Charles Maurin. Maurin was ten years older than Vallotton, and was studying under the same Jules Lefebvre. His name has become lost to the history of art; for his contemporaries, however, he was an interesting artist and a notable personality. Thadée Natanson recalls the friendship between Maurin and Toulouse-Lautrec which began at the same Académie Julian and which remained for the rest of their lives. Toulouse-Lautrec respected Maurin for his devotion to his trade. "In fact, it was as a professional that he first became interested in Vallotton," wrote Natanson, "and in painting, they were not very far apart. They spoke about Ingres with enthusiasm, which was less passionate in Maurin's case, but more sincere." Maurin, the "cynic", as Natanson called him, was really attached to his younger colleague. His faith in Vallotton often lent support to the young Félix in moments of doubt and lack of self-confidence, and such moments were not infrequent. In 1886, Maurin wrote to Vallotton:

Outskirts of Lausanne, 1893.
Oil on canvas, 24 x 34 cm.
Private collection.

Mountain Passage, 1894.
Oil on cardboard, 29 x 27 cm.
Private collection.

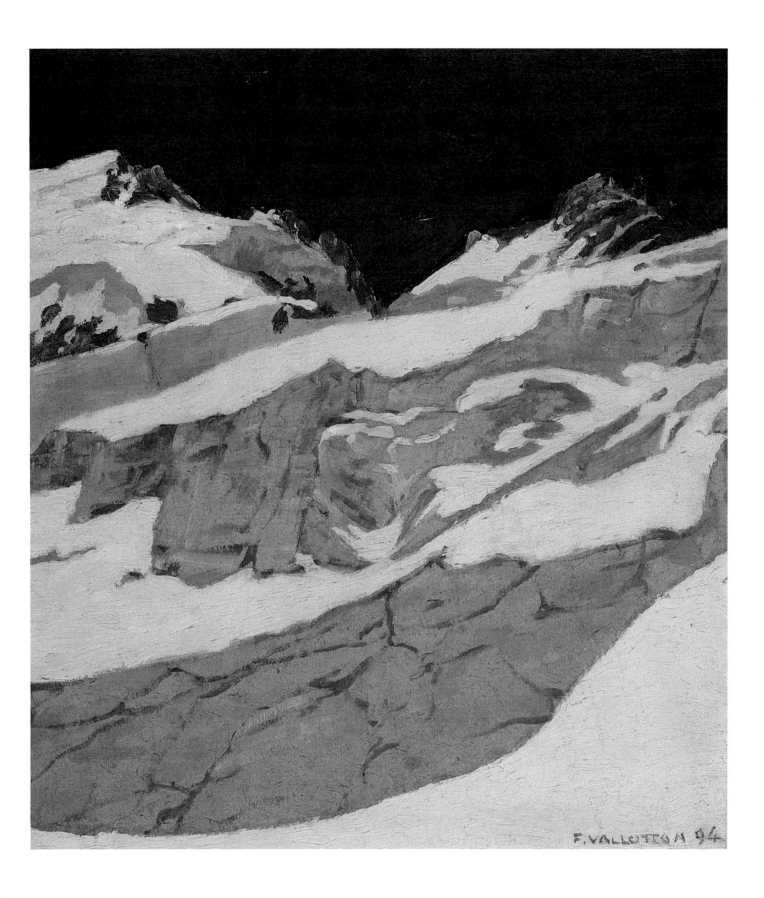

F. VALLOTTON 94

Lake Geneva, c. 1892. Private collection.

Path in the Forest, Oléron, 1894. Oil on wood, 25 x 34 cm. Private collection.

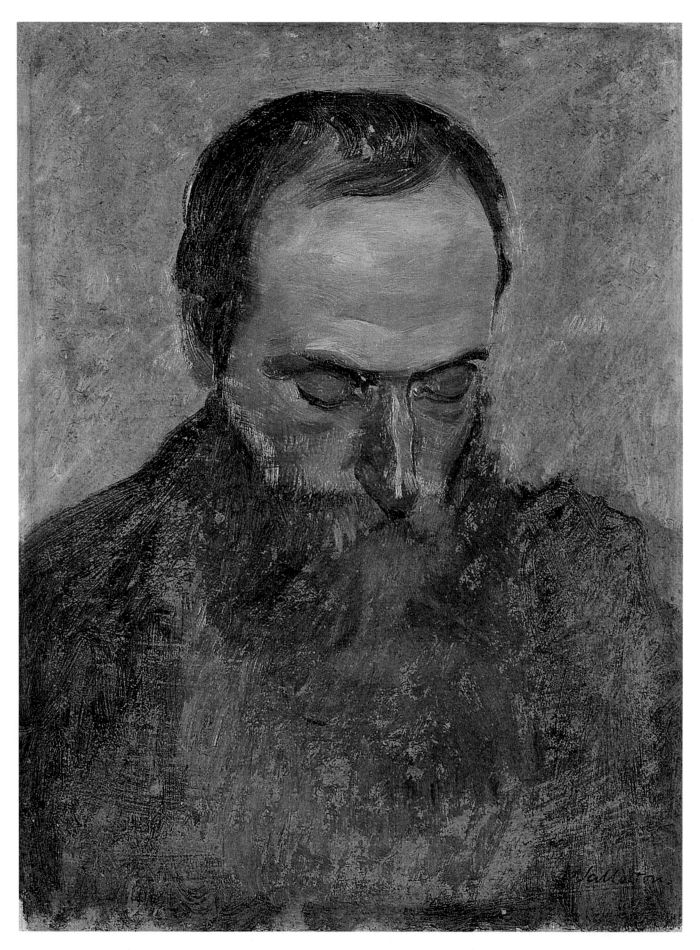

"Whatever you lack, it certainly is not artistic flair. It is rather some quality of character (please allow me to mention this to you. I would like you to be as open with me). From your last letter, it emerges that you lack strong will, and you are creating difficulties for yourself. But that is not the case. You do have willpower, but it does not manifest itself..."

In his attempts to steer Vallotton on to the path of true art, Maurin could sometimes be abrupt: "I don't like your letter." he wrote in the same year, 1886. "It seems to me that you dislike your profession although, in fact, it is the only thing which can raise your spirits. I have already written that you must not hope to make your fortune by painting... If you want to do painting, then have the courage to do so with love, and either sell very little of it, or none at all..."

Their correspondence over the succeeding years shows that Maurin's admonitions did not offend Vallotton, although it is possible that he did not entirely deserve them. Life in Paris was not easy for the boy from the shores of Lake Geneva; he had to spend every minute struggling for the opportunity to work as a painter. Just before his death, Vallotton gave a publisher a novel he had written which was entitled A Pernicious Life (La Vie meurtière). Fate condemned the hero of the novel to bringing ill fortune to those around him, from childhood onwards, which was the reason for his sufferings and demise. It was left to Félix's nephew, Maxime Vallotton, to explain that the novel was not autobiographical at all, and that none of the episodes related in it had actually occurred in the artist's own life. There was, however, a mood of melancholy and often despair, which Maurin put down to Félix's dislike of his work. It was indeed a difficult and lonely time for the young man. Natanson explained:

"Living in very poor circumstances in Paris, he was all wrapped up in himself. Later he would go into a fit of shivering at the slightest hint of the many and varied privations from which he had suffered in his youth. That is why, for example, he tried to smile when icy drops dripped on to his bed from the roof, and he turned the whole thing into a joke, saying that he preferred a real winter."

He was tormented by the fact that his father had to support him. Nevertheless, he would turn to his family again and again for help, as after paying for his lodging and for models, he would have nothing left for food. He tried to work just as much as he was physically capable of doing. In a letter written to his parents in 1888 Félix lamented:

"I practically never go out. I work from seven in the morning until five in the afternoon. This has not produced any great results so far, but everything must work out soon. In the mornings I have a model of whom I am doing a study in pastel. After that, I am busy with more

Portrait of Edouard Vuillard,
1893.
Oil on panel, 30 x 25 cm.
Private collection.

serious things, getting ready for the Exhibition. It is a pity that it costs so much, but there is no other way to do it, and this is still the only method for doing any serious work…"

Félix Vallotton was enormously industrious but, in striving for success, he would wear himself out by overworking. It was no wonder that he used to complain of the monotony of life, describing it day by day in letters to his parents:

"Monday. Once again I get down to my work; I have finished the portrait of my concierges, and they are happy, and now I have a magnificent armchair, so it is all for the better; as always, there is no news of the promised cocoa; and I have run out of food, but I hope to receive it soon. It is very cold here, but I have a nice view of the garden from my window; I do not enjoy going out, and I soon come back. I like living like this, and if my affairs were to improve slightly, I would be happy. I would very much like to achieve something in painting; something to do with portraits, as always. What do you want of me? That's the way I'm made, and it is only in this that I have any chance of achieving success."

The First Successes

Vallotton turned out to be right – it was indeed a portrait that brought him his first success. In 1885, the Salon, with his teacher Jules Lefebvre on the jury, accepted his *Portrait of Mr Ursenbach*. Ursenbach, an American mathematician and Mormon, lived in the next attic to Vallotton's, and they would sometimes chat in the evenings. Ursenbach posed sitting in the armchair in his drab room. It is difficult to imagine more dire circumstances: nothing but a paraffin lamp on a chest of drawers. It is also difficult to speak here about the traditional psychological analysis of the portrait – the man is frozen in stony immobility, with his arms resting heavily on his knees. But there was something bewitching and compelling about it, amongst the thousands of pictures at the exhibition, including some by famous names, to cause visitors to stop and look. French critics picked it out because of the high professionalism of the work. The author of the *Le Gaulois* review described the portrait as "honest and interesting, although somewhat dryish". The Swiss critics looked more attentively at the work of the young Vaudois: one of them saw "a power of expression" in the *Portrait of an Old Man*, which was exhibited in Geneva in 1886, while another one called it "naive and sincere". It is probable that, they had to be compatriots of Vallotton to see something that was hidden in the depths of the work and the character of the Swiss artist. Be that as it may, Vallotton himself looked soberly on his first success. He started the list, of all the paintings and graphic works which he ever did with the *Portrait of Mr Ursenbach*.

Portrait of Thadée Natanson,
1897.
Oil on cardboard, 66.5 x 48 cm.
Musée du Petit Palais, Geneva.

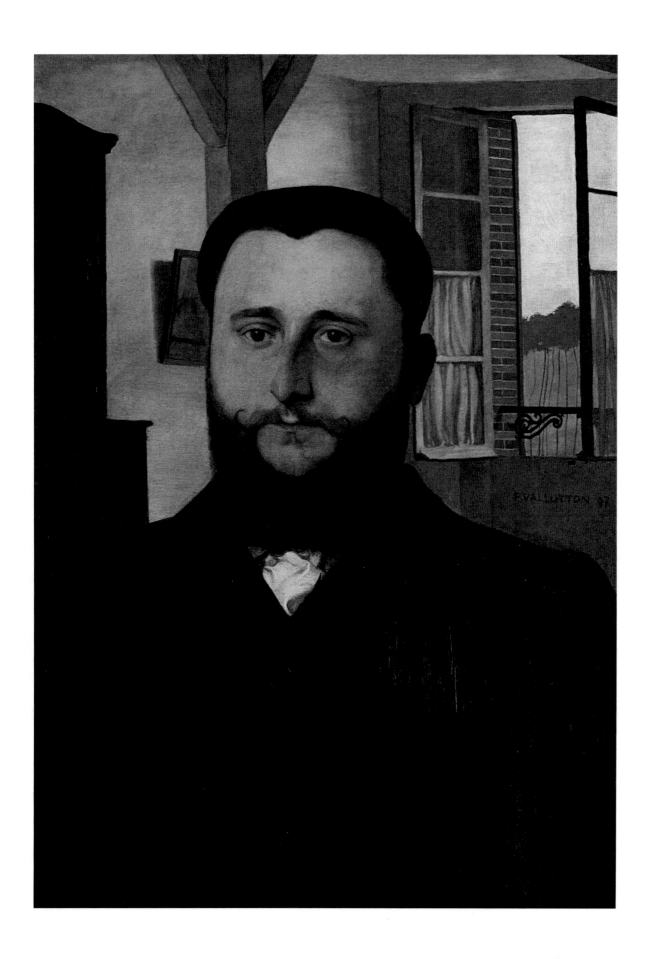

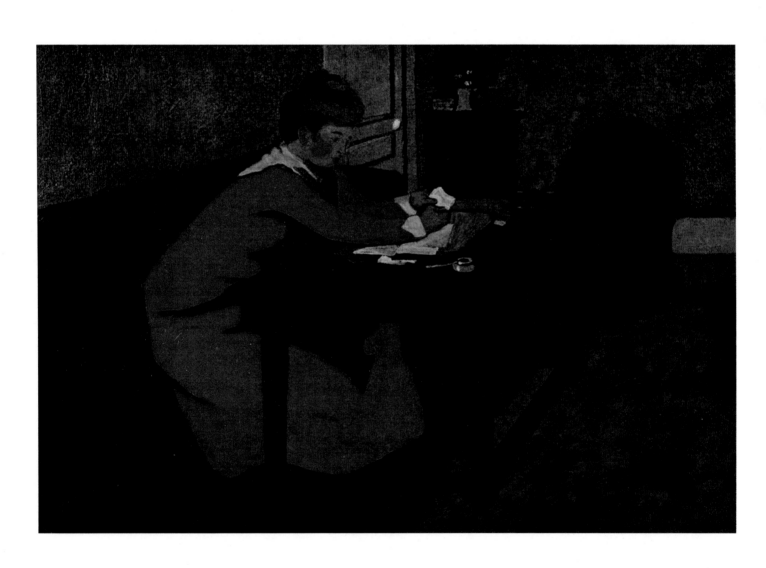

Misia at her Desk, c. 1897. Goache and pastel varnish on mounted cardboard, 35 x 52 cm. Musée de l'Annonciade, St Tropez.

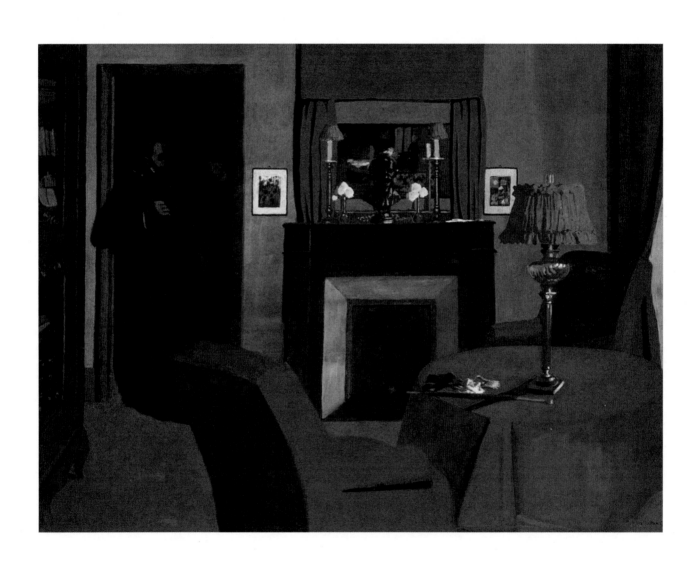

The Red Room, 1898. Oil on cardboard, 50 x 68.5 cm. Musée cantonal des Beaux-Arts, Lausanne.

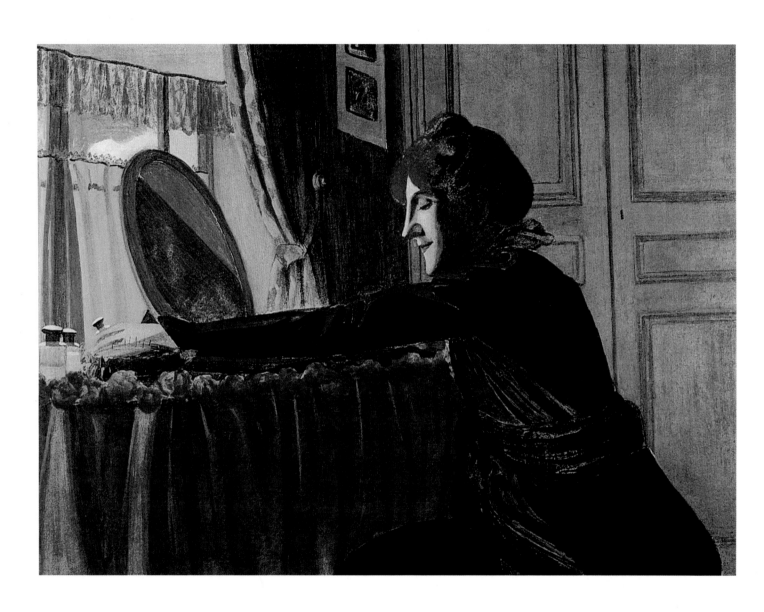

In the catalogue drawn up in his own hand, the *Portrait of Mr Ursenbach* is followed by a whole series of other works which provide a sort of chronicle of his life. Reserved and restrained in his personal relations, Vallotton expressed his devotion and tenderness towards his family in the portraits of his parents, grandfather, brother, and sister, whom he painted over and over again, whenever he visited Lausanne. Among the figures in his portraits appeared his uncle, Alexis Vallotton, and his wife Mathilde. In fact, it was Mathilde who invited Félix to make a joint trip to Vienna and Venice – a delightful present. His diary of the journey, which was illustrated with sketches, contained the first signs of love for the great Italian past. At this stage Vallotton still could not appreciate Titian, Veronese, and Tintoretto as the austere harmony of Bellini, Vivarini, and Cima da Conegliano made a deeper impression on him.

In the 1880s, the artist tried to earn a living from portraits. The list included the names of obscure people, and even portraits worked up from photographs. He carried out such commissions in both Lausanne and Paris. Among other models his list included the concierges mentioned in a letter to his parents who rewarded him for his work with an armchair.

In this period, Swiss expatriates living in Paris played a special role in the artist's destiny. Sometimes, like Dr Paul Gaudin, they found clients for him who commissioned portraits. More important were the contacts with Ernest Biéler, a noteworthy artist from Lausanne. Being some two years older than Félix, Biéler had been based in Paris for longer. He, too, had studied under Lefebvre at the Académie Julian and had trodden the same path on which Vallotton now embarked. Consequently, he felt for Vallotton and understood him, more than anyone else. In fact, it was he who asked his friend, Auguste de Molins, an artist who had exhibited with the Impressionists at their first exhibition in 1874, for letters of recommendation for Vallotton addressed to Renoir and Degas. In a letter to Degas, he said:

> "My protégé is absolutely alone in Paris without any connections at all
> apart from his contacts at the studio, which is far from enough to satisfy
> his intellectual needs. The studio is all very well, but there comes a time
> when close relations with a master are somewhat more important, even
> far more important."

Vallotton did not make use of these letters; however, de Molins had subtly identified in the very lonely young Swiss his need to be recognised by an older figure, a master. To a certain extent, Charles Maurin fulfilled this role for him; however, their relations were rather those of friendly equal rights. Maurin tried to help Vallotton in every possible way. In 1888, he wrote to Émile Renouf, an artist and painter of seascapes who had also been a student of Boulanger and Lefebvre, who was about to go to America:

The Artist's Wife at her Dressing Table, 1899.
Tempera on cardboard.
Kunsthaus Zürich, Zurich.

The Visit, 1899.
Gouache on cardboard,
55 x 87 cm.
Kunsthaus Zürich, Zurich.
(pp. 36-37)

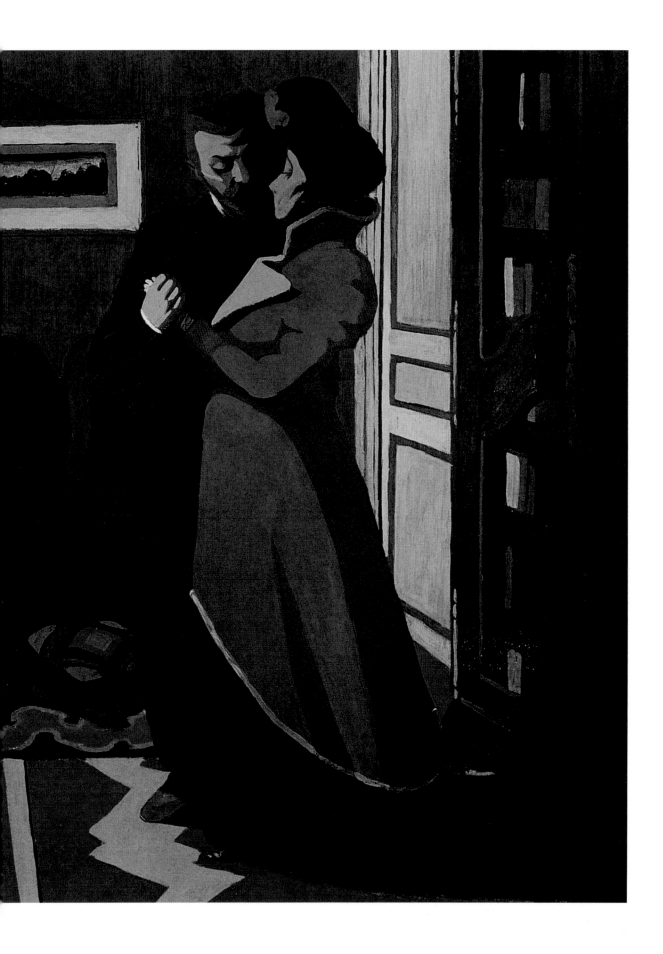

"I recommend to you my friend Vallotton: he proposes to go to America in order to try to earn some money. Despite his great talent (you can judge that for yourself), he is going through that period when the bourgeois think you are still too young to give you commissions. You could guide him in the early days, to help him to find work…"

Félix did not go to America, but there was the possibility of earning a living, or even more – the path to fame was opening up for him in a completely unexpected field.

Vallotton's list of works for 1886 included *Portrait of the Engraver Jasinski in a Blue Jacket*, and the following year he drew Félix Jasinski, hat in hands, in the other's studio. It is possible that Dr Morais, an oculist who was one of Vallotton's first acquaintances in Paris, introduced him to Jasinski, but it is equally possible that they simply met at the Louvre. The son of a Polish immigrant, Jasinski had studied etching and was earning money by doing engravings for *L'Art* magazine. Their friendship encouraged Vallotton to study the techniques of engraving. When Jasinski obtained a commission to engrave a large historical picture by the Polish artist, Jan Matejko, he turned for help to Vallotton as an already fairly experienced hand.

In Vallotton's own catalogue of works, engravings on metal started to appear as early as 1887. In a letter to his parents in November 1889, he wrote of concluding an agreement with a publisher to do some engravings. In the early days, it was a matter of reproducing pictures by contemporary artists. The list for 1889 included copies of etchings by Rembrandt. In the *Lausanne Gazette* dated 8 October 1891, the critic Charles Koella deplored the fact that only one engraving by Vallotton (of a picture by Velázquez) was on display at an exhibition in Lausanne: "This is an outstanding item that is rich, plastic, full of colour, and beautiful in its manner of execution, and full of those very qualities which make someone an artist."

It was not surprising, however, that Vallotton embarked on another new path in order to earn an adequate living. The list of works for 1891 saw the appearance of wood engravings, and in the following year they almost displaced the paintings. In 1893, the xylographs were joined by lithographs, and a great number of sketches for magazines and illustrations for books. One might think that for a period of eight years the Vallotton whose dream had always been to paint was replaced by someone else. Things went on in the same way until 1899. Then the picture suddenly changed, and he poured his talents exclusively into painting.

The new Vallotton, after mastering the highly complex technique of etching, suddenly changed over to the no less laborious and esoteric technique of xylography. With the very first block he ever cut, Vallotton began creating wood engravings which were not

Interior, Red Armchair and Figures, 1899.
Tempera on cardboard, 46.5 x 59 cm.
Kunsthaus Zürich, Zurich.

Dinner by Lamplight, 1899.
Oil on cardboard mounted on wood, 58 x 90 cm.
Musée d'Orsay, Paris.
(pp. 40-41)

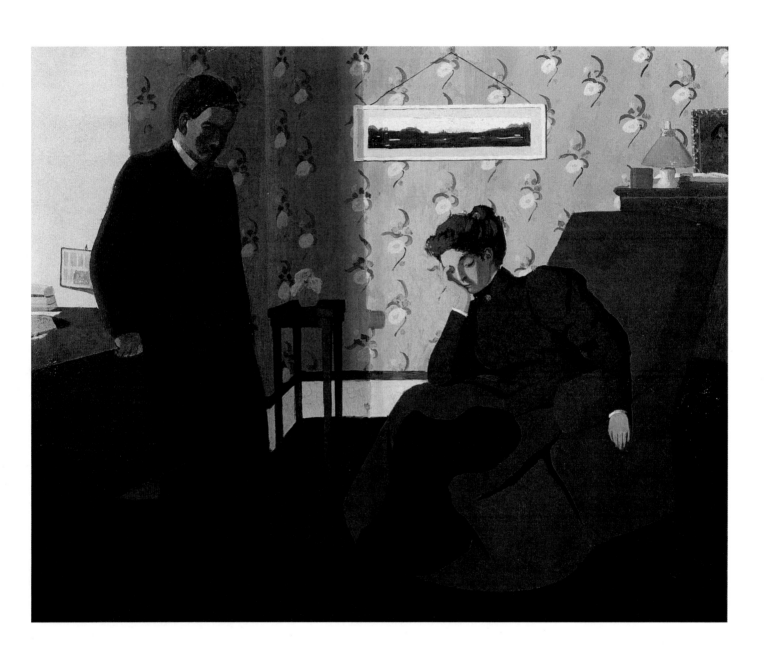

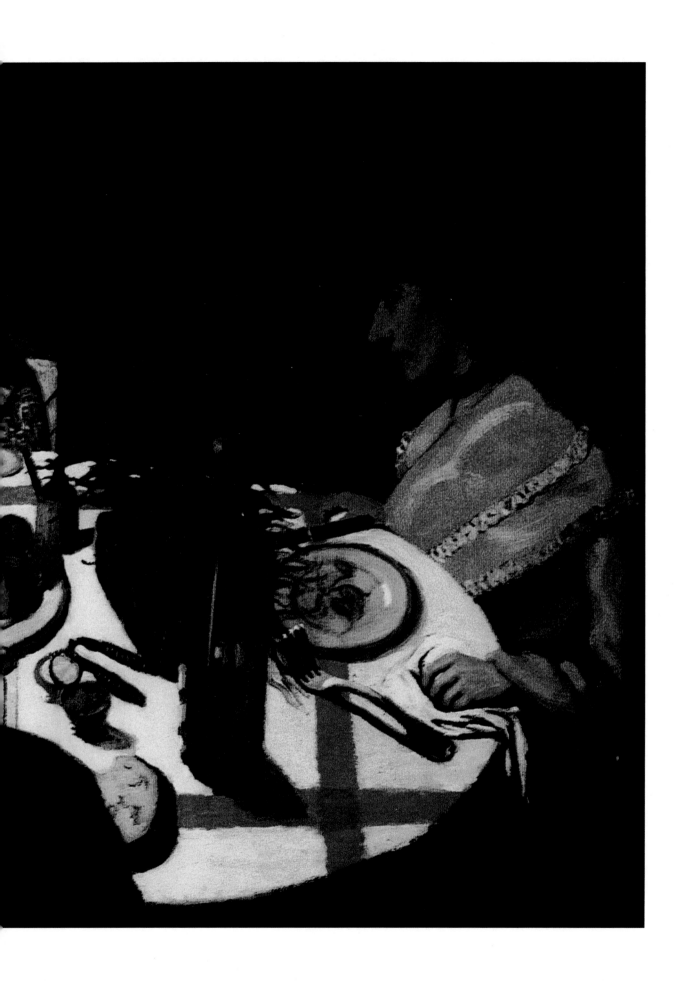

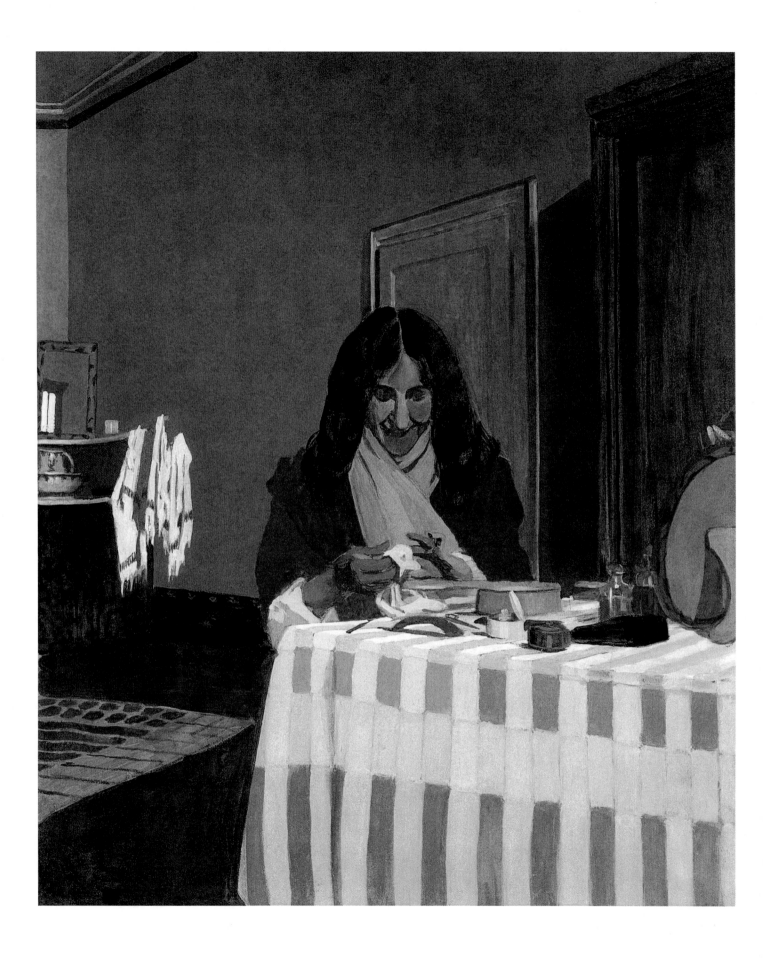

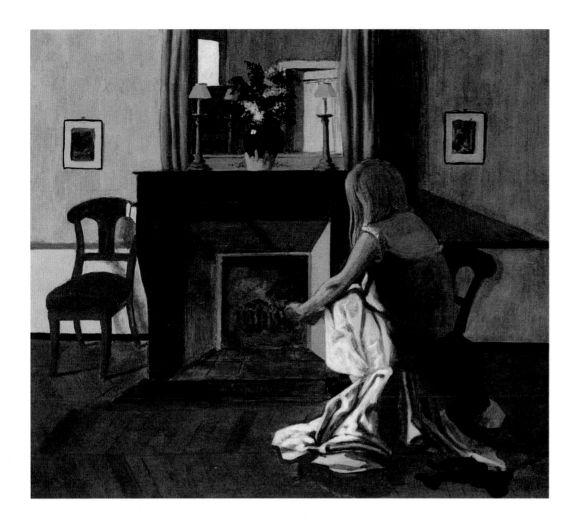

only faultless in their technique, but were also absolutely unlike any xylographs by his contemporaries or predecessors. As early as February 1892, Octave Uzanne most eloquently entitled his article in the *Art and Thought* magazine: "The renaissance of wood engraving – the neo-xylographer Félix Vallotton".

Seldom has any artist been able to boast that he was responsible for a revolution in a particular area of art by the age of twenty five. In a letter dated June 1892 to his brother Paul in Lausanne, Félix told of his worries and little pleasures:

> "…I must try to sell some engravings in Paris and Switzerland. I must think about further exhibitions – my reputation as an artist depends on that… My dear Paul, I shall send you prints of the two engravings which you requested straight away, and I hope that they will arrive safely; I am very glad that people are buying them… My last engraving has been displayed well at the Salon on the Champ de Mars and, I hope, noticed. I no longer worry about that at all;

Gabrielle Vallotton doing her nails, 1899.
Musée d'Orsay, Paris.

Interior with a Woman in a Nightgown, 1899.
Tempera on cardboard,
48 x 57 cm.
Private collection.

yesterday I sent an article about the exhibition to a newspaper … My wood engravings, it seems, have started making their way in the world, and they are bringing me real fame…"

And although he had to wait a long time for any earnings, and his relations with the dealers did not run smoothly, that was not the most important consideration now for Félix: his engravings were his pride. The articles about exhibitions which Vallotton regularly sent to Swiss newspapers earned him little money, but this did not keep him from writing them.

Behind his outward coldness and impassivity, Vallotton concealed a wealth of emotions and a passionate attitude to the world and to art which demanded an outlet. These articles became the means of expressing his subtle understanding and very individual evaluation of past and present artists. In a certain sense, they became objects of pride for him. Later, Vallotton spelt out his own preferences in art very clearly in *A Pernicious Life*.

"In painting, Holbein and Leonardo were my first idols; the free and penetrating side of their art agreed perfectly with my best inclinations, and it could not be otherwise. I fought against the great colourists more; I felt confused by Veronese and Titian because they deviated from principles too much. I only laid down my arms later, but then I surrendered to them completely, with a glad readiness to be conquered. Rubens always horrified me; I was never able to grasp the proportions of that genius who covers you like some gigantic sheet and enmeshes you. I did not like Van Dyck; Rembrandt was the last to conquer me, when I had a better grasp of the essence of many things and a better understanding of my trade, which I still had not mastered."

All of Vallotton's friends talked of his love for Ingres, by whom, in Natanson's words, he was "conquered without offering any resistance". In making Ingres an object of veneration, Vallotton was, as it were, summing up the demands which he made on painting; rationalism and clarity of expression, as well as the predominance of shape and line over colour. Whether he realised them in his own art and in what form, is a fairly complex question. In 1898, Meier-Graefe gave one of the possible answers to this:

"By returning to Ingres, Vallotton is trying to bring back the same elements in art. But he is certainly not returning to the times of Ingres; on the contrary, he is trying to transform these elements so as to give them a modern form and expression, and make them the engine of the artistic emotions which are now bubbling up in us."

Women Carrying Wood, 1899.
Oil on cardboard on canvas,
49 x 61 cm.
Private collection, Lausanne.

Morning Mist in Romanel, 1900.
Oil on cardboard, 24 x 54 cm.
Private collection. (pp. 46-47)

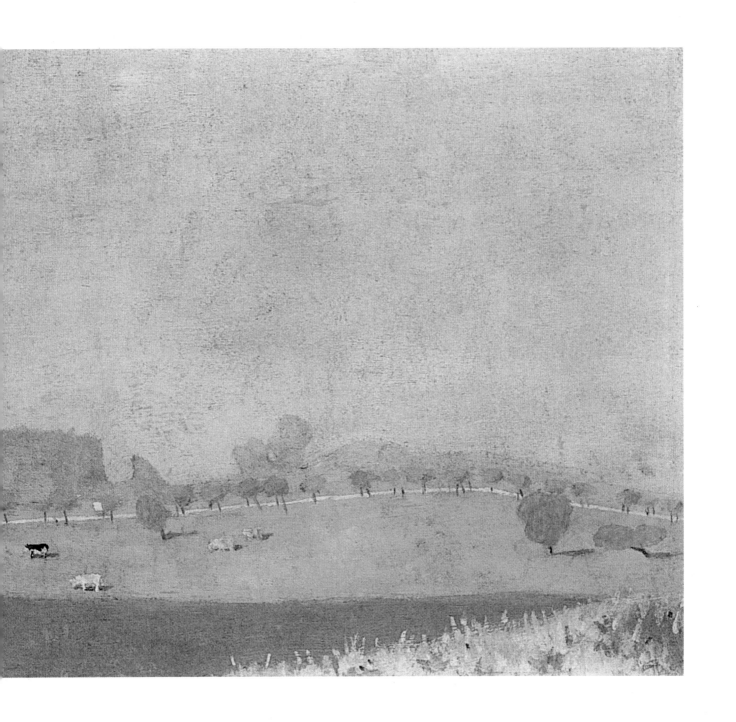

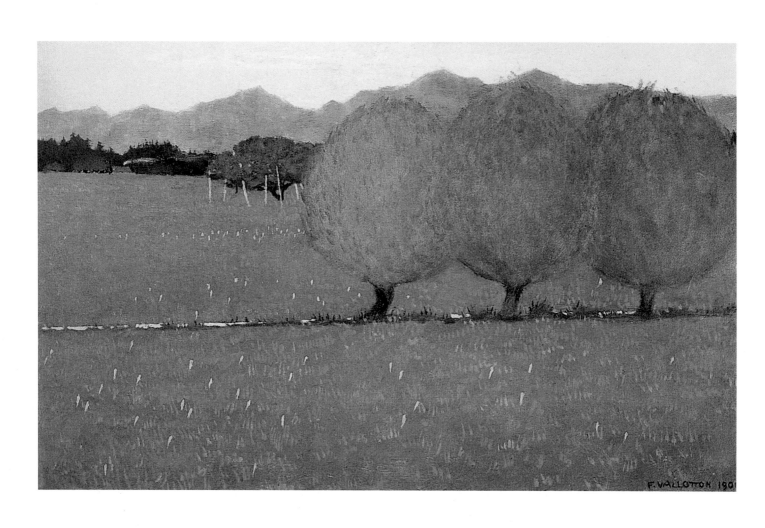

However, conclusions of this kind apply to somewhat later times, whereas then, in his youth, his own inclinations in art became the criterion for assessing past and present artists in his articles for the *Lausanne Gazette*. You have to possess a special gift to be able to assess the worth of art which is being created now in your own time, before your very eyes. Félix Vallotton had the courage to test himself in this respect. He became a correspondent for the *Lausanne Gazette*, his reviews of the Paris Salons appeared fairly regularly, and the author fought to ensure that their meaning was not altered even slightly. In an 1893 letter to his brother, he wrote:

> "I sent the paper an article on the Salon. If they change it and distort its meaning, that will be the last straw, and I shall tender my resignation. I shall not hang on to the laughable money which they pay me; anyway I spend too much time on these useless articles, and after all that they still want to sweeten them."

The newspaper's desire to "sweeten" Vallotton's text becomes understandable when you read the merciless and caustic comments he aimed at the exhibitors at the Salon des Champs Élysées. Vallotton compared the exhibition with a fashion show, because "only the sight of the pretty women who parade up and down there can make up for the dreadful boredom which grips you at the sight of walls which sweat from such a collection of frames; over-ornate, over-gilded, and over-large".

However, his caustic attitude by no means extended to all his contemporaries. His respect for the Impressionists was both profound and constant. By that time they had already gone through the most difficult period of their life, but had still not been totally accepted. The story of the Impressionist art collection which was bequeathed to the nation by Gustave Caillebotte, and from which the French government recoiled in such horror in 1894, shows that their art still needed the support of the critics.

In 1890, Vallotton wrote that, in the future, the end of the 19ᵗʰ century would be made famous by Monet, Renoir, and Degas. In his account of the Georges Petit exhibition in 1891 he addressed some uncharacteristically warm and respectful remarks to Alfred Sisley: "If there is anyone at all who has his own style, it is him… If there is anyone at all who has fought for an idea and who deserves to have his day, then it is definitely him." He also devoted an enthusiastic article to the ever-young Pissarro. During the same period, his attention was caught by the poster, a sphere of art which was so important in the daily life of Paris at the end of the century. He rejoiced at the success of his compatriot Eugène Grasset and a Parisian called Jules Chéret, to whom he devoted an article in the *Lausanne Gazette* in 1891: "He is reviving the old French tradition," Vallotton wrote. "Everything he does

Les Colchiques, 1900.
Oil on cardboard, 34 x 55 cm.
Musée cantonal des Beaux-Arts, Lausanne.

Houses in Puteaux, 1900.
Oil on cardboard, 22 x 40 cm.
Private collection, Munich.
(pp. 50-51)

F. VALLOTTON. OO

is lovely, his drawing, his colour…; he has brought joy to modern grief, his fantasies are destroying the greyish monotony of utilitarian art; and the old Paris walls seem rejuvenated and decorated."

Deeply touched, Chéret wrote to Vallotton: "Your words of praise are especially dear to me, because they come from an artist."

It would not be worth talking at such great length, it would seem, about some seemingly chance field in which Vallotton's talent revealed itself, if it were not for the fact that it was here that his profound culture, shrewdness and versatility of interests made themselves evident. He elegantly and professionally analysed Böcklin's work, reproached the Englishman Burne-Jones for his inadequate skills, and devoted articles to the "Sunday artist" Henri Rousseau and a Holbein exhibition in Basle in 1897. "He simply painted life exactly as it is," Vallotton said of Holbein, commenting on his portraits in particular: "When you take a close look at them, little by little characters are delineated, souls are bared and personalities emerge, one after the other, like individuals in a crowd; a new aspect, of them emerges: sullen, bold or indifferent, tender, cruel or sinister."

Was it not the ability to wrap in apparent simplicity the complexity of human character and life, an ability which Vallotton possessed long before he discovered it in Holbein's painting, that brought him close to the old Basel master? Meanwhile, Vallotton's life was following its established course – his wood engravings were selling, and commissions were coming in for magazine drawings and illustrations from publishers and writers, including Jules Renard, Stéphane Mallarmé, and Remy de Gourmont. Graphic art now took up all his time. In a letter to his brother in 1894, he said: "I am doing engravings now, and a bit of painting from time to time, but so little that it is hardly worth mentioning." It seems that his affairs had attained some sort of relative order: "In the final analysis, I do not regret it too much," wrote Vallotton. "I have somewhere to sleep, I am warm, I eat well, and from time to time I can do some work to be sold, and that is worth something." The time had passed when he had to ask his brother or father to send him cocoa. Now he dreamed of his own studio, because he was still working in cramped conditions, but kept putting off the solution to this problem until better times came along. He had no doubt that they would come: he just had to keep working. A year later, nothing had changed, and he wrote:

> "I simply do not go out. I only want to grab a snack. I work all the
> time and am not complaining; at present I have a whole range of little
> things on the go, from the sale of which there will be almost enough
> money to live on, so I am far less occupied with looking for work than
> before. Of course, my painting is suffering as a consequence. I do
> very little or none at all and that is the dark side of my life."

Rock Wall in Bex, 1900.
Oil on cardboard, 46 x 36 cm.
Private collection.

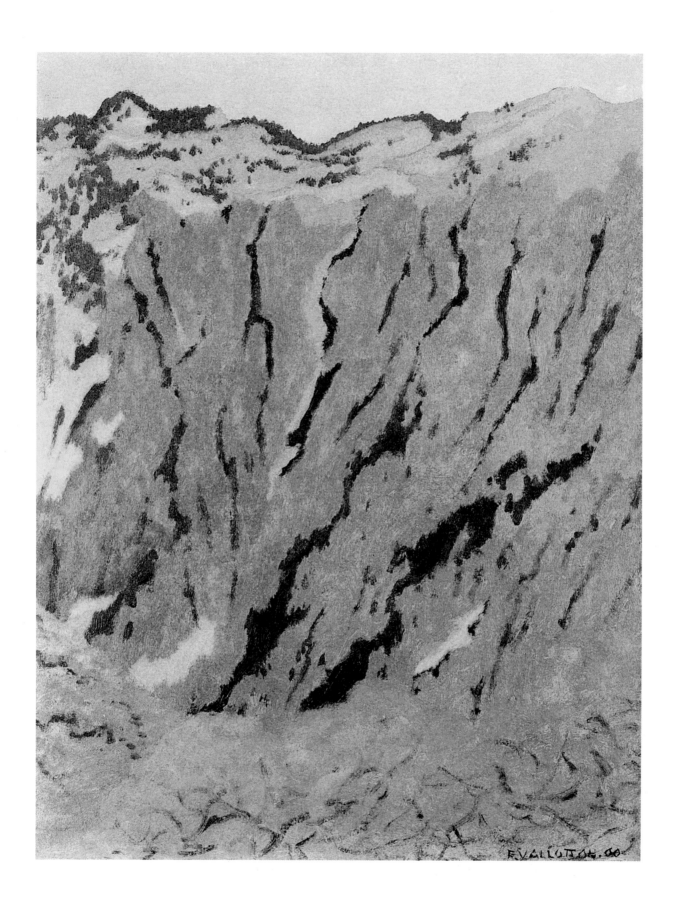

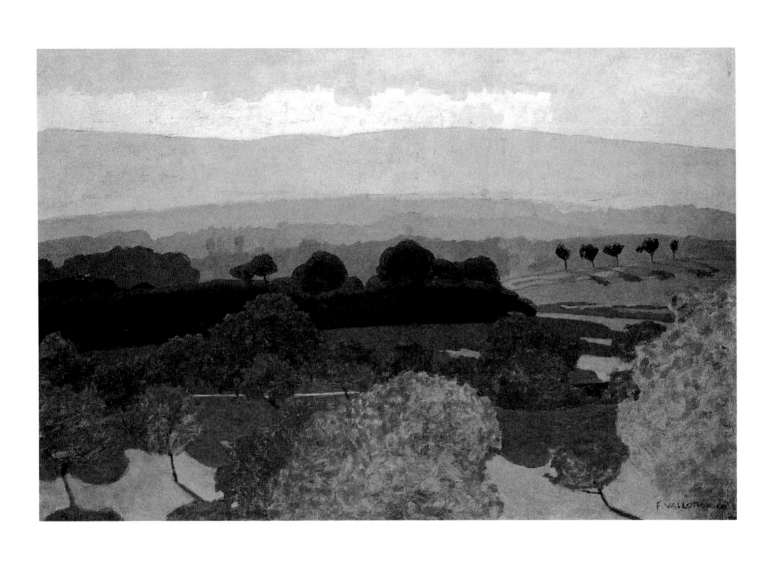

Romanel Landscape, 1900. Oil on cardboard, 51 x 78 cm. Private collection.

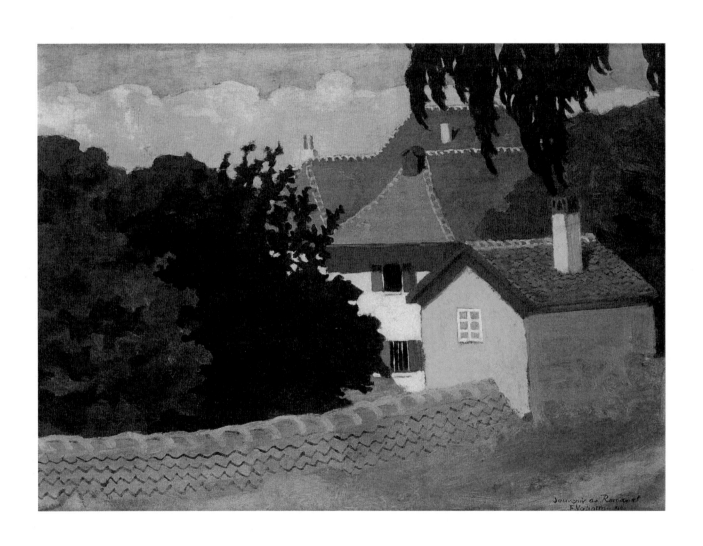

Remembering Romanel, 1900. Oil on cardboard, 40 x 56 cm. Private collection.

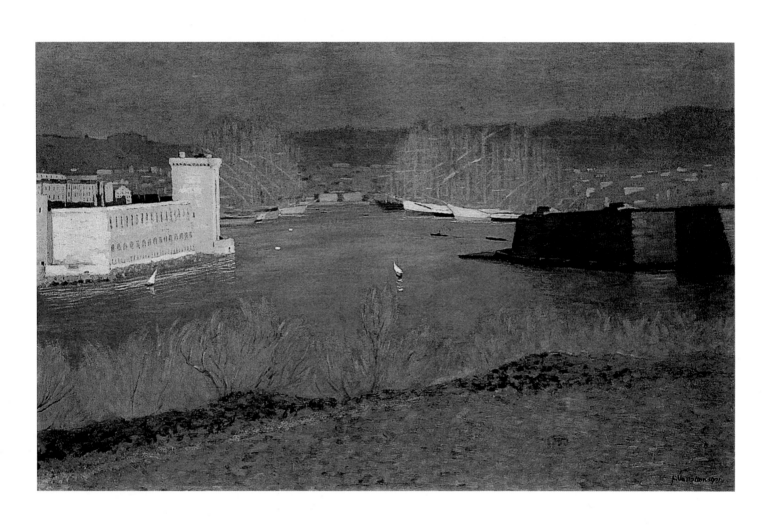

His Paintings

What kind of painting did he nevertheless manage to do from time to time? In letters to his brother, Vallotton constantly wrote about his intentions to spend some time in Switzerland, and said that he missed the mountains. If landscapes are indeed mentioned in the list of his works for the 1890s, they were painted either in Lausanne and its environs, or in Paris. The appearance of uncommissioned landscapes in Vallotton's œuvre (although there were occasions when he painted them for Swiss customers) is completely natural – anyone born on the shores of Lake Geneva can never forget them. Vallotton depicted the streets of Lausanne climbing towards the cathedral, the stony paths running down towards the lake, and the sails of the yachts in the peaceful backwaters of Puy. Painted in oils or watercolours, they were covered with a light, misty haze that was barely discernible to the eye. Their softness and transparency are reminiscent of the tradition which arose in the painting of natives of Lausanne and the wider Lake Geneva area as early as the 18th century. That landscape is so bewitching and its magnetism so powerful that you can still sense the Swiss countryside in the works which the Lausanne artists Jacques and Francois Sablet produced in Italy. During Vallotton's childhood years, the idol of Lausanne was François Bocion, who sang of the beauty of Lake Geneva. Bocion died in 1890, when Vallotton had already moved to Paris and established himself there, and even though they never had occasion to meet in person, Vallotton knew Bocion's painting perfectly well.

Did he imitate his older compatriot? There is no doubt that an influence can be sensed fairly strongly in Vallotton's landscapes, but it is difficult to reproach him for any lack of originality. They simply both looked at the country with adoring eyes. Later, in his novel, Vallotton devoted these rapturous and tender words to this area:

> "Above the woods of Verdon the bluish peak of Mount Dresch could be seen and on the right, almost on the horizon, a very small piece of the Dent Noir sparkling in the morning sun… The mist-shrouded surface of the lake, which suddenly cleared and turned greyish-blue whenever the west wind blew, stretched into the far distance, to the extreme south. It was within this frame that my early years were spent."

Mathisa Morhardt, in 1893, wrote of Vallotton in the *Lausanne Gazette*:

> "In his interpretation of nature, he looked for its subtlest aspects: soft colouring and concealed melancholy. It is interesting that, whenever he visits the shore of Lake Geneva, he deliberately turns his back on the excessively clear and grandiose expanses of water and mountains. He prefers the intimate little corners, bathed in light, muffled by the

Port of Marseille, 1901.
Oil on cardboard, 63 x 102 cm.
Private collection.

Children at a Pond, 1900.
Oil on cardboard, 29.5 x 49 cm.
Private collection. (pp. 58-59)

F. VALLOTTON. 00

translucent mist; his dream of comfortable, cosy bliss, it seems, reveals itself there with particular ease and particular harmony."

In a surprising picture, known under the title *The Patient* (*La Malade*, pp. 20-21) and described in his catalogue for 1892 as *An interior. One girl lying down, and another entering with a pillow in her arms*, Vallotton gave expression to his dream of bliss. This unsophisticated scene is reminiscent of the simple naturalism of the Swiss Albert Anker's pictures, which were popular in Lausanne. Anker, however, was not as naïve as he seemed at first sight: in their own way, his set of scenes from daily life make up a picture presenting the ideal of a happy Switzerland. And the over-obvious simplicity of Vallotton's painting evokes even more doubt.

In the precisely arranged frame of a stage, two actresses are taking the places assigned by the director, each busy with her role and her next line. The artist's slightly dismissive glance slides lightly and admiringly along the narrow neck and gentle locks of hair of the girl in the bed, but her face is hidden. Each object and each little detail has been completed with total illusion of material and form; however, together, they constitute an image of a familiar and everyday world, but which is so transparent and pure. It seems as if the artist is handling the glass objects on the table, one after the other, and they ring when touched lightly by his fingers. The window reflected in the glass of a carafe is reminiscent of the Old Dutch masters, and the harmony of the silvery and ochre-gold tints endows Vallotton's picture with the diffused light of Vermeer. And, as a finishing touch, an obvious flat spot of red makes a splash right in the centre. Above all, Vallotton demonstrated here all the beauty, delicacy, and culture of his palette. It is arguable that he never in his life produced pictures with a lighter mood. A girl called Hélène Chatenay acted as the model for the patient. A letter Vallotton sent to his brother in August 1893 included some words which were unusual for him: "I am living very quietly and, apart from the constant problems of money, very happily." Other letters from this period contain occasional references to "la petite" who sent greetings to Paul's family in Lausanne. "Thank you for the chocolate," wrote Félix in January 1893. "La petite was deliriously happy: she kissed the paper, the box, and the ribbon; then she assiduously wrote the note which I enclose. She is good-hearted, and to do anything for her is a sheer joy."

One day Vallotton and Maurin became acquainted with two young working girls and so Hélène Chatenay – affectionately nicknamed Tonton – came into Félix's life. She was often ill and Vallotton felt sorry for her. She made friends with his relatives in Lausanne and used to visit them, sometimes even without Félix.

"La petite is very tired," Félix wrote to Paul in 1894, "and thinks about you constantly. She is coming presently with a letter for you. She insists on sending

Barges Banks of the Seine, 1901.
Oil on canvas, 43.5 x 57 cm.
Private collection.

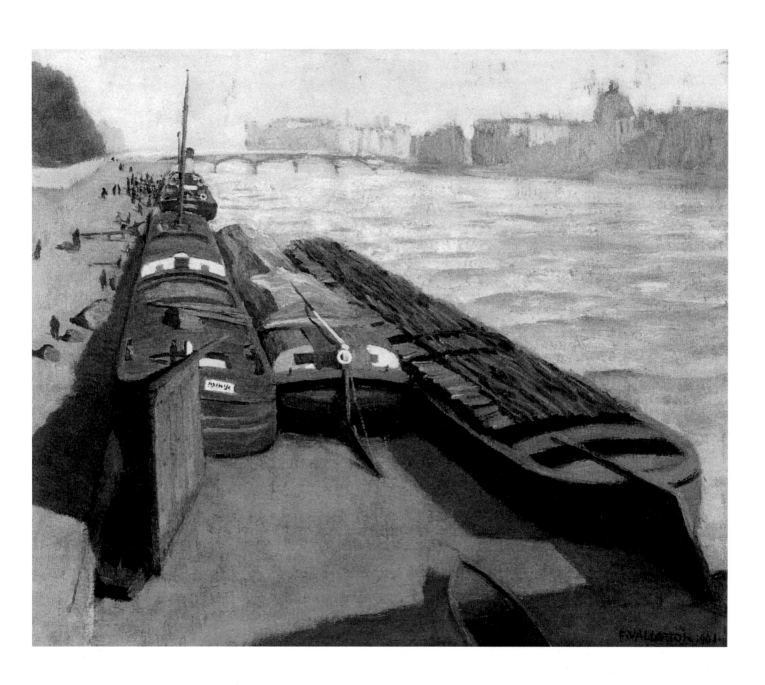

Dithée [Paul Vallotton's wife] four fine silk handkerchiefs which she received as a present and which she believes are too pretty for her…" In 1895, Hélène added some lines to one of Félix's letters to his brother Paul, writing in an unsophisticated manner without any punctuation:

> "Dear Tonton is writing to Paul I am at Félix's I visit him every Sunday we make a good breakfast and dinner we make a charlotte every Sunday and it never turns out right … I would like to see you very much because I have missed you so much this year because I have not seen you write a few lines to me in your letter to Félix…"

At one point Vallotton even decided to marry Hélène, as a letter from Charles Maurin indicates: "I was startled by you, out of friendly egotism," he wrote. "I am jealous of a friend who is getting married, and it seems to me as if something is being torn away from me…" Hélène naturally became a model for Félix Vallotton; he painted her nude, and did some portraits. In 1891, he painted *The Seamstress* (p. 19), and about 1892 he refers to an "interior of a kitchen with a figure, done at Ballancourt (Hélène Chatenay)". Plain and simple, Hélène pottering about with the saucepans on the stove, actually existed in his daily life, but the frail girl on the bed in the silvery room existed only in his dreams.

There are a few more lovely paintings that remained almost unnoticed in the stream of engravings with which Vallotton flooded Paris and which were all the critics noticed. In 1896, he painted a small work entitled *The Mistress and the Servant*. At first glance it produces the impression of being a comic sketch: a young, sturdily built housemaid with a rosy complexion is supporting a lady with a yellow complexion and bright red hair who is shivering with fear of the cold water. Some critics, including Gustave Geffroy, promptly consigned Vallotton to the ranks of the "humourists". However, as always with this artist, it was not such a simple matter. Classically constructed on the basis of intersecting diagonals and perpendiculars, his composition was balanced with mathematical accuracy. Even in their absurdity, the figures of the mistress and the housemaid demonstrate Vallotton's brilliant mastery in painting a nude model. His line not only conveys any movement with a lightness of touch, but also traces a graceful arabesque on the surface of the canvas. The stylised warm range and bold splashes of local colour remove his work completely from the realms of everyday genre painting into the realm of decoration. And only the rocks in the limpid wave breaking against the shore in graceful, semi-circular lines, afford us a glimpse of that far-off corner of the soul where the restrained Vallotton concealed his love for nature.

A tendency towards decorative painting can be observed in the interiors with figures which he often painted during this period. In these works, Vallotton's nude models bathe,

Old Street in Nice, 1901.
Oil on cardboard, 68 x 53 cm.
Kunstmuseum St Gallen, St Gallen.

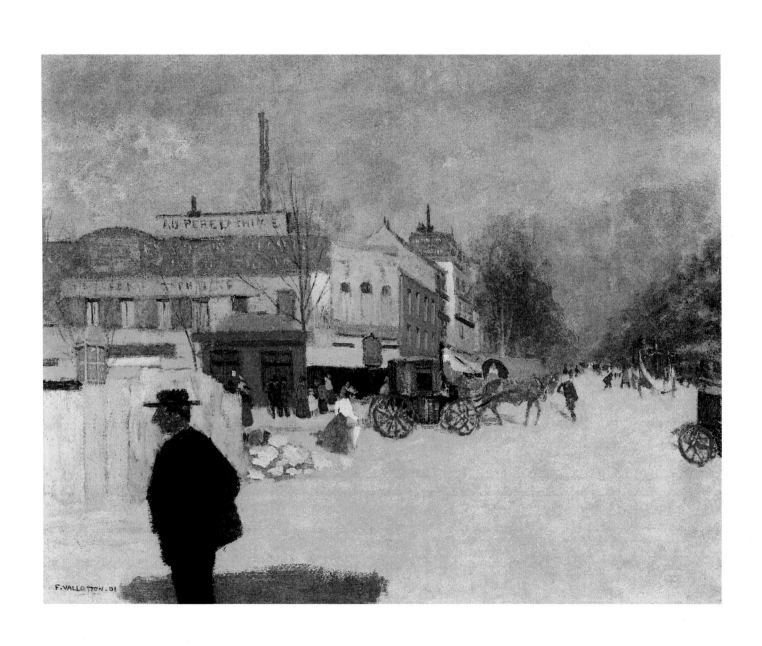

Place de Clichy, Paris, 1901. Oil on cardboard, 43.5 x 57 cm. Private collection.

Honfleur and the Bay of the Seine, 1901. Musée Eugène Boudin, Honfleur.

brush their hair, or play with kittens, presenting the viewer with an image that is sometimes graceful and sometimes touchingly clumsy and vulnerable to the prying eye of the outsider. In combination with depictions of furniture, ornaments, and patterns in the carpet, they make up some refined compositions.

A special place is occupied by *Summer. Women Bathing in a Tiled Pool in the Open Air*, painted in 1893. Vallotton's records state that *Summer* was exhibited at the Salon des Indépendents. It was given scant attention by Roger-Marx and Félix Fénéon, but rated magnificent by the Swiss critic Morhardt.

> "I must admit that, at first, this spectacle embarrassed visitors to the Salon des Indépendents. Such a treatment of young women entering a river, one by one, in order to refresh themselves, has about it something too contrary to common practice not to be shocking," he said, and explained the author's intentions in this way: "Without worrying about anything apart from the harmonious composition of form and colour, he was trying to convey an impression of the magnificence and fullness of life which reveals itself at a lovely time of year."

An exclusive concern for the decorativeness of colour is indeed striking in Vallotton's canvasses from 1893. There is a play between the red, fixed by two rectangular surfaces, and the green, the texture of which is given variety by the horizontal strips of steps and some darker spots in the background, all painted with surprising fantasy. The small flowers scattered among the grass, as well as the beams of sunlight drawn in gold, are reminiscent of mediaeval "des mille fleurs" tapestries, while at the same time the women's hairstyles and their deliberately unconstrained poses make *Summer* a modern picture.

Francis Jourdain said that in Vallotton's studio he saw a *Spring* which was a companion piece to *Summer*, but which the artist later probably destroyed and did not even include in his catalogue. It depicted some girls gathering flowers.

> "The figures were arranged on the canvas one above the other, without any great concern for perspective … Although it had a good deal of the caricature about it, the picture was permeated with its own kind of grace, almost playful naughtiness, the harmony of which, intentionally reminiscent of a chocolate-box, was cynically made to look ludicrous."

Near Honfleur, 1901.
Private collection.

Judging by this description, these two pictures made up a single stylised group, their theme – the seasons – being a favourite during the Symbolism period in literature.

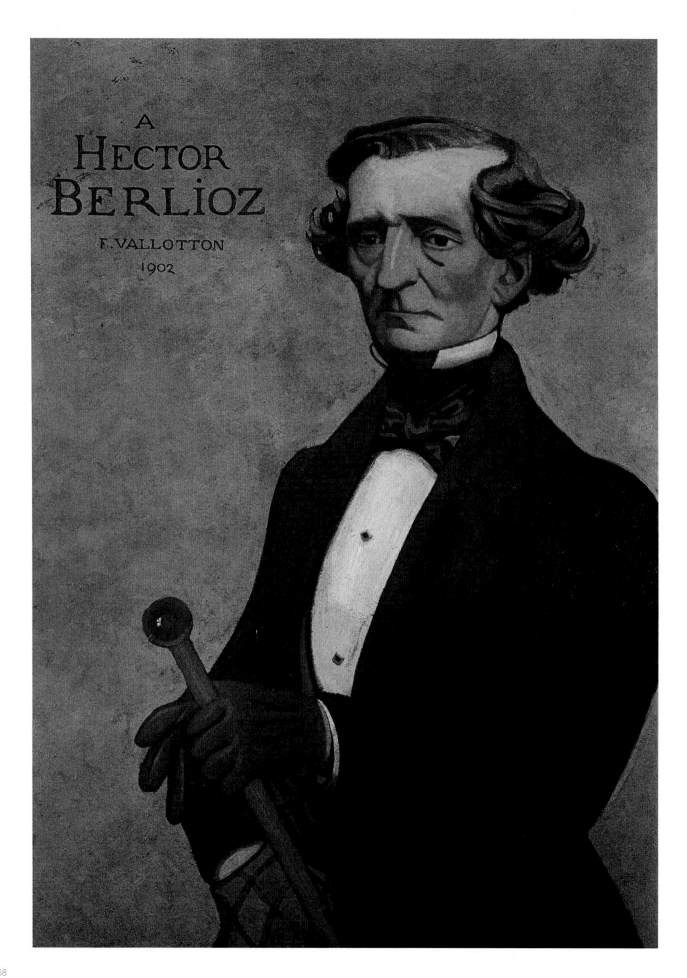

A
HECTOR
BERLIOZ
F. VALLOTTON
1902

The Nabis and Engraving

Encountering the Nabis

Four years later, in 1897, Vallotton's friend Maurice Denis painted one of his own versions of spring – the picture familiar under the title *The Sacred Grove*. These canvasses, so different though they are in colour and attitude to nature, adhere to the general principle of decorative aesthetics which was forming at the time. Vallotton's high cultural level and erudition, his refined understanding of the purely graphic problems of painting, and his brilliant individuality placed him among the circle of artists who were destined to create a new decorative style.

It is difficult to say exactly when Félix Vallotton's friendship with the "Nabis" group of artists and Symbolist writers began. The earliest surviving letter from Édouard Vuillard to Vallotton is dated August 1894 and is written so confidentially and intimately that it suggests a relationship of quite long standing. "My dear friend," he wrote, "…I am quite ashamed that I have not written you a single word since you left, and I reproach myself for this every day; I hope you realise how lazy I am, and that you do not suspect me of indifference…"

The beginning of this friendship could have been connected with the Académie Julian, through which most of the Nabis passed. Vallotton could also have been one of those whom Paul Sérusier gathered together after returning from a visit to Gauguin in Pont-Aven in 1889 or 1890. If so, he became one of the first to admire the famous Nabis "talisman" – a cardboard cigar box on which Gauguin had painted a landscape. Charles Cotais, an artist and compatriot of Charles Maurin, may also have recruited the Swiss artist into the Nabis, as he himself was a member. It is also possible that Vallotton joined the Nabis in 1891, when *La Revue blanche* – the magazine of the Symbolist writers, published by the three Natanson brothers – was launched. From the first moment of its existence, Vallotton became intensely active not only in engraving, but also in magazine graphics.

Whatever the means by which he arrived there, Vallotton was in from the very start, along with his contemporaries: Pierre Bonnard, Édouard Vuillard, Maurice Denis, Paul Ranson, and Ker-Xavier Roussel. Paul Sériusier, an expert in Eastern languages, named their friendly association the Nabis, from the word *nabhi* used for the Old Testament prophets in Hebrew. It is considered that the Nabis did not officially initiate Vallotton until 1907; however, it is difficult to say to what extent their circle can be regarded as a formal institution – not without reason did Thadée Natanson call them all "pseudo-prophets". They arranged their famous dinners, which were closed to outsiders, in one or other of the cafés which they frequented, or gathered in Vuillard's mother's corset workshop. They spent their

Decorative Portrait of Hector Berlioz, 1902.
Oil on cardboard, 105 x 75 cm.
Private collection. (p. 68)

The Toast, 1902.
Oil on cardboard, 49 x 68 cm.
Private collection, Paris.

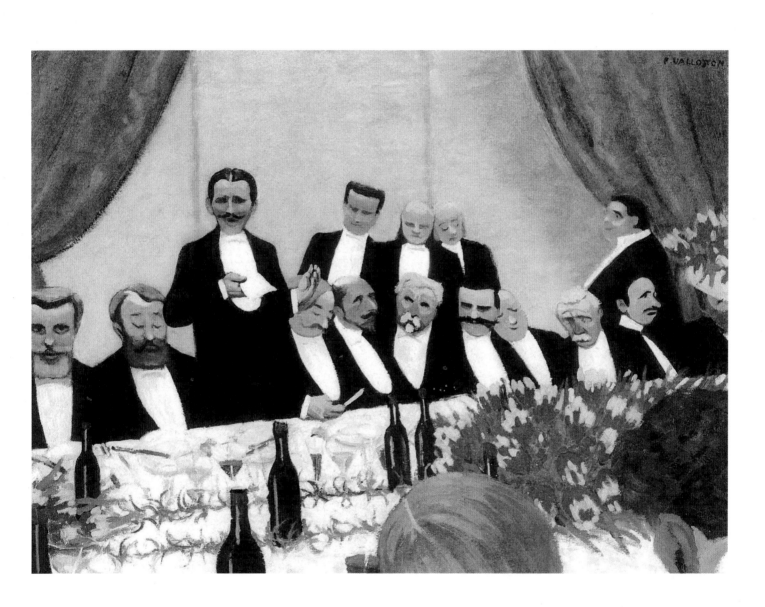

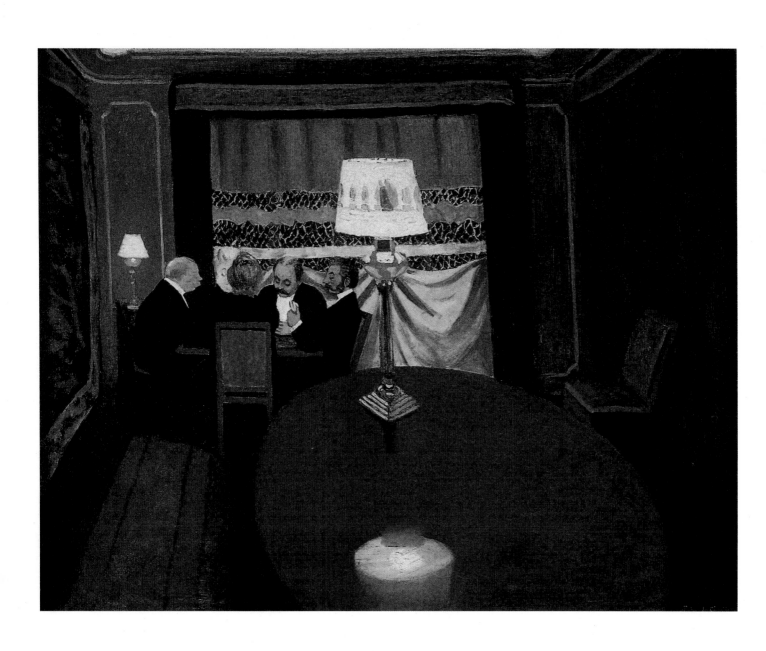

The Poker Game, 1902. Oil on cardboard, 52.5 x 67.5 cm. Musée d'Orsay, Paris.

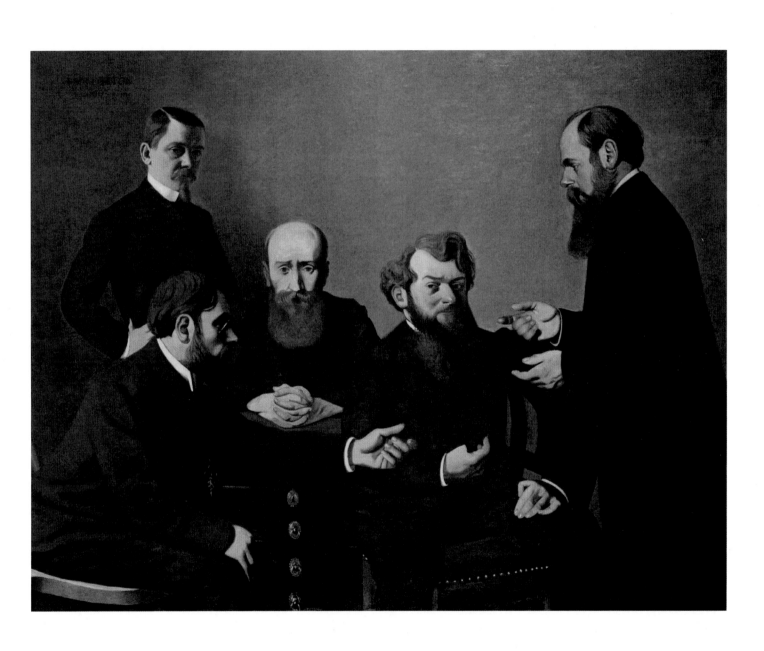

The Five Painters: Bonnard, Vuillard, Roussel, Cottet, and Vallotton, 1903.
Kunstmuseum Winterthur, Winterthur (Switzerland).

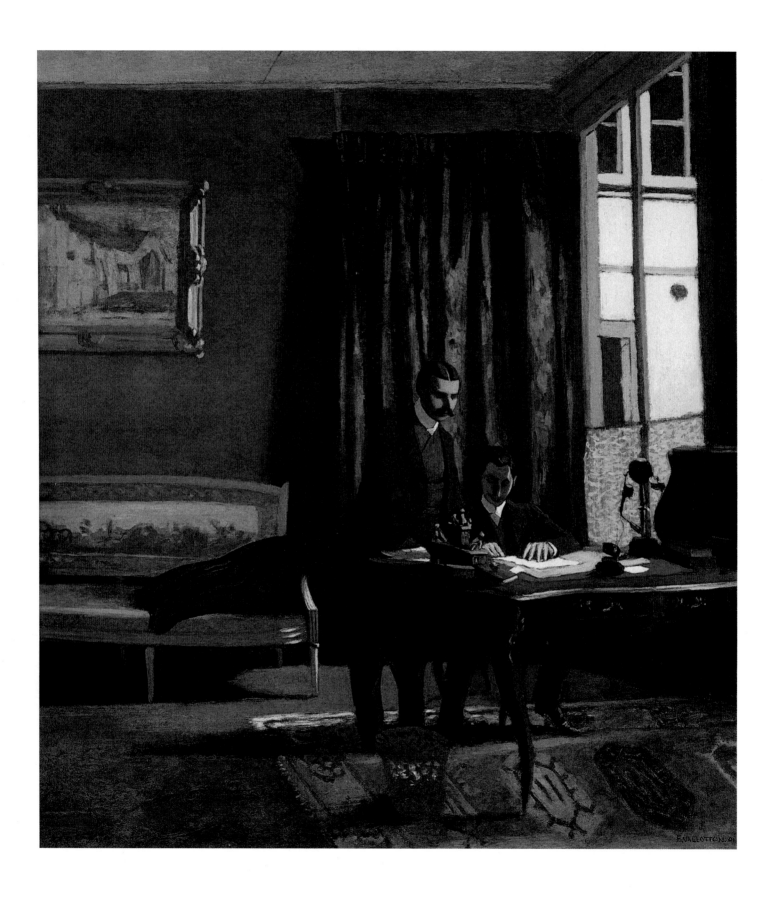

evenings in the "Temple" – Paul Ranson's studio, the walls of which had been painted by Denis, Bonnard, Vuillard, and Roussel. Marie-France, Ranson's wife, was called the "luminary of the temple". They also had a special language in their correspondence, not understood by the uninitiated, which they used animatedly in the 1890s. They were all very young, and their rituals represented a kind of game with some elements of mysticism, which they, incidentally, regarded with complete seriousness. New "brethren" were usually introduced by one of the members of the group.

In 1889, Paul Sérusier, who was effectively the organiser of the Nabis group, wrote to Maurice Denis about Édouard Vuillard's initiation: "Welcome! I am dreaming of a pure brotherhood in the future, consisting entirely of artists who are confirmed devotees of the beautiful and the good, taking as the foundation of their creative work and their conduct that quality which is hard to define, and which I call by the word Nabi." Félix Vallotton was too shy and ironical to take the rituals or the fervency of some of his friends' enthusiasm seriously. For example, he called the thoroughly modern female figures in paintings on sacred subjects by his great friend Maurice Denis, a confirmed Catholic, "Holy Virgins on Bicycles". But this did not stop him from taking very seriously the Nabis' ideas on aesthetics, which coincided with his own independently formed artistic convictions.

In an article in 1890, Denis wrote these remarkable words which presaged the concepts of painting in the 20th century: "Before it can become a war-horse, a nude woman or the narrative of some story, a picture is a flat surface covered in paints in one order or another." This attitude to a painting in the 1890s was less relevant to the works of Denis himself than to *Summer* or *The Mistress and the Servant* by Vallotton, not, however, in the least because the latter was consciously striving to put Gauguin's lessons or Denis' theory into practice. Above all, Félix Vallotton had to go his own way, which in the present instance was to lead him to those who became his friends for life.

Thadée Natanson recalled:

> "Vallotton came to us, not directly from his native Switzerland, but after he had already spent a fairly long time in Paris. He came to us very young and very slim, with fair hair, an oval, somewhat asymmetric face, a tiny moustache and no beard whatsoever … He seemed to be on the alert at all times, and this further intensified the impression of reticence, of which he could never completely rid himself."

Josse and Gaston Bernheim-Jeune in their Office, 1901.
Private collection, Paris.

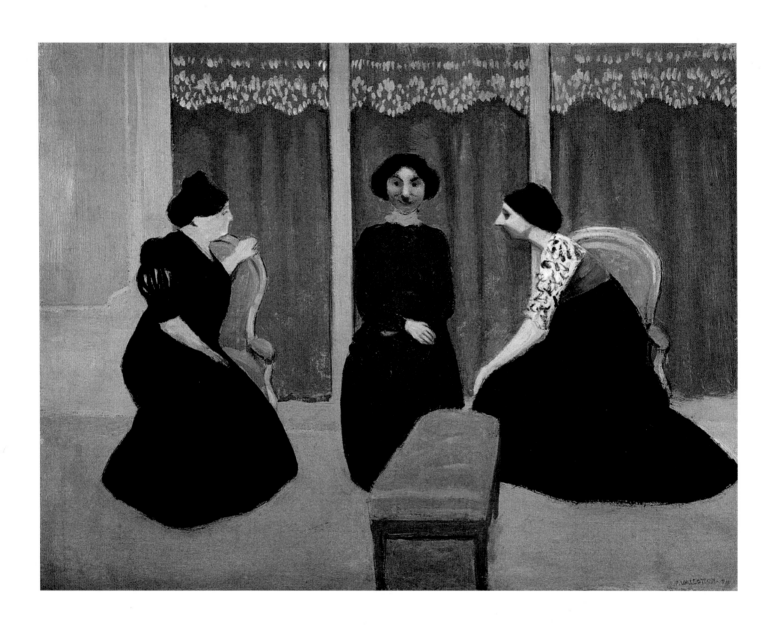

Gossip, 1902. Tempera on cardboard, 38 x 51 cm. Private collection.

Interior, 1903-1904. Oil on cardboard, 61.5 x 56 cm. The State Hermitage Museum, St Petersburg.

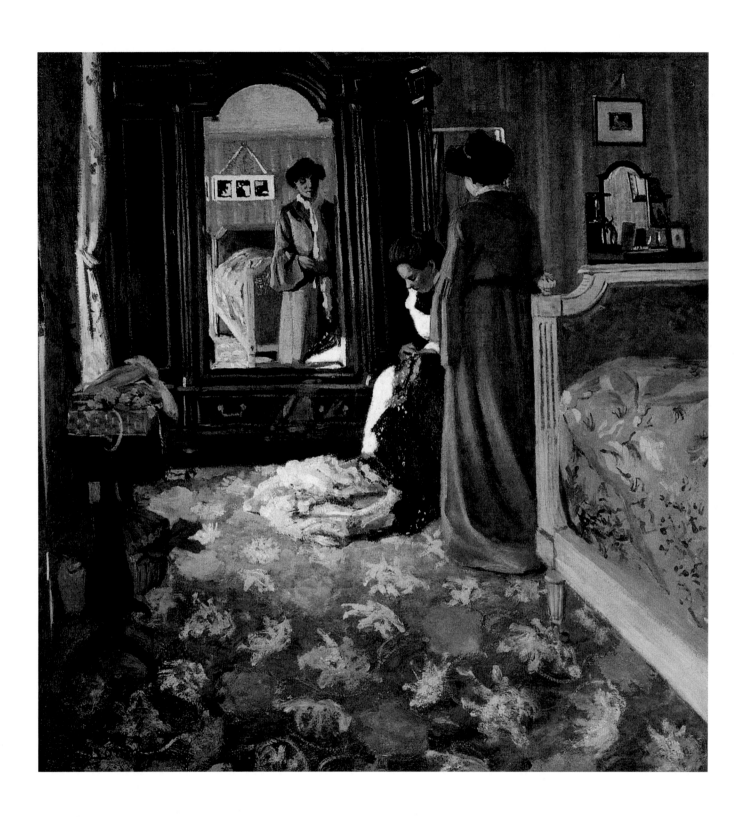

It is probable that Vallotton fairly quickly and naturally took his place in the brotherhood, because, like the other Nabis, he was given a nickname. Along with Denis, the Nabi of the Beautiful Icons; Bonnard, the Highly Nipponised Nabi; Sérusier, the Nabi with the Sparkling Beard; Vercade, the Nabi-Obelisk; Lacombe, the Sculptor Nabi; and others, Vallotton became the Foreigner Nabi, and that after years of living in Paris! However, such a distinctive designation did not separate Vallotton from the other Nabis. One noteworthy feature of the Nabis association was its internationalism. The young Frenchmen readily accepted the Dutchmen Meijer de Haan and Jan Verkade, the Danish Jew Mogens Ballin, the Hungarian József Rippl-Ronaï and the Swiss Vallotton into their brotherhood. In 1891, in his capacity as master, Paul Sérusier commented on the successes of the new brethren: "Jan has made great progress in drawing and spiritualism. His portraits of peasants become madonnas … Ballin gives you a presentiment of strange, serious, rich, and fantastic art."

Thadée Natanson recalled later that it was in the Salon on the Champ de Mars that they saw the portrait of the Hungarian artist's grandmother for the first time, "signed by a foreign name of which none of us had heard before. Bonnard, Vuillard, Vallotton, Ker-Xavier Roussel and, I think, Maurice Denis unanimously paid due tribute to the unknown creator. Completely unknown, because we were not yet acquainted with Maillol, who was already friendly with this Rippl-Ronaï". Natanson tells how this youth with his peasant gait and marvellous smile prepared some dishes for them with Hungarian pepper that burnt the tongue "which did not in the least prevent us – besides there was Tokaji wine, which did not prevent us either, quite the contrary – not Vuillard, nor Vallotton, nor Bonnard, nor any of us from wildly applauding the joyous verses of the Hungarian songs, or from singing together in chorus and joining in the refrains to them all, which Ronaï made us all learn…"

To some extent the Nabis anticipated the style of Parisian artistic society at the beginning of the 20th century, but they differed from that multifarious milieu, which spontaneously took shape later in Montmartre and was completely disorganised, in remaining a closed group. It is probable that this exclusivity held its own charm for Vallotton, with his Vaudois character. Here, he could forget about being on his guard. Natanson said of him that his attachment to his Nabi friends was particularly profound and passionate, "to the extent that he would utter shrieks of joy whenever he met them, and would hurriedly make fun of them before they could make fun of him…"

In the Bois de Boulogne, 1903.
Oil on cardboard on wood,
28 x 47 cm.
Josefowitz Collection, Lausanne.

They differed not only in nationality and character, but also in faith, political convictions, and affiliations. They included artists and sculptors, musicians, actors, the director

Aurélien Lugné-Poë (the future founder of the "Creativity" theatre), and the orientalist Cazalis – the Nabi Ben Kalir. They were drawn together most of all by that refined culture which they themselves possessed and which they brought to their work. They shared an adherence to a theory which had much in common with the theory of Symbolism in literature.

Most of the Parisian Nabis were still studying at the Lycée Condorcet under Stéphane Mallarmé, and constantly attended the Symbolist writers' evenings afterwards, wrote articles for *La Revue blanche*, or did drawings for the magazine. "The aesthetics of Symbolism," said Maurice Denis at the unveiling of the monument to Debussy in Saint-Germain-en-Laye, "is the poetry of intuition … it is the art of conjuring up and prompting memories, instead of narrating and reporting, it is the pure lyricism which poets and artists have attempted to express in their work…" However, this definition does not touch on language which was something personal to each one of them. In 1900, in his *Hommage to Cézanne*, Maurice Denis assembled the Nabis brethren around a picture by Cézanne and the old man Odilon Redon, while evoking the memory of Gauguin, to whom this still life by Cézanne had belonged. But not one of the Nabis artists directly followed in the footsteps of one of his idols. In the words of Natanson, "Sérusier, who did not teach painting to Vuillard, or Bonnard, or Cottet, or Roussel, or Vallotton, or even Maurice Denis, did them all a great service in making them think".

The Nabis possessed one further quality which heralded the arrival of the new century: they debunked the myth about the Artist with a capital letter who demeaned himself with lower forms of creativity. Absolutely everything which could be produced by the hands of an artist was of interest to them. They illustrated books and drew posters, they produced xylographs and lithographs, they painted walls and ceilings, they made decorative panels and screens, and sketches of scenery and costumes for the theatre, and they carved furniture from wood; Vallotton also tried his hand at the most widely differing areas of art: he made marionettes for Nabis plays, drafts of a stained-glass window, and monumental murals for the Federal Tribunal in Lausanne, designs for a postage stamp and playing cards, in addition to from his output of engravings, book illustrations, posters, and magazine drawings. In 1897, at the Salon of the magazine *Le Figaro*, which was devoted to the crafts, he exhibited two objects: a paper-knife and a sweets box. He recalled them with the following comments:

> "These objects, made without any great pretensions, are mere trinkets, but at least they demonstrate exquisite taste and artistry, as well as careful execution. We recall the lid of the sweet box by

Forest Path, 1903.
Oil on canvas, 55.5 x 46 cm.
Private collection.

Ancient Evening, 1904. Oil on canvas, 392 x 142 cm. Private collection.

Les Bruyeres, Varengeville, 1904. Private collection.

Vallotton. It has been executed magnificently in the drawing and in the technique of arranging the wood with a lovely harmony of shades, and without any painting."

So the Foreigner Nabi essentially entered a paradoxical association built on common principles and full of the independence of creative expression. "They are quite different in their own inclinations, their own temperaments and their own education, and have a very respectful attitude to the efforts of their predecessors," wrote Octave Mirbeau in the catalogue for an exhibition of pictures by Vallotton in 1910.

> "In order to support their association, they derived strength from some other source than petty vanity, the thirst for honours, or striving for success and fortune. They had nobler purposes: each one had the will to develop and become stronger, in their own thoughts and in their own individuality. Besides, they were intelligent, and, over and above that, they had a passion for intelligence ... Higher intelligence, which was not restricted to art, to their own art, but which extended into all aspects of life. Their friendship was a joy and was useful to them at the same time."

"My dear friend," Vuillard wrote to Félix Vallotton in the summer of 1897 from Villeneuve-sur-Yonne, where he was visiting their mutual friend Thadée Natanson, "your stay here has left me with memories of paradise ... At the table, Thadée read us your letter, which was a refreshing treat for us all. They love you here very much." No matter where they lived, Thadée Natanson and his wife Misia used to have artists, writers, and musicians as guests. Vallotton was not simply a sought-after member of the circle – his presence was essential to his friends. "Life here has not changed significantly," wrote Thadée Natanson to Vallotton from Villeneuve, "apart from the fact that, when you left, you left a vacuum behind." And sometime later, in the autumn of the same year, 1897, Misia Natanson wrote from Venice: "We often think about you, my dear Vallo. That is the nicest thing I can say to you, because you know that when in Venice you think only of those whom you love." Misia Sert (née Godebska) was born in St Petersburg. She came from a Polish family, and probably possessed that special charm of Slavonic women which none of the Nabis could resist. "Misia will write to you herself." Vuillard wrote to Vallotton from the Natansons' house in Villeneuve in 1897, "but what she will not tell you is that she is as charming and kind as always, and that she is dressed in bright colours which would make you happy and makes me glad, too. Maybe you will come back after all?"

Undergrowth, 1904.
Oil on canvas, 58 x 40 cm.
Musée cantonal des Beaux-Arts, Lausanne.

Woman at a Piano, 1904.
Oil on canvas, 43.5 x 57 cm.
The State Hermitage Museum, St Petersburg. (pp. 86-87)

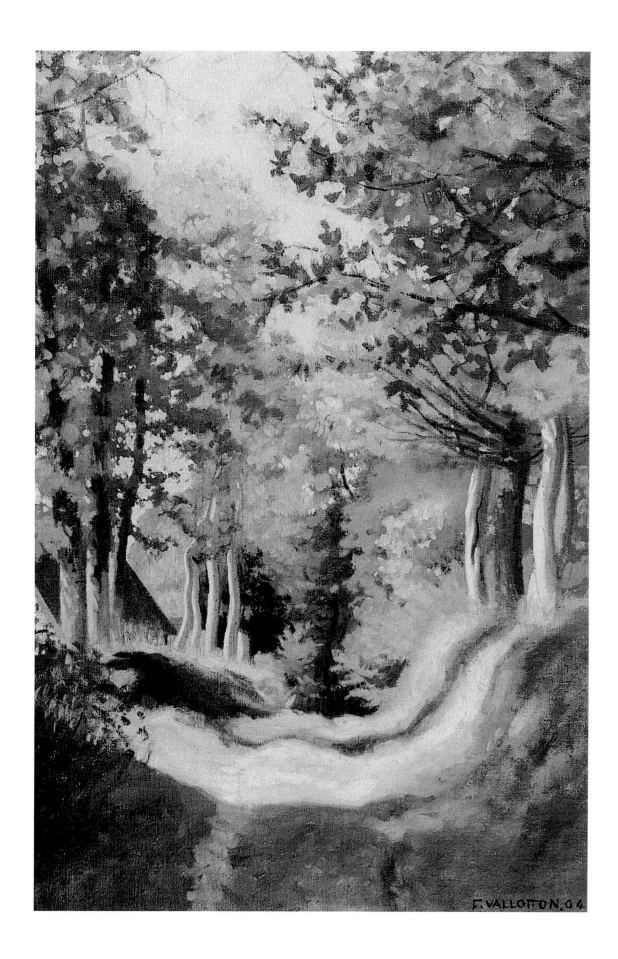

F. VALLOTTON. 04

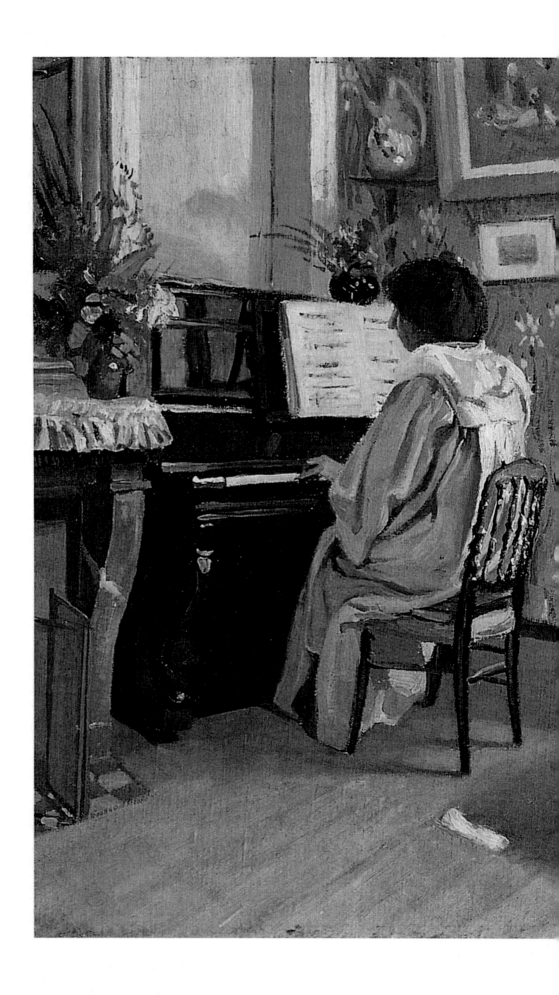

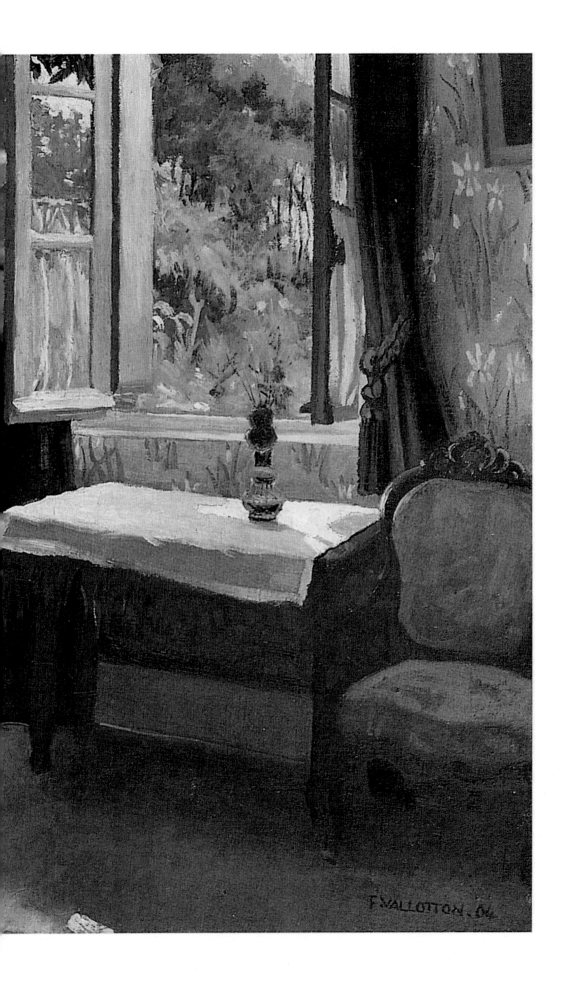

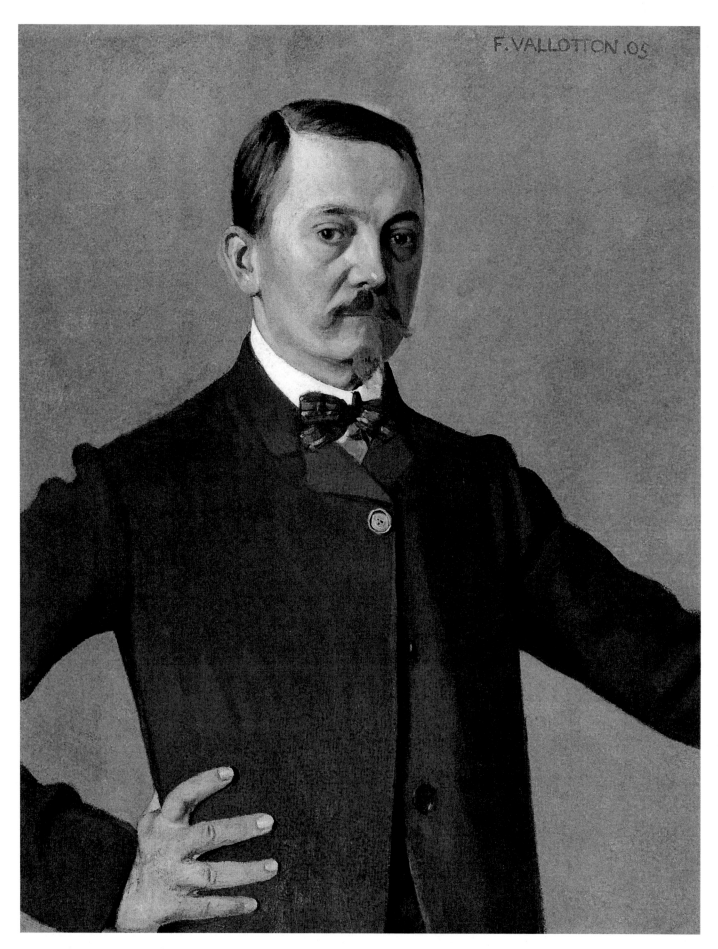

F.VALLOTTON .05

Their first love was art, and they expressed their delight in beauty by means of line and colour. Misia was painted and drawn by Renoir, Vuillard, and Vallotton. Vallotton's portraits radiate Misia's lively charm. He did her portraits in oils, tempera, gouache, and pastel. The range of colour in his painting would perhaps never again be so harmonious and so touchingly soft. He had the gift of conveying movement, the specific curve of a figure or its grace with a single narrow line. And although all the portraits of Misia belong to his engraving period, only once did he depict her in an engraving on wood. It is even difficult to call it a portrait, but a reminiscence of Misia does feature in the print entitled *Symphony*: the outline of her hair, the shape of her eyes, and the line of her gracefully elevated shoulder – the bright image of a woman playing the piano in a darkened room. And the faces of the men listening to the music are turned towards her. "A wicked fairy, she knows how to build everything and destroy everything," Annette Vailland wrote of Misia. "She is lovely, with a somewhat devilish beauty, despite her charming Minerva profile … A musician who is inscrutable, adorable, and wicked, she casts a spell on all these young men…"

Despite his self-control and unflinching coolness, Vallotton, the man from Lausanne, was also one of that number. His deceptive exterior and manners inculcated by a Protestant upbringing concealed a tender soul and a wealth of emotions. Vallotton loved to draw portraits of people who were dear to him, employing some widely differing methods in doing so. He painted the brothers Stéphane and Alfred Natanson and Alfred's wife, the actress Marthe Mellot, in an ideal, classical manner, using all the rich nuances of form found in traditional painting. But he did the *Portrait of Thadée Natanson* (p. 31) with the sort, of naïve frankness of which perhaps only Douanier Rousseau was capable. The portrait of five Nabis in 1903 - *the Five Painters* (p. 73), where Vallotton himself appeared side by side with Vuillard, Bonnard, Cottet, and Roussel, was painted in a deliberately severe, frontal manner, stylised a little like a group photograph.

Engraving

In every work Vallotton was able to grope out something hidden very deeply beneath a covering of apparent simplicity, whether it was subtle stylisation or a thin veneer of self-irony. His portraits are straightforward only in those rare cases when painting provided an adequate expression of his sentimental life. However, that is really another story, and it begins after the end of his graphic period, when Félix Vallotton had already been accepted as a great engraver. But why did he become an engraver?

Self-Portrait, 1905.
Oil on cardboard, 82 x 64.5 cm.
Kunsthaus Zürich, Zurich.

Woman with a Black Hat, 1908.
Oil on canvas, 81.3 x 65 cm.
The State Hermitage Museum,
St Petersburg. (p. 90)

Portrait of Mme Haasen, 1908.
Oil on canvas, 80 x 65 cm.
The State Hermitage Museum,
St Petersburg. (p. 91)

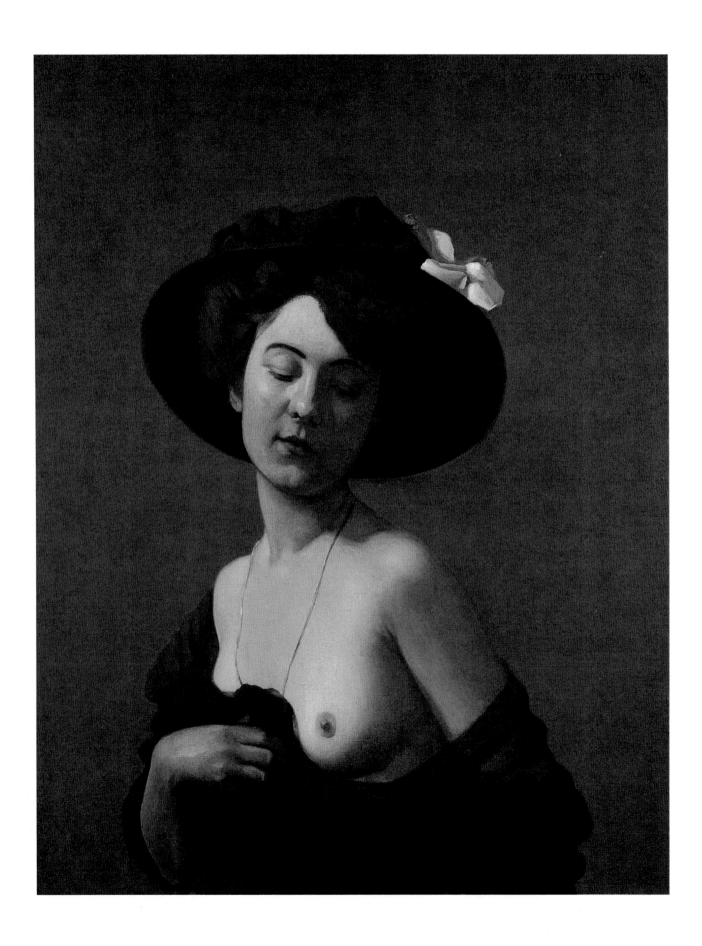

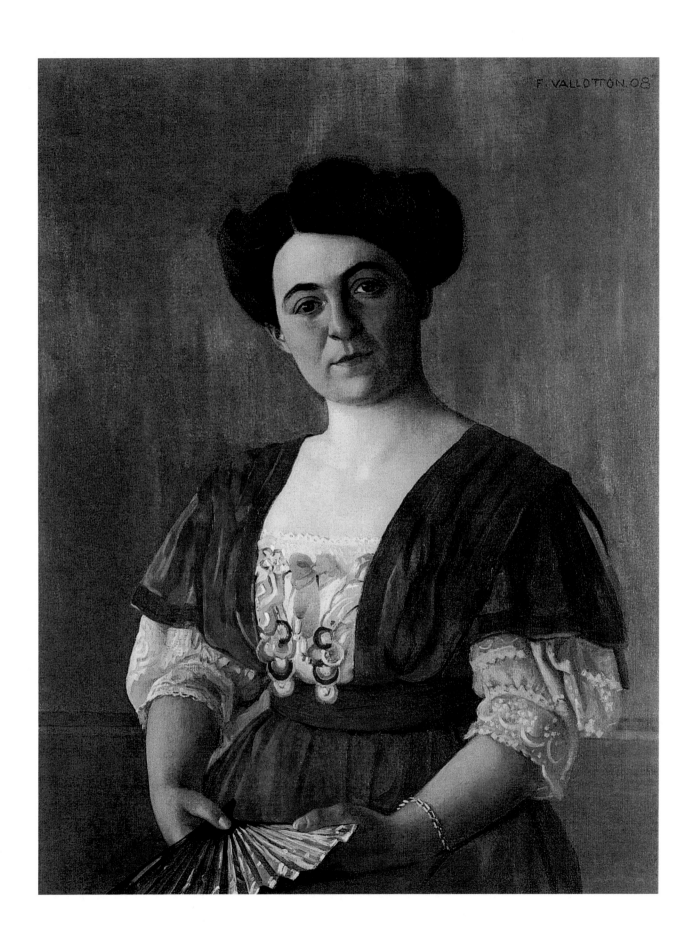

First of all, engraving was undoubtedly a way to earn money. In the 18th century, it had already come to occupy a completely distinctive place among the other arts: translating the beauty of the rich language of painting into the language of tone, and finding, in the restricted world of black-and-white, the equivalent, of a picture which could successfully be reproduced. Etching and copper engraving, made famous by Rembrandt and Goya, had declined to the level of a reproductive technique, and the more refined the technical methods became, the more the engraver lost his creative nature in the attempt to copy someone else's work with more precision as the only goal. In fact, it was as etchings that Vallotton had copied the pictures of the great artists in his youth. The possibility cannot be excluded that the very fine delicacy of the craft held an attraction in itself for him. Despite the appearance of photo-mechanical methods in the middle of the 19th century, which almost supplanted reproductive engraving by its end, there were still some artists who preferred to see their pictures reproduced in the noble technique of metal engraving. Usually, such work was done by professional craftsmen from families who had engaged in engraving for generations and it was unusual for a painter to master the craft. Indeed, more than anything else, this fact of Vallotton's biography testifies to his strange character which always led him to choose the most difficult path. Even more unusual was the fact that Vallotton produced his first original works not by the already tried and tested method of metal engraving, but in wood engraving, which was totally new to him.

There was a time when xylographs by Dürer, Holbein, and Cranach sold throughout the whole of Europe. Since then much had changed. With the appearance of movable type, wood engraving virtually disappeared from books, and it was used only in rare instances – for vignettes, cheap popular prints, and playing cards. Admittedly, at the end of the 18th century, with the appearance of more powerful printing presses, engravers changed their technique slightly. Instead of using blocks cut along the grain, they worked on hard wood cut across the grain. These new-style blocks (xylographs) were particularly resistant to high pressure, did not wear out too quickly, and would stand a long print-run.

Young Woman with a Yellow Scarf, 1911.
Oil on canvas, 100 x 80 cm.
Musée cantonal des Beaux-Arts, Lausanne.

Evening, Honfleur, 1909.
Private collection. (p. 94)

The Vagabond, Honfleur, 1909.
Oil on canvas, 74 x 54 cm.
Private collection. (p. 95)

The attractiveness of the cross-cut block for the engraver lies in the fact that it can be worked with a steel burin, without taking the direction of the grain into consideration, permitting effects which rivalled metal engraving for delicacy. However, this very perfection of technique and the unlimited possibilities of wood engraving had a negative consequence in that xylography was now also used as a means of reproduction and the engraver remained merely a master craftsman. The great master of 19th-century book illustration, Gustave Doré, drew on a block of wood covered with white primer, just like on a sheet of paper, after which a whole army of engravers

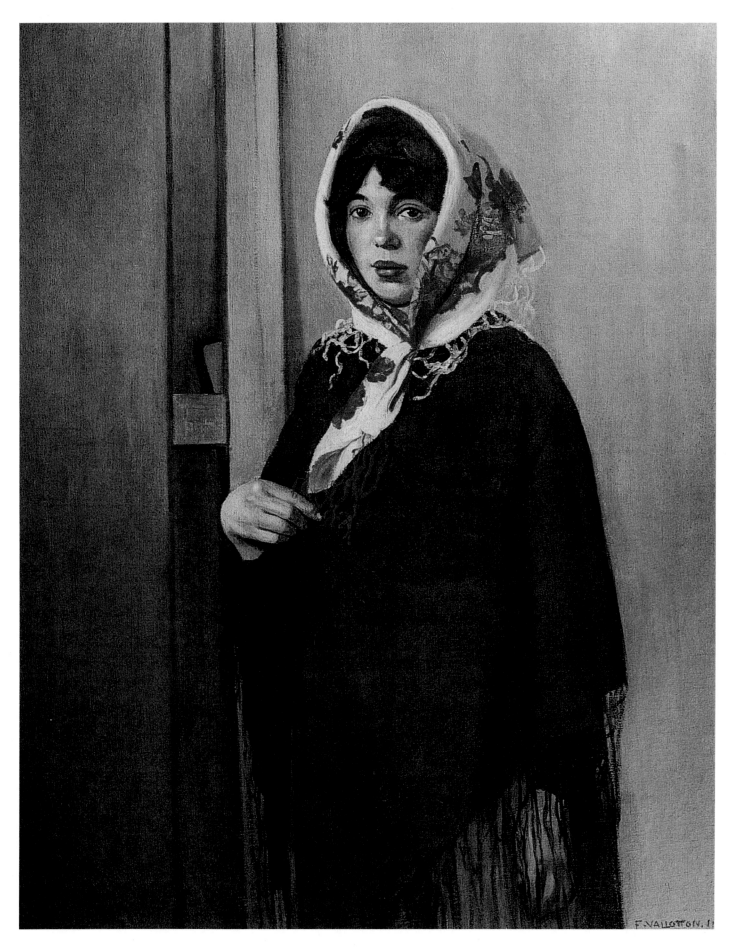

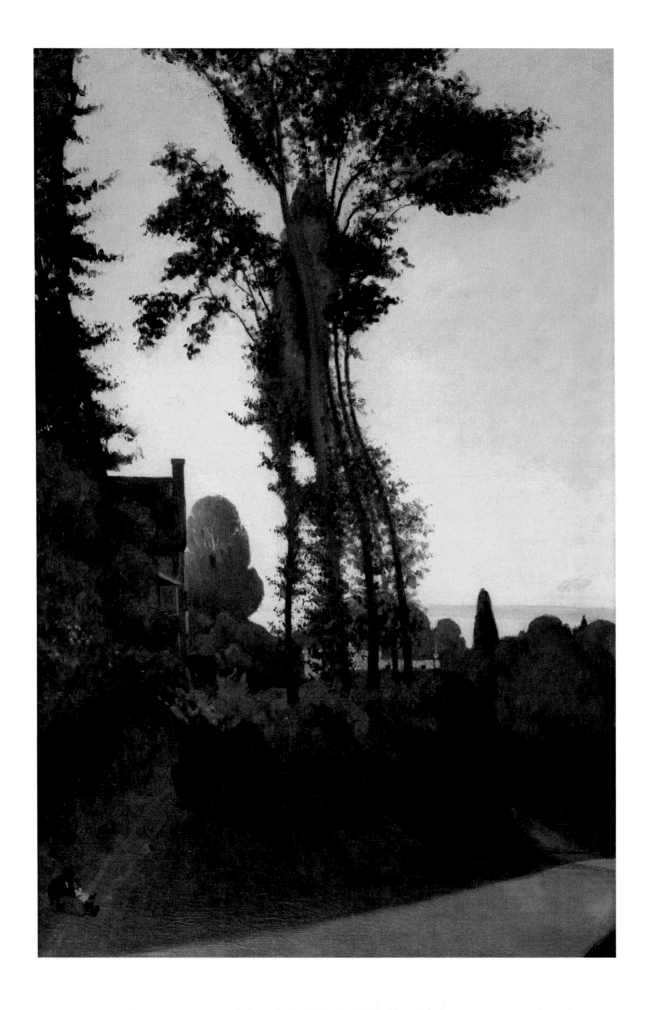

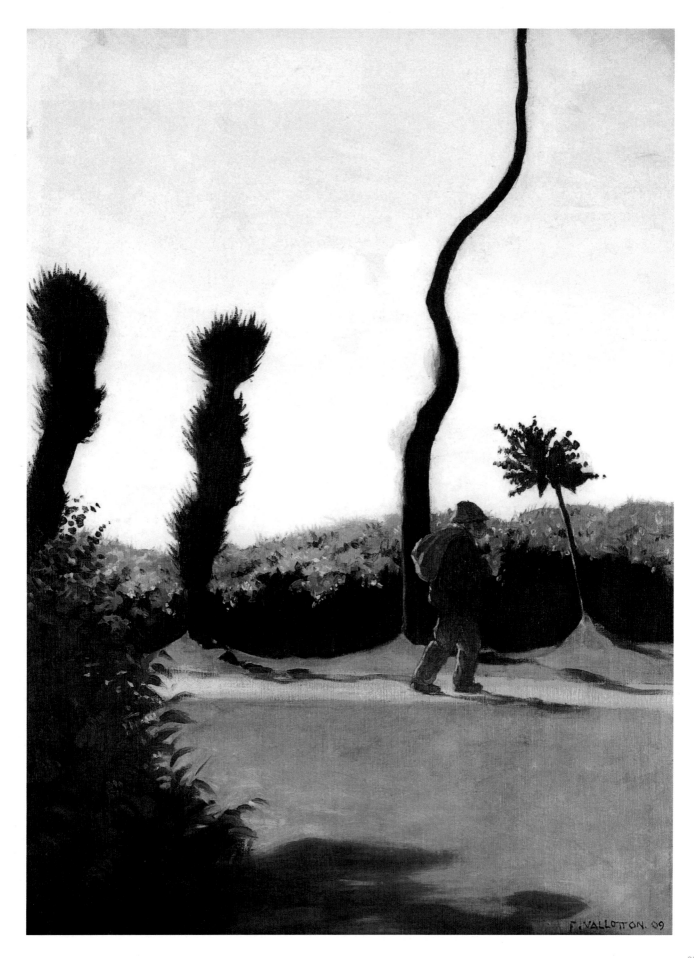

F. VALLOTTON. 09

translated his drawings into the idiom of xylography. Fortunately for the engravers, technical perfection turned against itself. At the end of the 19th century, a movement emerged which favoured a return to wood engraving as a branch of fine art. There was just one thing that stood in the way, the fact that the specialist engravers were not artists, and artists did not possess the necessary skills. The revival of original xylography in the second half of the 19th century had to be started by members of the families of craftsmen-engravers.

In France, one of the first was Auguste-Louis Lepère, who produced both woodcuts and xylographs, and whose tools were those of a 15th-century craftsmen. Towards the end of the 19th century, attention turned to wood engraving everywhere: in England, the Pre-Raphaelites acquired a taste for it, especially William Morris; the Norwegian artist, Edvard Munch, worked in this technique; Paul Gauguin changed over from relief on a wood block to engraving along the grain; his friend and follower, Émile Bernard, even used the pattern of the grain in his prints. As for what the artists got out of engraving, Félix Bracquemond, who had devoted all his energy to reviving the print, said: "Lithography must remain lithography, and wood must remain wood." The Paris magazines *Illustration*, *Revue Illustrée*, and *Imagier* now turned their attention to original prints and particularly to wood engraving. In 1888, Émile Bernard published a specialist newspaper entitled *Wood*. The Symbolist writers, captivated by the Middle Ages, preferred the artists to use the ancient technique of xylography when they did the illustrations for their works. It was no wonder that wood engraving also fell within the sphere of interest of the Nabis artists. In 1891, Félix Vallotton, who had not yet joined the Nabis then, cut out a self-portrait on a wood block.

The twenty six year-old Vallotton portrays himself as someone who has grown worldly-wise, immersed in himself, an observer aloof from life. In the background of the print are a city street, passers-by, distant mountains, clouds, and the sun with straight-line beams of light. It is quite likely that the overt naivety of this particular composition – a large figure in the foreground against a landscape background – launched a series of expressive self-portraits by Swiss artists at the turn of the century, such as those by Giovanni Giacometti or Albert Welti. Be that as it may, their common sources lie in the Renaissance. Vallotton uses the same classic line as the German masters of the 15th century, and for more than just fashioning shape: the hardness of the wood can be felt in each stroke, offering resistance to the artist as he pares off a strip.

Cutting across the grain dictates not only technique but also the means of depiction where, in the words of Roger-Marx, "not only is the colour finally

La Villa Beaulieu, Honfleur, 1909.
Oil on cardboard, 27.4 x 34.8 cm.
Private collection.

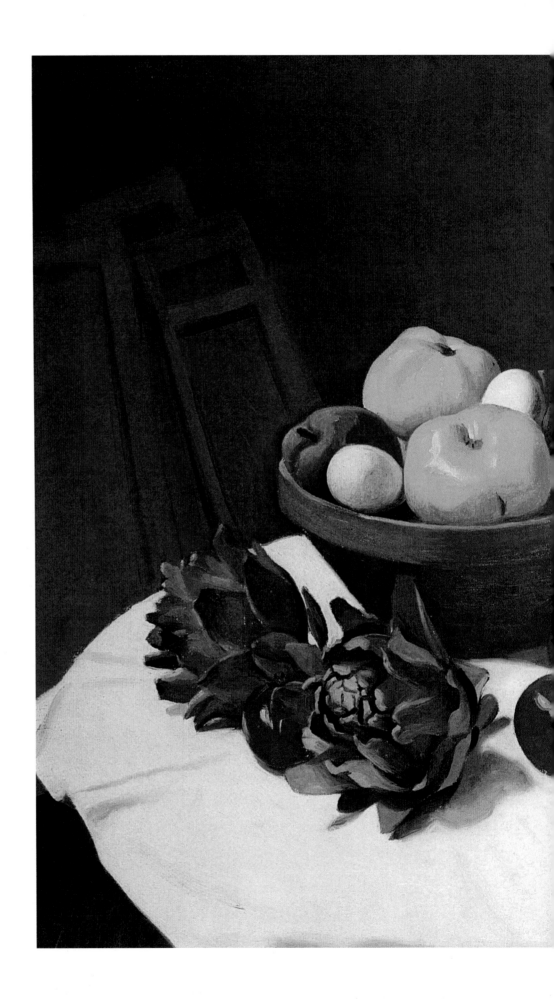

Still Life with Tomatoes, 1911.
Oil on canvas, 66 x 81 cm.
Musée cantonal des Beaux-Arts,
Lausanne.

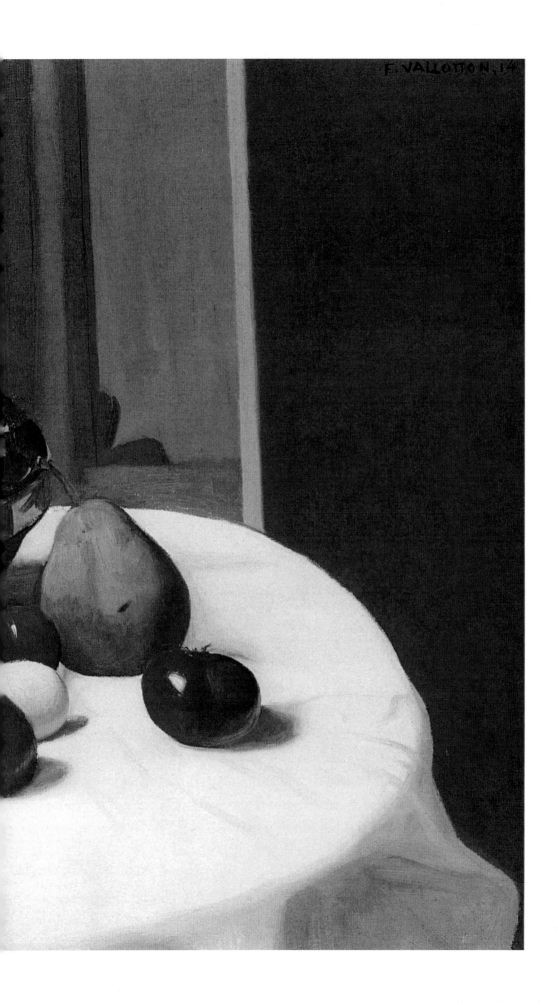

banished, but where the wide expanse of the untouched block predominates with tragic sharpness, in contrast to the large white ground".

In the same year, the first xylographs were followed by portraits of Verlaine, Berlioz, and Wagner, in which the artist explored the possibilities that had opened up to him: he played with a primitive stroke applied with concentric circles, dividing the print into black and white halves; he combined an emotional, jerky stroke with a black patch on a pure white background; and sculpturally fashioned the shape of a face, using a precise, stubborn stroke. No matter how he worked, the most important thing had been accomplished already – the black and white had lost the sense of representing only light and shade in nature, and had become elements in the stylised language of engraving. In his first genre print, *Burial*, there are almost no white highlights on the black, while the black blades of grass on a white background are almost ornamental. The first landscape print, which marked the start of the whole series, depicted the Swiss Alps, the passion for which figures so largely in Félix's letters to his brother. Who knows, perhaps the mountains which he saw in his childhood, where patches of black shadow alternated with sparkling white glaciers, became one of the sources of his laconic language as an engraver. However, his fondness for nature was still too great, and each fold in the mountains, so often painted in oils, was too carefully studied, for him to transpose their drawings on to flat black and white patches within the first year of taking up engraving. Vallotton more probably arrived at a candidly flat approach to the plate as a result of the influence of Japanese engraving which had been discovered by the Impressionists and which became one of the sources for Vallotton's generation in the search for style. And although Vallotton's passion for Japanism was not as strong as Bonnard's, it certainly did play a role in his wood engraving. The treatment of perspective found in Japanese landscapes made itself particularly strongly felt at the start of his career as an engraver – in the series of mountains and in the print entitled *A Lovely Evening*. Vallotton's black-and-white prints later became so original and independent that the different influences fused within it ceased to be apparent, blending into an idiom which is unlike anyone else's. In Vallotton's graphic works, there was no period of apprenticeship, and even his first engravings did not appear to be mere experiments, but rather a new word in art. And, once again, Vallotton astounded his contemporaries. Indeed, it was in graphic art that numerous facets of his talent manifested themselves: as portraitist, drawer of everyday life, decorator, and stylist. In 1892, L. Joly commissioned a series of sixteen portraits from him of prominent figures in the fields of politics, the press, literature, and art – *Immortals of the Past, Present, and Future*.

Vase and statue, 1911.
Oil on canvas, 54 x 65 cm.
Private collection.

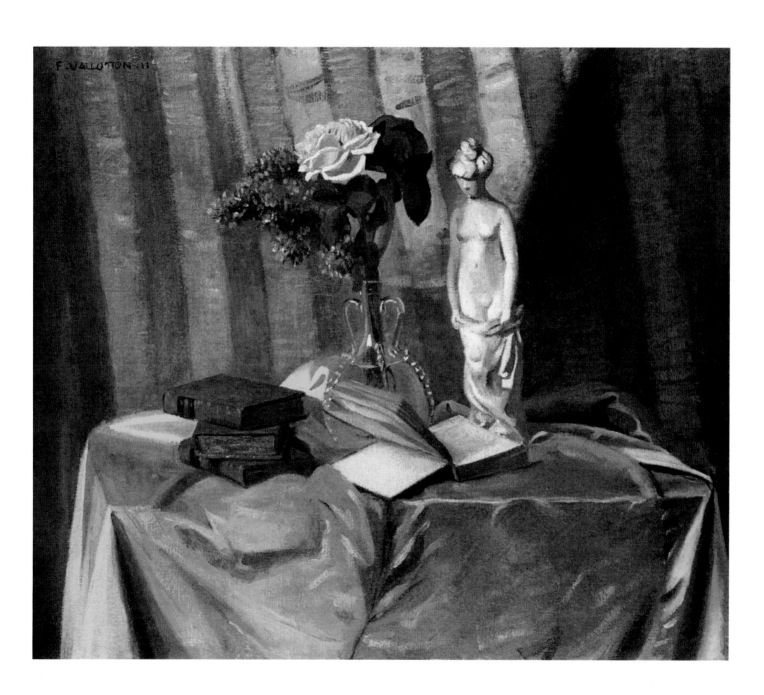

Field of Green Oats, 1912. Oil on canvas, 73 x 100 cm. Kunstmuseum Solothurn, Solothurn.

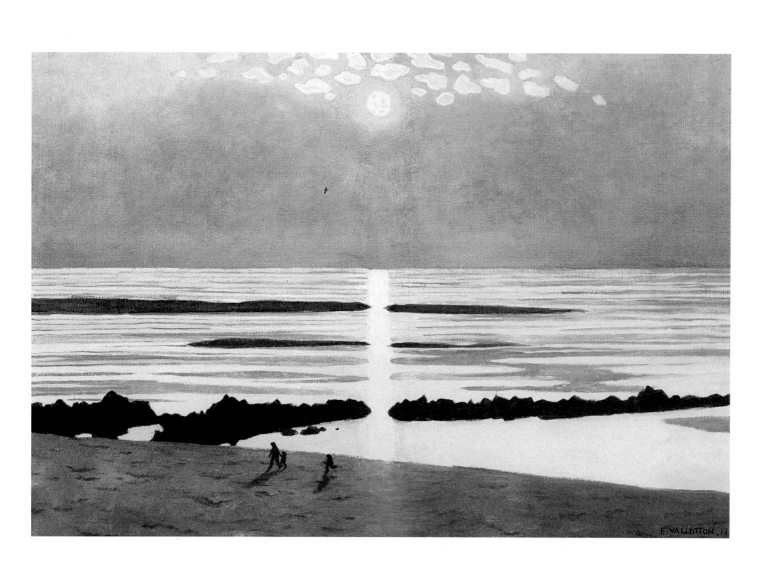

Yellow and White Sunset, 1911. Private collection.

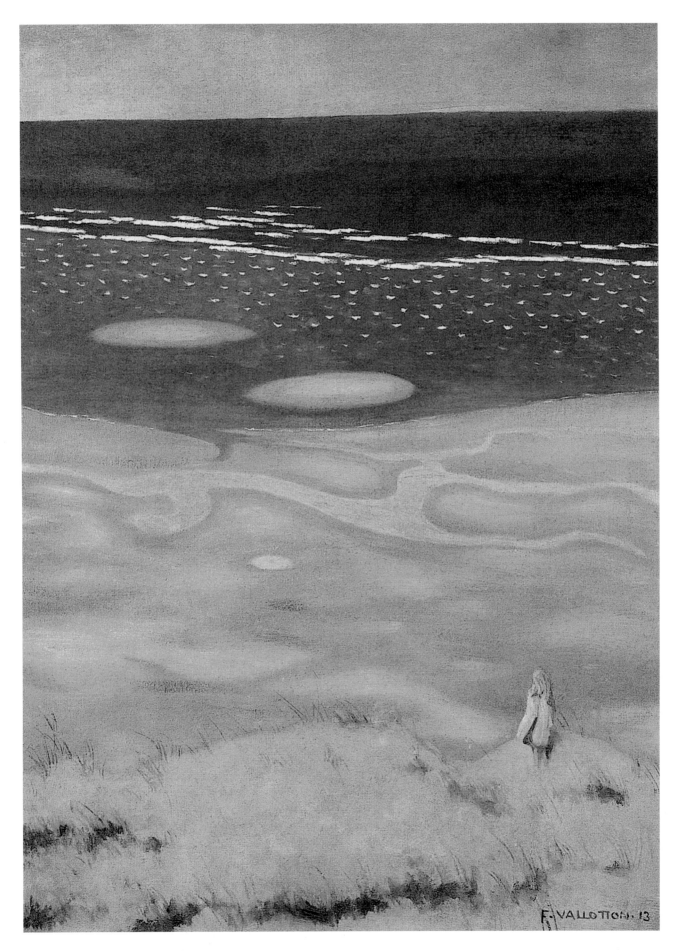

Vallotton also tried to produce something of his own in lithography, a medium so favoured by the greatest painters of the 19th century. "…I must get used to the technique and try to be original, but so far I have not succeeded," the artist admitted in a letter to his brother, merciless as ever towards himself. In fact, the contrast with wood engraving was too great – lithography is capable of preserving the natural softness of a pencil drawing and the subtlety of tonal nuances in prints, and as a medium does not demand any abstractions. Apart from that, a caricature portrait tradition was already established, the best examples being by Daumier. This tradition, however, remained alien to Vallotton: his Alexandre Dumas-fils, Alphonse Daudet, and even Pierre Loti, wearing a child's shirt and holding toys in his arms turned out sad and even tragic figures. "I am proceeding with the immortals: twelve have already appeared," he wrote to his brother in April 1893. "They are selling, but I am not satisfied. I am doing other things for Joly which are more typical but have a smaller print-run." Those "other things" were probably a remarkable ex libris, one of only a few Vallotton produced, as well as some small decorative engravings.

Over the last decade of the 19th century, Vallotton published a whole galaxy of the most diverse graphic works. From 1893, he worked for French, American, and German magazines, including Le Rire, L'Estampes Originales, The Chap Book, Pan, Die Jugend and, of course, Le Cri de Paris and La Revue blanche which were published by the Natanson brothers. His portraits of writers regularly appeared in La Revue blanche. In 1893, he produced a series of small wood engravings for the magazine, depicting bathers. Based on the juxtaposition of black and white spots penetrating each other, they were beautifully suited to the magazine page, whilst retaining at the same time a sense of the engraver's effort in applying pressure to his tool. Even in a simple magazine drawing, Vallotton resorted to the same devices which he used in engraving. In the illustrated reviews of the official Paris Salons for the magazine Le Rire, his sparing and rather rough linear design again suggests the movement of the graver.

The relief printing of wood engraving was best matched to the technique of book-printing, and it was Vallotton who brought moving type and xylography together again. Vallotton probably became acquainted with Jules Renard at the editorial office of the La Revue blanche, where the Nabis artists and Symbolist writers used to meet, and possibly where he also met the critic Félix Fénéon, who used to tell Toulouse-Lautrec tales, and Jules Renard, who was adept at stinging everyone with his witty remarks. In April 1894, Renard wrote in his diary: "Vallotton, with his quiet, simple, and so dignified appearance, with his sleek hair precisely divided by a perfectly straight parting, with his restrained gestures, with his not very complicated

Rising Tide, 1912.
Oil on canvas, 72.5 x 54 cm.
Kunstmuseum Solothurn, Solothurn.

Low Tide, 1912.
Oil on canvas, 56 x 97 cm.
Private colletion. (pp. 106-107)

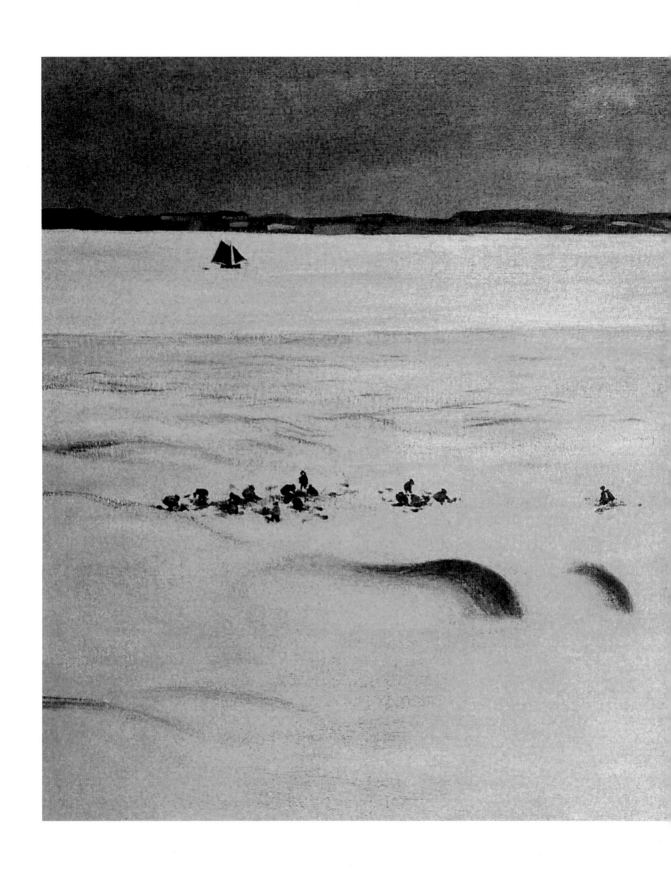

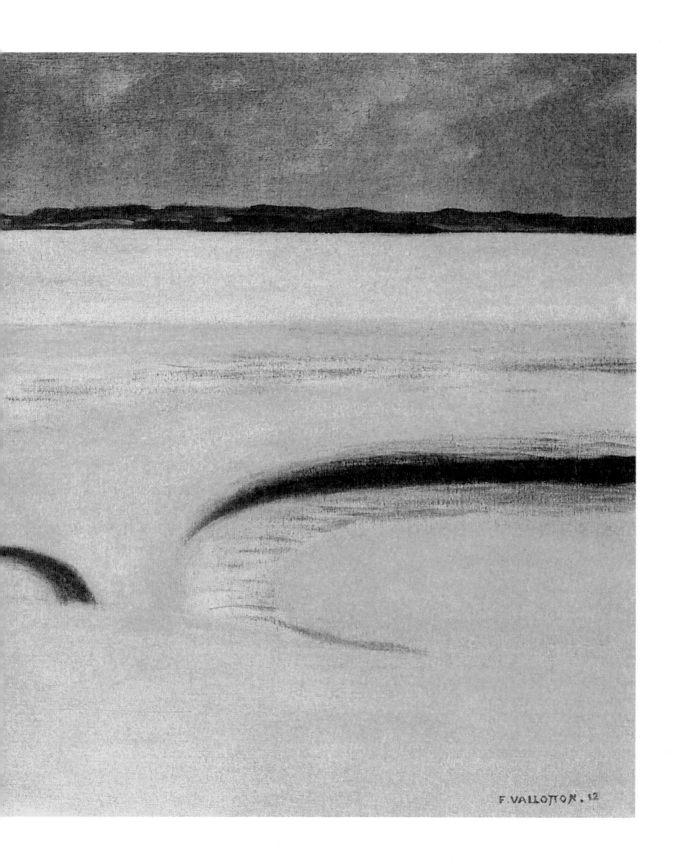

theories and with something very egotistical about everything that he says." His evil irony disappeared, however, when discussing Vallotton as a professional, and in 1895 he asked the artist to do the illustrations for his Mistress, which was being printed by the magazine *Le Rire*.

"My dear Vallotton," he wrote in September 1895, "your first drawings are excellent. I thank you and congratulate you. Jules Renard." This was the beginning of a collaboration which produced several illustrated books, including the beautiful *Poil de Carotte* (Redhead). In the same year, 1895, Vallotton received a letter from Remy de Gourmont: "Monsieur," said the writer, "*La Revue de Revues* intends to publish, under my signature, a series of articles on writers and, above all, on new poets. They would like the essay on each writer to be illustrated with a portrait signed by you, similar to those in the *La Revue blanche* which were noticed by everybody." Their work resulted in the *Book of Masks*, where Vallotton's portraits exist on equal terms with the text by Remy de Gourmont.

Vallotton used his black-and-white idiom to find a solution which could be called the formula of the face. That was the case with those writers whom the artist knew personally and drew from life, and not from a photograph – Remy de Gourmont, Jules Renard, and André Gide. Stéphane Mallarmé, who knew Vallotton well, when ordering the portrait of Arthur Rimbaud from the artist for his article, wrote: "Only you can do something original from a famous portrait." The Russian critic Shchekatikhin wrote that Vallotton's masks "elegantly and precisely decorate the pages, spiritualising the sheets of paper with their play of broken lines or a sharply outlined patch". However, they are pieces of artistic work in their own right also because the portraits often come into obvious conflict with the text, destroying the Symbolist mystery created by Remy de Gourmont. One magnificent example is the mask of Émile Verhaeren, an elderly society man, with carefully brushed, thinning hair and a fashionable moustache, a poet whom the author associates with the generation of "narcissi nodding along the river": "Having forged some strange and magical weapons for twenty years, he lives in a mountain cave where he hammers away at the red-hot iron, radiating the gleam of the fire..."

Auguste Lepère, the father of the new French xylography, ordered some drawings from Vallotton for his magazine *Image*, and later, in 1902, invited him to take part in the exhibition "Five Centuries of Engraving on Wood". In 1896, Vallotton did a poster for the Paris Exhibition of New Art (Art Nouveau) and in the same year did the cover, illumination, and vignettes for the books *The Snake Woman* and *The Brightly-Coloured Bird*, published in Berlin by Otto Julius Bierbaum. The delicate

Landscape with Trees or *Last Rays*, 1911.
Oil on canvas, 100 x 73 cm.
Musée des beaux-arts de Quimper, Quimper.

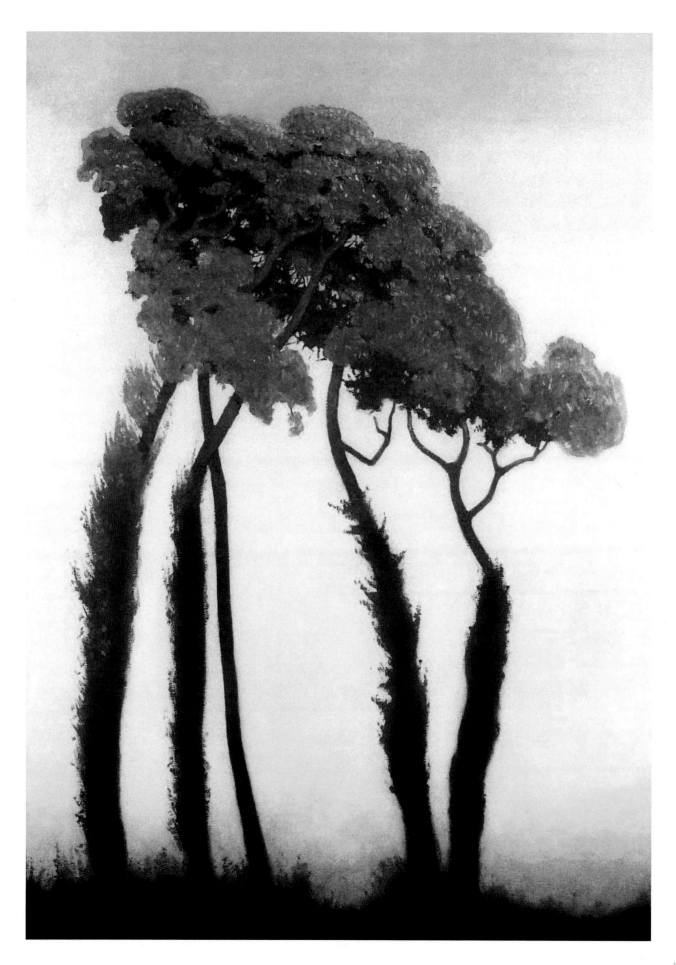

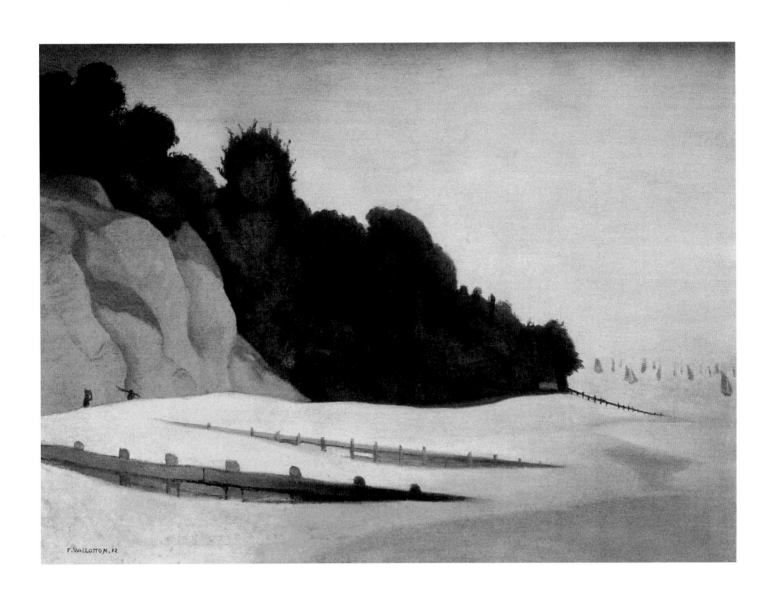

ornamental quality of these works, combined with a touch of light irony which Vallotton succeeded in introducing almost invisibly even into the decorative motif, represented his contribution to the creation of the Art Nouveau style. "I have received your parcel, and I am delighted," wrote Bierbaum, who was not personally acquainted with him, to Vallotton, and, a little later: "Heartfelt thanks for your beautiful drawings, which have given me pleasure again and again." Recognition came deservedly and quickly, it extended to all aspects of his graphic work, and was universal; however, it originated with his wood engraving and, in fact, Vallotton's most brilliant achievements were associated with this. "My dear Monsieur Vallotton," Renard wrote in 1894, "you cannot believe what pleasure you gave me when you sent me your excellent portrait of Edgar Poe. I am not familiar with his appearance, but intellectually this can only be him. You possess a staggering way of being simple." Only Vallotton could employ the simplicity dictated by the wood block as an expression of psychological complexity. It is difficult to identify the photograph of Fiodor Dostoyevsky the artist used. In his portrait there is only black and white, the precisely drawn line of the cheek-bone, the wrinkle on the forehead, and the dark patches in the eyes – but, as a result, the face is alive with tense and anxious thought.

"Dostoyevsky and Stendhal," says Natanson, "were among his idols. The creator of the Karamazovs and the narrator of *Reminiscences of an Egotist*, especially the former, often gave me the key to Vallotton's remarks." Something deeply intimate brought Dostoyevsky and Vallotton close together, perhaps his own hard life, impoverished youth, and years of loneliness, or perhaps it was his character, in which there was, in Natanson's words, "a kind of appetite for grief". It was probably Dostoyevsky's influence that made him produce, at different times, a number of engravings devoted to the theme of crime and punishment. Their expressiveness is amazing: an intense line conveys swift movement in *Murder*, and a black patch with rhythmic flashes of colour is the horror of what is to come in *Execution*. The psychology of the crowd was also intelligible to Vallotton; he could feel its pulse beating. "I was sitting on the terrace of a cafe," he wrote in his novel *A Pernicious Life*. "Before my very eyes, a dark stream of pedestrians flowed past; sometimes some item of clothing would stand out, a coquettish hat, or a burst of loud laughter. Heads of strangers, tired faces, and some foreign physiognomy or epaulettes here and there…"

Like Degas, he did not draw in front of his models. "Vallotton always remained an artist without a model," said Meier-Oracle. But later, with a sure hand, he would remove large patches from the wood block here and there, neatly cutting out specks, spots, and strips, and his engravings would show a crowd examining wares, fleeing in panic

Riverbank with Trees, 1912.
Oil on canvas, 73 x 100 cm.
Private collection.

from the police, and gathering around spectacles; children's legs would flash past, umbrellas would be put up, and the pitiful figure of someone being arrested and gripped with a merciless hand would be squeezed in. "Nothing made him more angry," Natanson wrote, "than injustice, and most of all the kind that made others suffer."

By using various textures in his patches, he obtained decorative effects and almost created the illusion of colour, as in the prints *Idleness* (p. 192) or *Night*. However, his artistry truly revealed itself in two series of engravings: *Musical Instruments* and *Intimacies*. In the former, illuminated details emerge, like individual sounds, from total blackness: a white cat, the mouldings on furniture, the piano keys, or the flowers on the wallpaper; here man is alone music. In *Intimacies*, a couple is constantly present in the scene. The actual faces change, and only the language of the engravings remains the same. Now the black surface is frankly, triumphantly dominant – it has ceased to be merely a shadow. The artist made up the lighting himself, and a candle or a window served him only as an excuse. His stylised light unexpectedly reveals a face, the curve of a neck and shoulder, and bottles on a dressing-table. That very detail to which he was so attached in his early painting had taken him far away from naturalism. Striped wallpaper, divan cushions, and palm leaves had become symbols of that secluded little world in which the drama of human life is constantly played out.

As Vallotton was creating the *Intimacies* series of engravings, its motifs gradually passed over into his painting. He and She began to live in a world of colour; however, the tension is lost in the interiors with blue wallpaper and red armchairs, and the drama is replaced by uneventful tedium and light flirtation. It seems as if Vallotton's interest in the mysteries of the human soul gave way to a new and, as always with him, unexpected experiment: the flat patch of pure colour replaced the black and white surfaces of the print. What had been predicted with such astonishing intuition by the critic Julius Meier-Graefe, in his monograph on Vallotton in 1898, came true:

> "Painting is his last phase; for him, wood engraving represented the preparatory period, when he discovered everything that he would want to transpose into his painting now. It can be said that this period is 'the past'; because – although it is hoped that Vallotton will present the public with many more prints – it will be difficult for him to add much more that is new to his technique demonstrated in his engravings."

The Cliff and White Beach, Vasouy,
1913.
Oil on canvas, 73 x 54 cm.
Arthur & Hedy Hahnloser-Bühler
Collection.

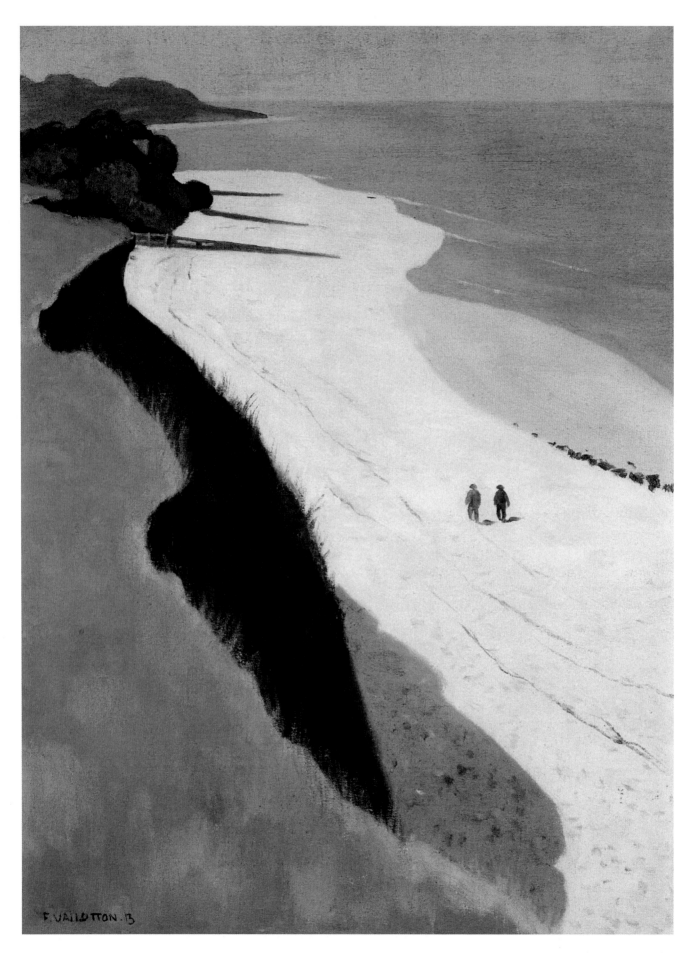

F. VALLOTTON. 13

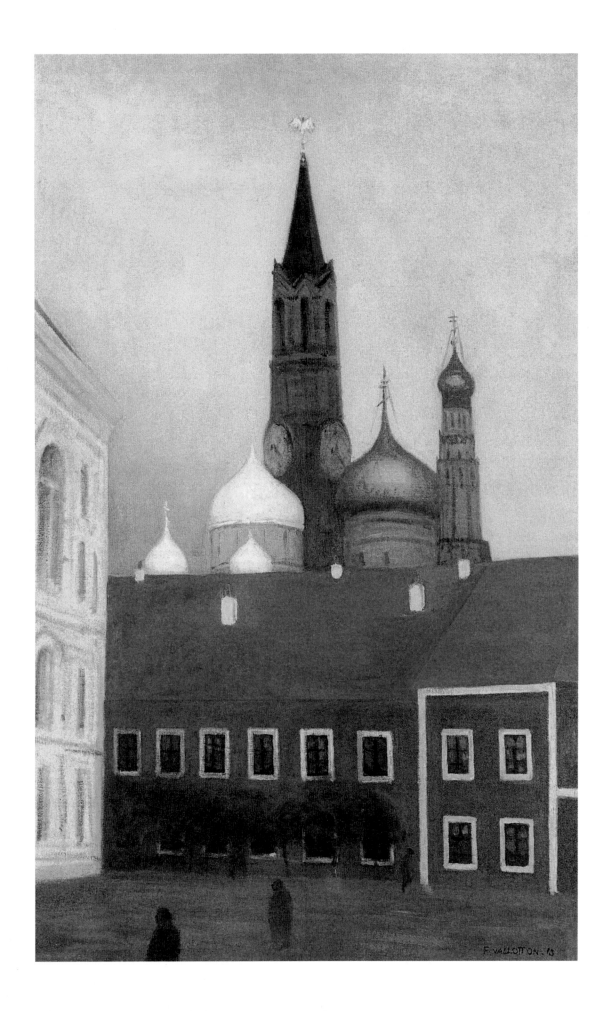

The Turning Point of Vallotton's Career

Vallotton had reached the most serious hurdle in his life, and the people who were close to him sensed it. "My dear friend," Vuillard wrote to him from Paris in September 1899, "I intend to catch a train on Saturday after dinner, and visit you in Étretat that evening. I hope you don't mind. We must have a very serious talk and virtually get to know each other again. I feel as if there has been a revolution..."

It all began in 1896, when Vallotton was commissioned to draw a portrait of a girl called Madeleine Rodrigues. In 1899, he informed his family that he would be marrying her mother very shortly.

> "As for my fiancée," Vallotton wrote to his brother, "she is a widow, as I have already told you. Her surname is Rodrigues, and she is the daughter of Monsieur Bernheim, the famous art dealer. I have known her for four years now. She is a very good woman, and we both understand each other without any difficulty. She has three children, the oldest fifteen and the youngest seven, so they are already being educated. They are very attached to me, and I am fond of them. We both want to live without changing anything or almost anything in our habits, neither I in my work, nor she in her daily life, and it will all make very good sense."

This marriage seemed too rational to Vallotton's family, who saw it as a yearning to escape from the constant disorder of his life and, possibly, to find firm support in his close relations with the Bernheim art dealers. In addition, his family regarded his break-up with Hélène Chatenay as a betrayal, as they had all become attached. Félix had Hélène in mind when he wrote to his brother: "I hope that Dithée [his brother's wife] did not consider me any worse than I really am." He himself was no less worried by what was to become of Hélène, and he tried to justify himself:

> "I am causing her grief, and I feel it myself, perhaps even more strongly than she does, and she knows that, she understands my feelings. I have always told her that I will get married, I have been telling her so for years now, our relations are purely friendly … I am telling you all this, so that you will not be upset on account of my behaviour; I am doing all that I can, and I am convinced that I am depriving her of nothing, and her wound, from which I am suffering, I assure you, at least as much as her

View of the Kremlin in Moscow, 1913.
Oil on canvas, 85.5 x 56.5 cm.
Rudolf Staechelin Collection, Basel.
(p. 114)

Trinità dei Monti, Rome, 1913.
Oil on wood.
Private collection.

The Sea, Honfleur, 1915.
Oil on canvas, 56 x 96 cm.
Musée cantonal des Beaux-Arts, Lausanne. (pp. 118-119)

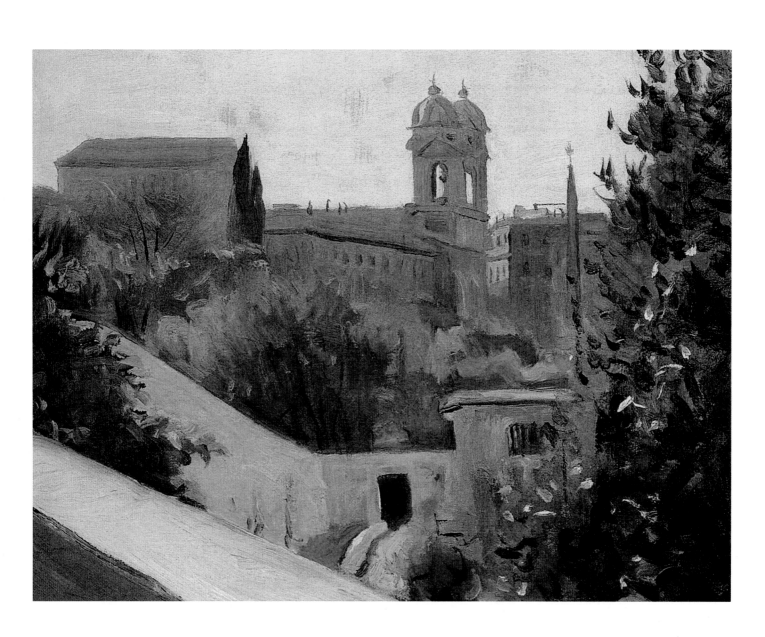

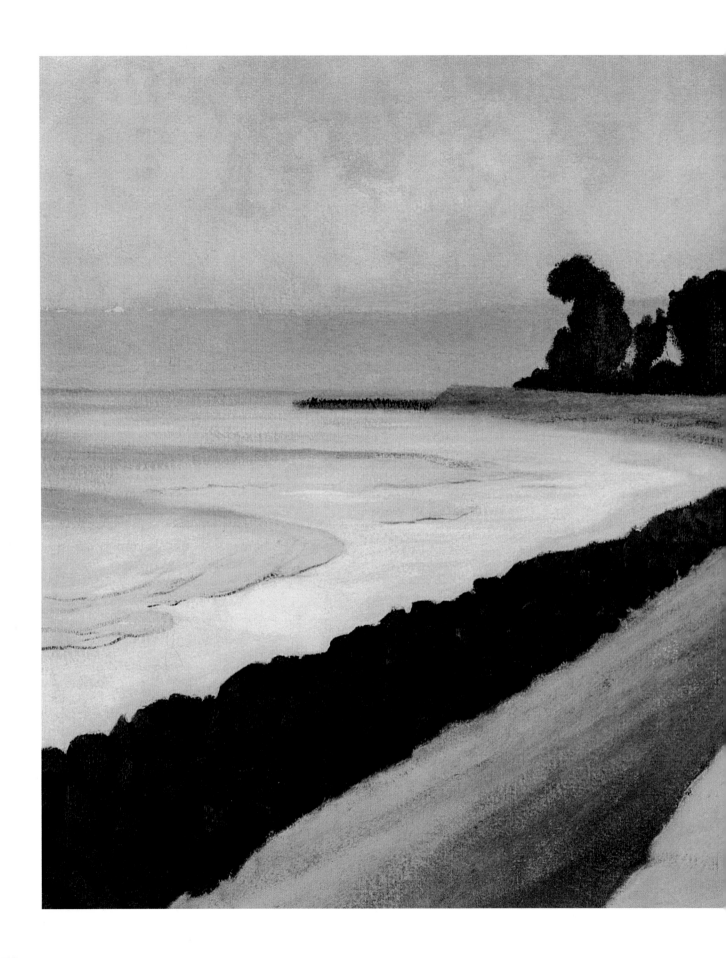

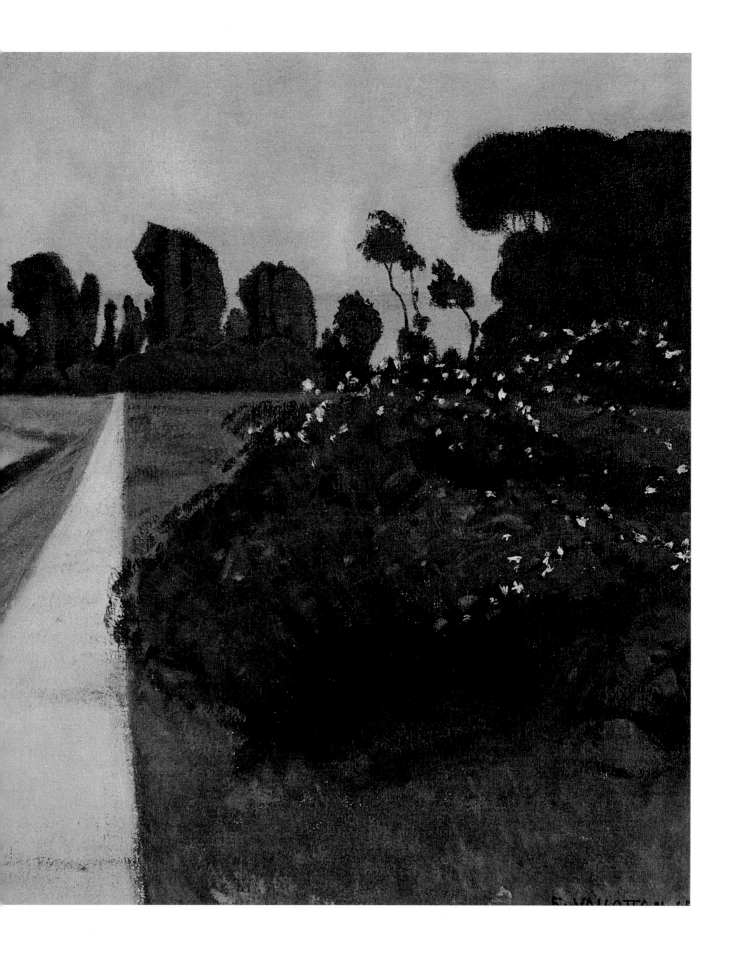

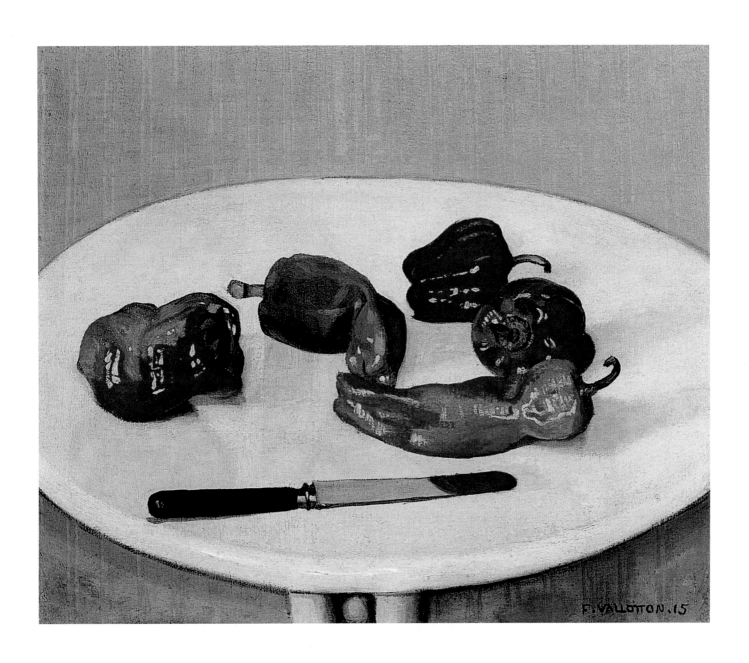

(as she will tell you) will heal over, and our attachment to each other will be preserved."

The verbosity of the explanations, which are repeated in his letters, testifies to his profound concern, the reason for which lay not only in the break with Hélène. It is no wonder that he referred to the material side of the proposed marriage again and again: "They are very distinguished and rich," he wrote about the family of Gabrielle Rodrigues.

"Both brothers are continuing the family business on the Rue Laffitte … She has no great fortune, only an annuity which provides for her and the children. The children's future is guaranteed by the family. I must also mention my work, which is becoming twice as intensive, and, you understand, I am blessed with the support of her family, indeed that is their profession, and I like them all."

Félix, it seems, was trying to convince himself of the lightness of this step. Like a true Vaudois, he subjected everything to doubt, and his new, safe, bourgeois life remained a constant reproach, although in reality it hardly amounted to a rebuke. Very few artists can take pride in the kind of success enjoyed by Vallotton before he was thirty. From the age of twenty, he presented his painting every year in Paris, in the Salon des Artistes Français, and later in other official Salons. From the same year, 1885, onwards, he regularly exhibited in Switzerland: Lausanne, Geneva, Basel, Berne, Neuchâtel, and Yverdon, and nowhere did his work fail to attract the critics' attention. In 1892, Vallotton began to exhibit in the Salon des Indépendents. In 1893, he first took part in a Nabis exhibition, and from then on he constantly participated in them. In 1894, his works could be seen in a number of European countries starting with the Libre Esthétique exhibition in Brussels, followed by Secession exhibitions in Vienna, Berlin, and Munich. As for the Paris art dealers, by the time of his marriage he had already conquered Le Barc de Boutteville and Ambroise Vollard, and in 1899 he exhibited with the Nabis for the first time at Durand-Ruel's. It is probable that his exhibitions at the Bernheims', who were very sensitive to contemporary art, would have taken place regardless of his relationship with Gabrielle Rodrigues. Thanks to his graphic works, Vallotton's name constantly appeared in the press. For a year before his marriage, he had been considering the need to obtain French citizenship.

"My unofficial status here is becoming unbearable," he wrote to his brother in February 1898. "So much so that I intend to apply for citizenship. I think that I am acting correctly, because in my present

Still Life, Red Peppers on a White Laqured Table, 1915.
Oil on canvas, 46 x 55 cm.
Kunstmuseum Solothurn, Solothurn.

situation I feel dependent on everyone and helpless. It is paralysing me in my work, and my position as a foreigner is beginning to depress me."

The fundamental reason for taking this step lay, however, in his relationship to his fiancée. "I love her very much," he wrote of Gabrielle Rodrigues to his brother, "which is the main reason for this marriage, and she loves me also; we know each other very profoundly, and we trust each other. In short, I regret nothing, and I nourish the highest hopes."

Immediately after the wedding, Vallotton took his wife to Lausanne, where she was warmly welcomed by his family. Gabrielle entered the friendly circle of Nabis naturally enough. In 1900, Vallotton rented the Château Romanel near Lausanne, where his house guests included the Natansons, relatives on the Bernheim side and, of course, Vuillard, who was a friend of Gabrielle's cousin, Lucy Essele. In the same year, 1900, Vallotton finally obtained French citizenship. He and his wife rented a large apartment with a studio near the Grand Opera, on the Rue de Milan, but in 1903 moved to the Rue de Belles Feuilles, in his favourite part of Paris, near the Bois de Boulogne.

The Return to Painting

The year 1900 saw the start of the second half of Vallotton's life, where there was no more room for printed work – it was given over completely to painting. However, his engraving period could never be forgotten. In 1899, Vallotton drew a picture entitled *Dinner by Lamplight* (pp. 40-41), and after the title he added the explanation: *The Effect of Lamplight*. The painting was an obvious tribute to the interest which French artists had long shown in the effects of artificial light, and the results which it could produce in the most diverse directions. Vallotton's friends – and most of all Vuillard, the closest of them – often explored the possibilities of using lamplight. In his 1892 picture, *Two Women in the Lamplight*, Vuillard painted the figures in the foreground, using vast planes of shadow to demonstrate possible means of attaining abstraction and expressiveness. However, this was not typical of Vuillard's gentle painting, and in 1897, in his *Large Interior with Six People*, which he presented to Vallotton, the lamplight was the cause of that twinkling of patches of colour which creates the specific and decorative charm of his pictures.

Before the Storm, (Villa Beaulieu Entrance, Honfleur), 1916. Oil on canvas, 89.5 x 81 cm. Studio stamp on lower right.

Vallotton arrived at his *Dinner* by another route. It seems surprising that the future Impressionist Claude Monet, took an interest in the effects of lamplight in 1868-1869,

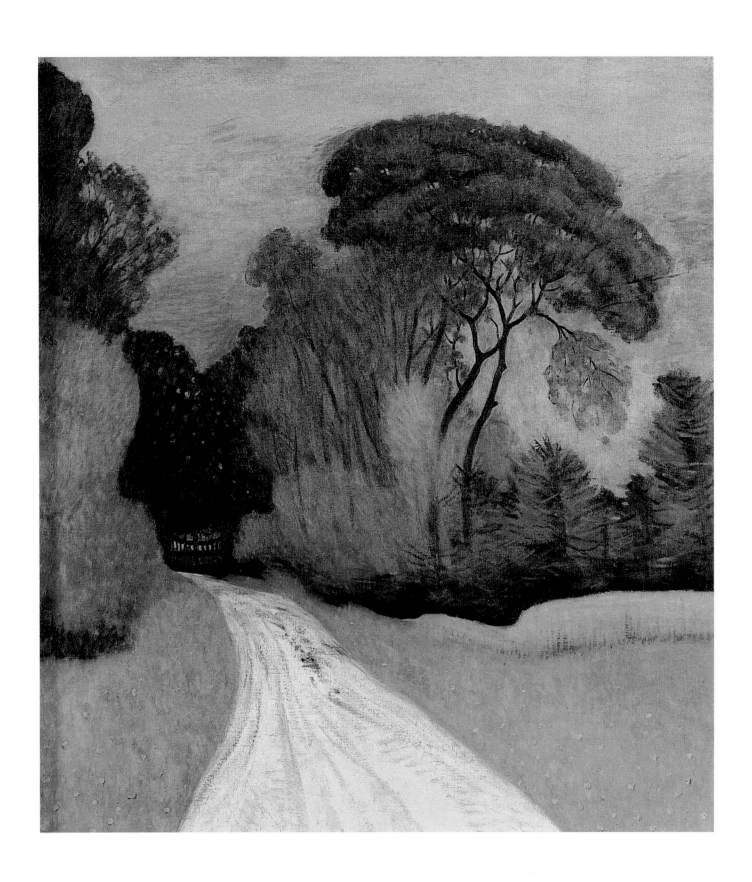

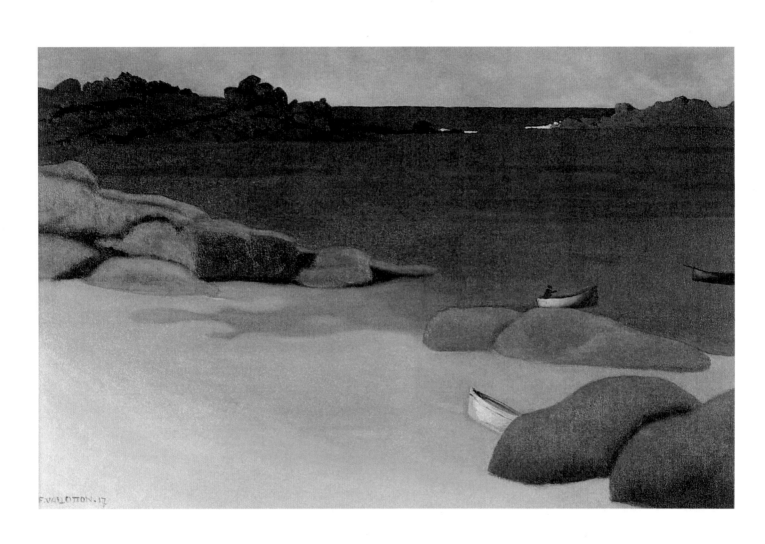

Trégastel Bay, 1917. Oil on canvas, 55 x 87 cm. Private collection, Lausanne.

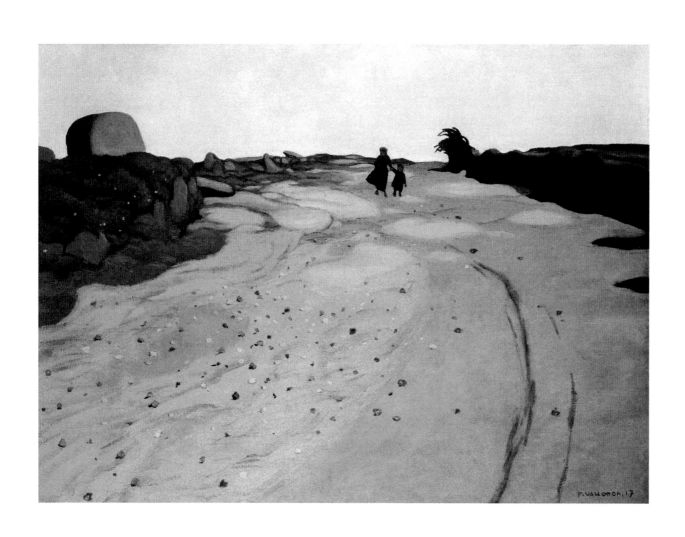

Breton Landscape, 1917. Oil on canvas, 73 x 100 cm. Private collection, Lausanne.

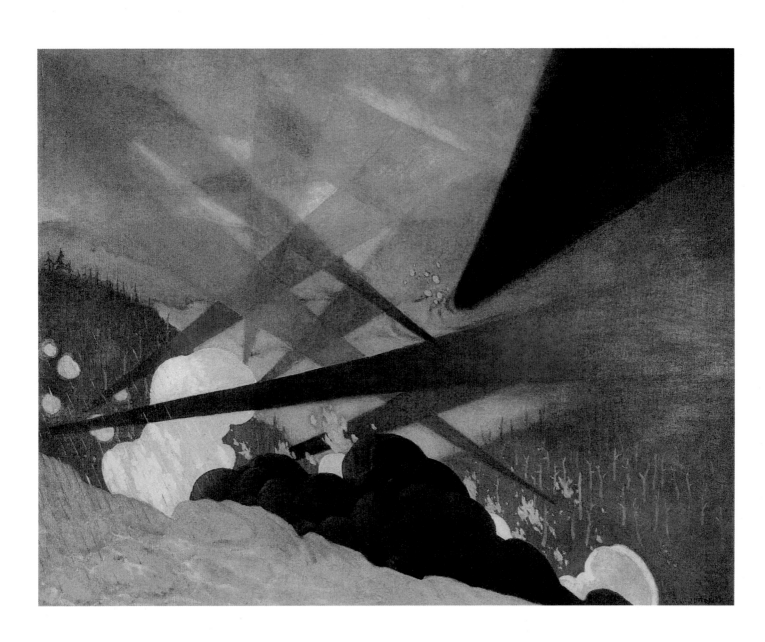

but never again returned to it. In his *Dinner*, Vallotton was precisely following in Monet's footsteps. He already had a deep understanding of the significance of artificial light as a means of abstracting light and shade in the strong black and white patches in engraving. He has already developed all manner of effects in his *Musical Instruments* and *Intimacies* series. The question now was to what extent the same device would be effective in colour. Vallotton repeated it in painting *The Poker Game* (p. 72) and *Billiards*, carefully converting patches of shade into planes of colour. He drew a woman rummaging in a linen cupboard, peculiarly illuminated by the light, of a lamp standing on the floor.

However, a particularly special role fell to *Dinner*. Although it is difficult to regard the picture as a portrait, it nevertheless presents Vallotton's new family. In a fascinating way, the light outlined the oval of Madeleine's face and Madame Vallotton's profile, and caught the boy's chewing movement. This is one of the scenes of everyday life; however, even the slight caricaturing of the subjects here is devoid of any cold irony. The very lamp in Vallotton's dining room conveys a feeling of the cosiness which gives rise to its light, and the brightly lit chequered tablecloth, and every object on it. Vallotton goes farther than Claude Monet, even using his own kind of photographic effect here – the very large figure of the artist himself in the foreground and the sharp reduction in size of the objects in perspective. There is nothing surprising about this, because Vallotton and Vuillard both belonged to that generation for whom photography had become an everyday event. They themselves found pleasure in taking photographs, and it would have been strange at least if such an erudite artist as Vallotton had not thought of the mutual influence between painting and photography. Vallotton's *Dinner* was not a work to remain unnoticed, and there is no doubt that the Swiss Giovanni Giacometti was following in his footsteps when he painted his picture *The Lamp* in 1912. Vallotton's *Dinner* signified much for his own future: you can see here not only his striving to develop the special genre of the interior with figures even further, but also an ever-growing interest in the object.

"I am not to any extent an Impressionist, although I sincerely appreciate such art," he wrote later, "and if I have any merit at all it is that I have resisted its powerful influence." Only once did he submit to its influence, and that was during the early years of his happy family life. In the summer of 1903, he painted the interior of a country cottage in Varangeville, with floral wallpaper, bouquets of wild flowers, and Gabrielle wearing a blue dressing gown, at the piano - *Woman at a Piano* (pp. 86-87). The greenery of the trees is reflected in the pane of an open window, and sunlight and fresh air fill the room. He was calm and happy, and his painting reflected the harmony of his world. Indeed, Vallotton's own brand of Impressionism

Verdun, 1917.
Oil on canvas, 114 x 146 cm.
Musée de l'Armée, Paris.

was the 1900-1904 series of interiors of his apartment with the figure of Madame Vallotton, either sitting at the back of the room, or fading into the perspective, or reflected in a mirror. Engravings from the *Musical Instruments* series hang on the bedroom wall. The greenish-gold range of colours, the soft pink patches of the clothing – all this creates an impression of such immediacy and such complete absence of decorative stylisation which is difficult to find in his later work. Vallotton's natural reserve and his constant fear of expressing his feelings did not allow him to idealise even those whom he loved. But the plain face of his wife, drawn in her dressing gown, in the artist's studio on the Rue de Milan, the intimacy of her movement with a slight inclination of the head, the warmth of her smile is a moment of happiness that has been caught by the artist. Behind Gabrielle are pictures executed in those genres which Vallotton practised most from 1900 onwards: a nude model and a landscape of Honfleur.

Even in Vallotton's pencil sketches that diffidence can be sensed which he, in fact, always experienced in front of a naked model. Having already mastered the technique of drawing the nude female figure during his student years, Vallotton with some justification regarded himself as a disciple of Ingres: in early 20th-century art, it is difficult to find such classic accuracy of outline and form as his nudes possessed. After the decorative canvasses of the 1890s depicting nude women amusing themselves with kittens or playing draughts, came a whole series of figures in interiors, following, as it were, in the line of Edgar Degas' pastels: women dressing, pulling on stockings or barely covering up their nakedness with a bed sheet, as if they had suddenly sensed the presence of an unseen observer. Like Pierre Bonnard, Vallotton catches a woman in the boudoir, when she need least of all fear a stranger's glance. The only difference from Bonnard is that, even here, Vallotton was not able to surrender immediately to feelings of love for his model. His brush records all those irregularities of her figure which she, it would seem, should hide. It is as if he were constantly creating irony of Ingres' classic conception of nudity, which he admired so much.

Francis Jourdain recollected the Ingres retrospective which was held at the Salon d'Automne in 1905, where Vallotton's picture *Models Relaxing* was also exhibited. Among the works by Ingres there was the *Turkish Bath*, which later entered the Louvre. Jourdain explained:

> "It was not at all well known and became the object of endless quarrels between artists. The remark it drew from Maximilien Luce immediately went the rounds. 'It looks like a dish of brains!' exclaimed the old Gavroche … It is entirely possible that Vallotton, who was

Four-de-Paris, 1917.
Oil on canvas, 81.5 x 65.5 cm.
Private collection.

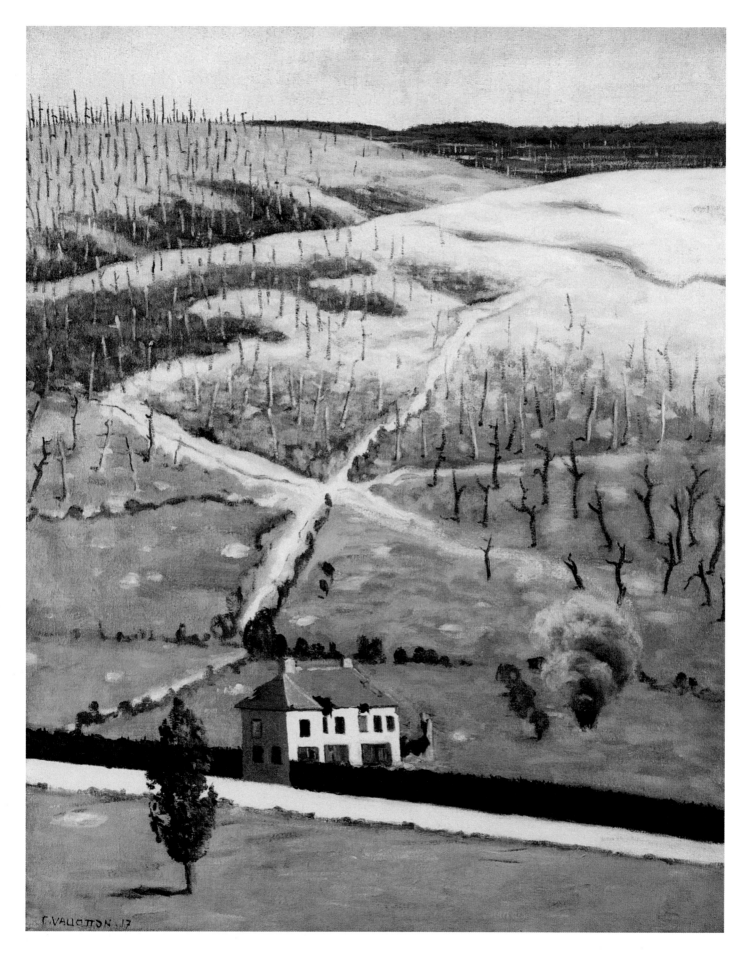

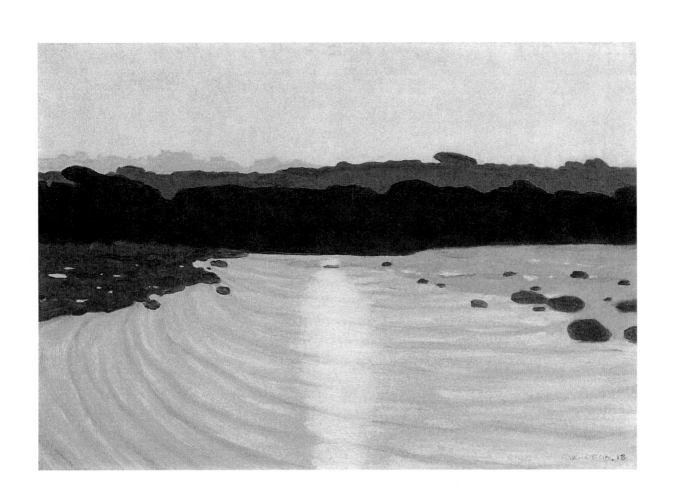

Evening in Ploumanac, 1918. Oil on canvas, 46 x 54 cm. Private collection, Basel-Binningen.

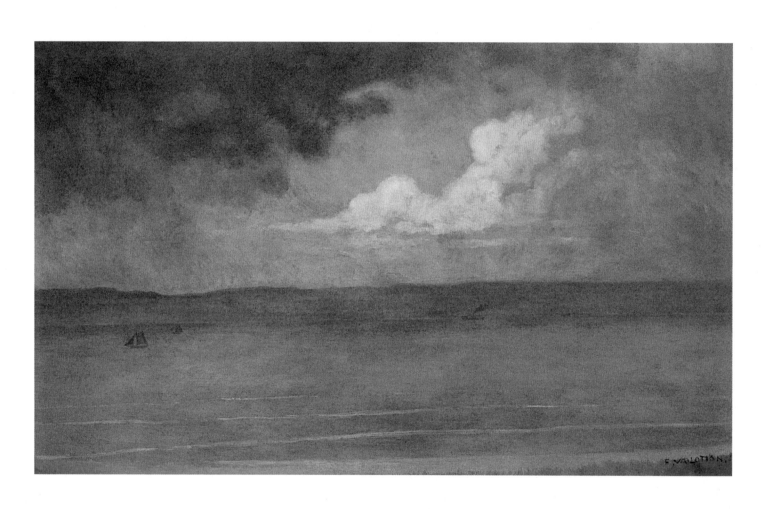

Un Grain, Bay of the Seine, 1918. Oil on canvas, 55 x 92 cm. Pictet and Cie Collection.

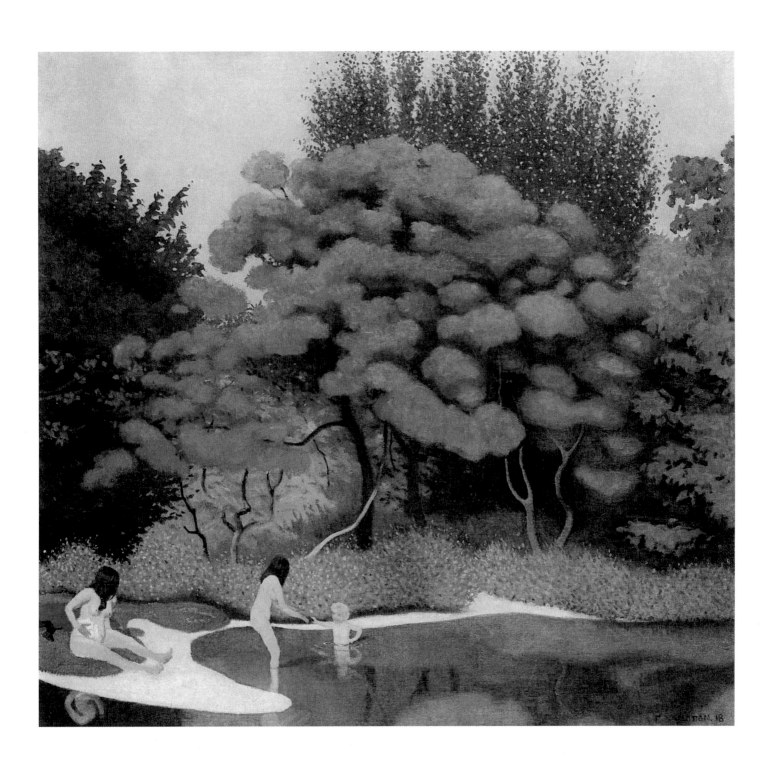

certainly no fetishist, sensed that there was some truth in that caricature of a pronouncement ... However, when our friend Baignaire showed him the *Turkish Bath*, Vallotton was unable to conceal his feelings. He burst into tears."

In 1907, Vallotton drew his own *Turkish Bath* (p.184-185). However, his odalisques were those women of the 1900s who had excited his irony when he saw them in Maurice Denis' pictures. Vallotton's women have modern hairstyles and an almost clumsy manner of holding themselves, even if they are called Angelica or Andromeda. A young blonde Europa, clinging frantically to the slippery back of the bull is utterly lacking in classical grace. Vallotton even produced such anti-feminist pictures as *Hatred* or *Violence*. However, perhaps it was the Salon d'Automne and his own proximity at the same time to Ingres and the Matisse group – Derain, Vlaminck, and Van Dongen – that caused him to reconsider his point of view, leading to the appearance of such canvasses as *Sleep* (pp. 190-191), *Patience*, and *White and Black*. His experiments continued the Neo-Classical line established in 1905 by *Models Relaxing*; but a large, flat, coloured surface had come into his painting. The juxtaposition of flat patches of pure colour – red, green, blue, and yellow – is reminiscent, on the one hand, of his previous experience in engraving and, on the other hand, of the fact that a new century had begun, one in which Matisse's group, dubbed the Fauves – "the wild beasts" – by Louis Vauxcelles at that same, notable 1905 Salon d'Automne, had taken their place.

Vallotton could not yield completely though, and Matisse would continue to irritate him for a long time to come. In his review of the Salon d'Automne in 1907, he describes Matisse's picture *Luxe, calme et volupté* in the following manner:

> "The colour is pleasant, although also flat, and the treatment is harmonious, although fairly primitive. This creates a strange impression; from a distance, it is attractive because these waves of colour, representing nothing in particular, create a lovely effect on the wall; but when you come closer, the charm immediately vanishes, and it is disappointing... interest lapses automatically; hopes are dashed and the delicacy disappears, because the need for precision is inseparable from painting, and precision in art is bound up in the means of expression."

Even when he was already close to working in pure colour, Vallotton could not give up his scrupulous manner of painting, Charles Guérin used to relate how Vallotton

Bathers in the Undergrowth, 1918.
Oil on canvas, 82 x 88 cm.
W. and H. Zehnder Collection,
Wallisellen.

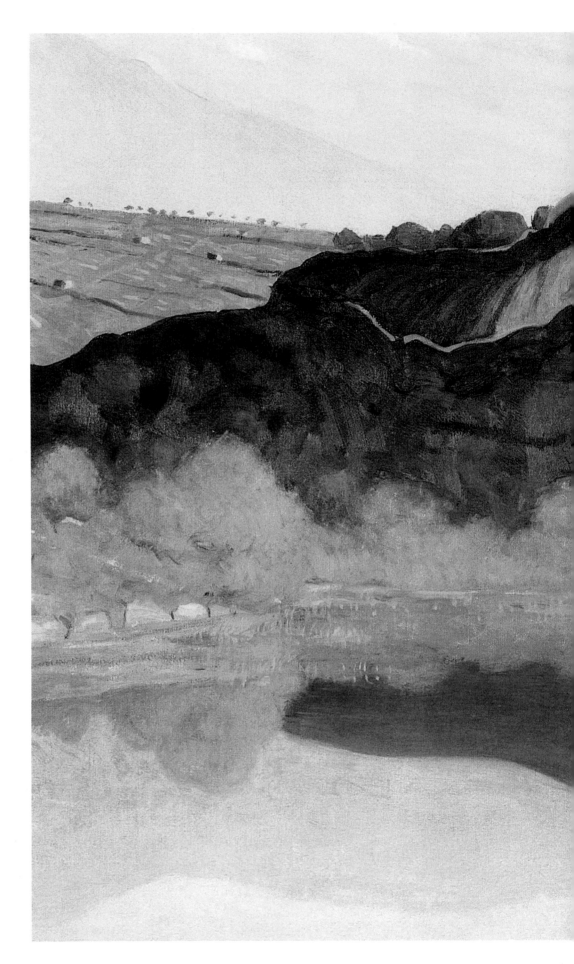

Géronde Lake, 1919.
Oil on canvas, 60 x 81 cm.
Musée cantonal des Beaux-Arts,
Lausanne.

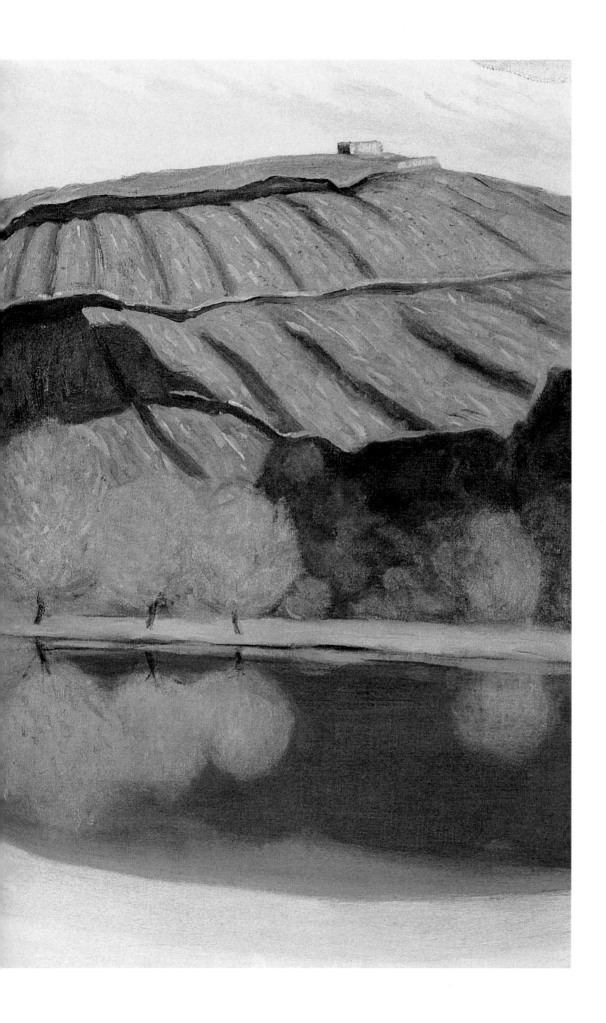

drew his portrait: "Having made a quick sketch in chalk, he started filling in the background round the head, without any doubts or any clearer definition. Then he started on the hair, shaped the forehead and the left eye ... finishing it off completely at the first attempt... That, he said, is how they worked in Lefebvre's studio." He used a melting stroke brushwork technique worthy of David and Ingres, and created ideal shape by means of chiaroscuro. Beyond the bounds of this manner of painting, there lay the landscape. Vallotton never was an Impressionist, and did not seek to catch the fleeting effects of atmosphere and light. He seemed indeed to distance himself ever further from direct impressions from the real world.

In 1900, he painted, together with Vuillard, from life at the Chateau Romanel. Vallotton's landscape already had that decorative texture which was reminiscent of his wood engravings, with their specks, tiny cells, and strokes for blades of grass. Large patches of shade, in green and blue, also justified Meier-Graefe's prediction: Vallotton had imported what he discovered in black-and-white graphic art into his painting. However, the matter was far more complicated. Vallotton could indeed be charged with a certain conservatism: it was difficult for him to reject the idea of virtuosity underlying his craft. However, he understood perfectly the necessity and benefit of fresh sources. The story goes that, one day, Douanier Rousseau told Vallotton: "We're going the same way!"

In 1903, Vallotton painted a series of landscapes at Arc-la-Bataille. They contain many signs of that special erudition which distinguished him: the classic coulisse composition, based on a linear perspective, that went back to Poussin; the palpable three-dimensional quality of the tree tops, indebted to Cézanne: the fine patterns of foliage and the moiré effect on the water, all associated with a quest for decorative style. There is, however, one other little detail: the toy cows on the green grass. Rousseau's naive manner of expression already fascinated Vallotton, and he understood that he and Le Douanier were "going the same way" long before Picasso, Van Dongen, and Apollinaire, who did not hold their notable Rousseau Banquet in the Bateau-Lavoir on Montmartre until 1908, an event described by the poet Andre Salmon.

Yet the hint of Rousseau does not turn Vallotton's landscape into something fantastic. On the contrary, that naivety springs organically from the charm of rural France, its peaceful rivers and green meadows. The whole cycles of landscapes which Vallotton painted in Normandy, and later in the Loire, the Dordogne, and other parts of the country, make up a real poem. Later, in the second decade of the century, he made his coloured patches more and more abstract, and almost completely abandoned fine details: the poetic feeling still remains, however. This was how the secretive artist made his

Landscape at Sunset, 1919.
Oil on canvas, 46 x 55 cm.
Private collection.

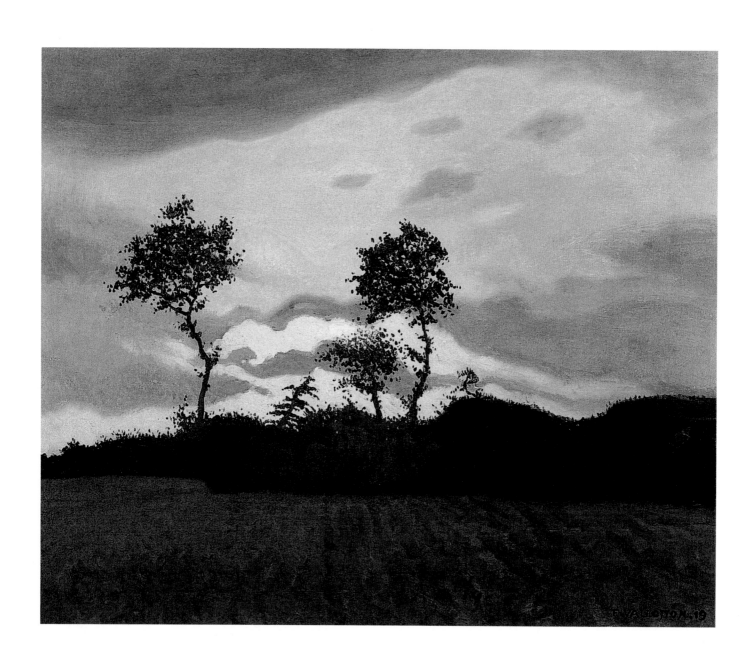

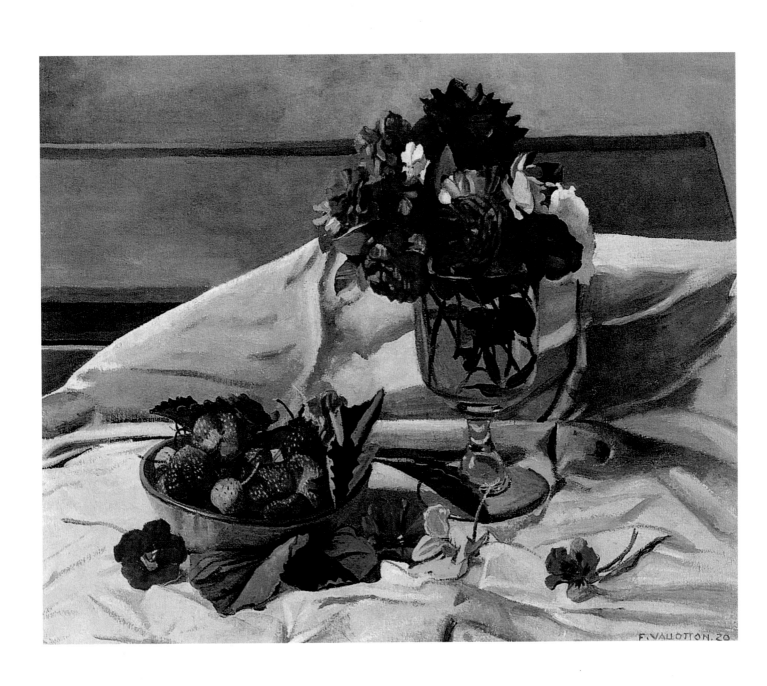

Flowers and Strawberries, 1920. Oil on canvas, 61 x 73 cm. Private collection.

Metal Platter, 1920. Oil on canvas, 65 x 81 cm. Collection d'art de la Banque Cantonale Vaudoise.

declaration of love for the country which had adopted him. On 5 October 1916, Vallotton wrote in his diary:

> "I dream of painting that is free from any literal following of nature. I would like to recreate landscapes only with the aid of the feeling which they evoked in me, a few basic big lines and one or two details selected without any precise connection with time or lighting. In essence, that would be something like a return to the celebrated 'historical landscape'. And why not?"

In fact, in the early years of the century, Vallotton had actually tried his hand at that as well: he drew some landscapes with nudes, some even with mythological figures in the style of Camille Corot's Italian landscapes. Admittedly, he now rejected both literal treatment and what he called "historical landscape". Perhaps another entry, made three days later, better explains his concept: "I am finishing off the large landscape which, without a doubt, will complete my Andelys series. I have derived the greatest satisfaction from it; not being restrained by any precise memory of nature, I had a clear field in front of me and I felt free."

Les Andelys was the birthplace of Poussin, whose name would always remain one of the greatest for the artist. For *Memories of Les Andelys*, however, he did not use Poussin's classical landscape construction. The illusion of flying high above the ground provides an opportunity to see the river, the islands, the woods, and the distant hills from a point of view which does not exist in real life. Of Poussin's legacy, only the main feature remained – the eternal grandeur of nature.

It is possible that this feeling actually originated back in Vallotton's native Swiss Alps. The Swiss mountains again appeared on his canvasses at the end of his life, cleansed by memories: "I have started some landscapes of glaciers in the high Alps," he wrote in his diary in 1919. "I have done it from imagination, and I enjoy inventing shapes and points of view."

In France, Vallotton fell in love with the different landscape of Honfleur, far removed from majestic Alpine views. A cosy little port, almost toy-like, with immense expanses of beaches and countless sails. Vallotton had a passion for everything connected with the sea, and his memory housed the most unlikely information on how ships of various countries were rigged, but only a few friends were allowed into this secret. "Vallotton was in love with the sea, like a Swiss admiral," Jules Renard wrote in his diary.

View of Cagne from Horseback (detail), 1921.
Oil on canvas, 80.5 x 60 cm.
Musée cantonal des Beaux-Arts, Lausanne.

In his last novel *Corbehaut*, written in 1920, Vallotton chooses surprising words for the Honfleur landscape:

> "In places, the bay reveals some muddy shallows, looking like the backs of huge whales; there the boats would rest, grounded in the shallows, with their pointed bows and their sails brailed … It was even hotter, although the yellowing sun vividly coloured the foam round the piles, but the shadows seemed colder already, and their violet hue was becoming less transparent."

Tarred Barracks in the Vineyard, 1921.
Oil on canvas, 60 x 73 cm.
Collection d'art de la Banque Cantonale Vaudoise.

Sunlit Path in the South, 1920.
Oil on canvas, 72 x 60 cm.
Musée cantonal des Beaux-Arts, Lausanne.

He drew and painted all this incessantly: the little cubes of the houses of Honfleur seen from a bird's eye view, the lighthouse and the pier, the lamps lighting up in the windows, and the sky and the foam of the breakers coloured fantastically by the setting sun. Perhaps it was in these landscapes, very firmly attached to nature and as beautiful as a memory, that Vallotton most successfully realised his concept of "historical landscape". In December 1918, a strange entry appeared in Vallotton's diary:

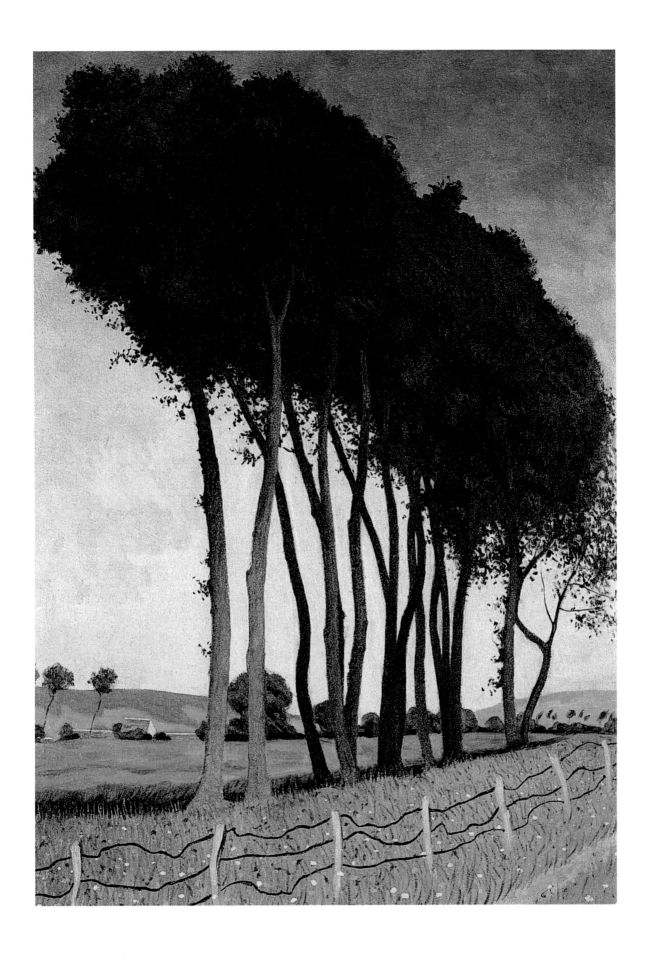

"Surely I do not intend to start a still life period?" That sounds like an unexpected revelation about himself.

Vallotton always painted still lifes, but in the last decade of his life they patently predominate over other genres. Perhaps his preference for the object to a certain extent is the result of his view of perfection of his craft: "It is essential that painting should once again become a difficult craft," he wrote in May 1919. "Only striving after perfection will produce such a result. We are too limited and poisoned by the catching of the serendipitous." Vallotton was thinking of the "downside" of Impressionism which led painting away from the materiality and permanence of form. Cézanne had already made the journey back, but Vallotton had to do it over again for himself, at the expense of the same Sisyphean toil. He reminds us, not of Cézanne, but of Louis Le Nain:

> "A man, woman, child, dog, bottle, bread, or basket, and just how the basket, dog, or child takes pain in the effect which is achieved in the picture, and how each one of these elements attains complete resemblance by using every means possible. It seems to me that this blade of grass could become the main thoroughfare and lead us straight to the target."

More often than not, he chose flowers, vegetables, and fruit. There were a few apples placed on a table or in a basket; tulips, dahlias, and marigolds in earthenware jugs or low vases; some red peppers or blue-black aubergines on a white table. "The object fascinates me more than at any other time," he wrote. "The perfection of an egg, and the moisture on a tomato, mint, or hydrangea present me with such problems. I tackle them without any pedantry, and by trying as far as I can to keep it as a painting, not falling into the paradox of purism."

Such a danger did exist: suffice it to remember Picasso's Cubism and all its followers. However, for Vallotton, the idea of purifying a geometrical form of the properties of a living object was completely unacceptable. His flowers had to retain their freshness and fragrance; his jugs had to retain the warmth of the soil and convey the smoothness of the glaze. The still lifes of his last years are more reminiscent of the painting of the old manner of painting: the still life with apples and pears which was painted by the Swiss Jean-Éntienne Liotard at the age of eighty is now in the Geneva Museum; or the lump of cheese depicted by Goya, now owned by the collector Reinhardt in Winterthur; and, of course, the German and French still lifes of the 17th century, where each berry and each little object was as carefully placed separately and as complete in itself, as in Vallotton's canvasses.

Family of Trees, 1922.
Oil on canvas, 100 x 73 cm.
Private collection.

Low Tide at Villerville, 1922.
Oil on canvas, 91.5 x 73.5 cm.
Private collection. (p. 146)

The Old Olive Tree, 1922.
Oil on canvas, 72 x 60 cm.
Musée du Petit Palais, Geneva.
(p. 147)

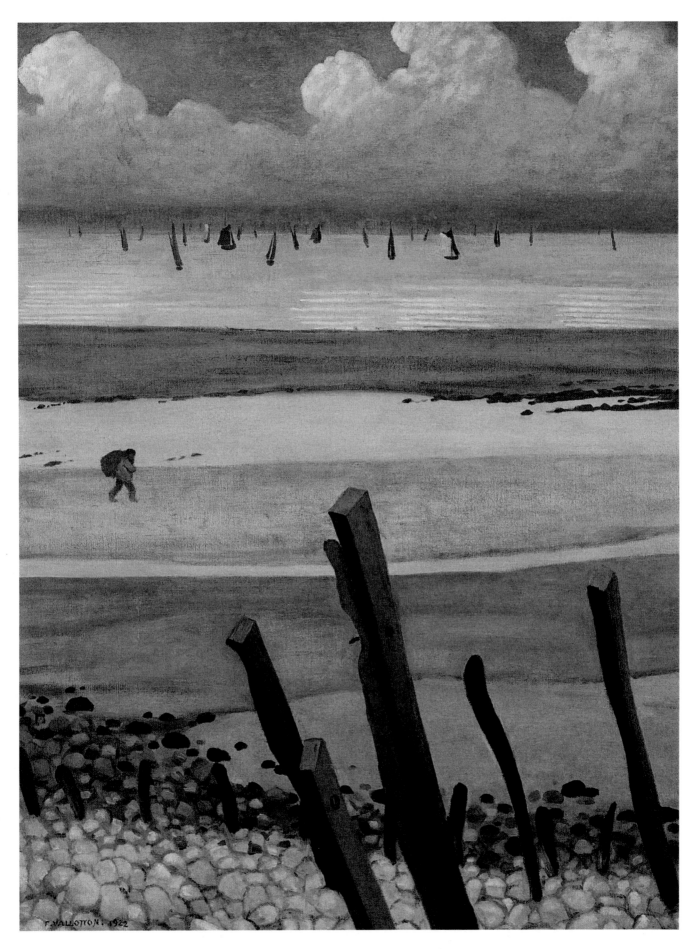

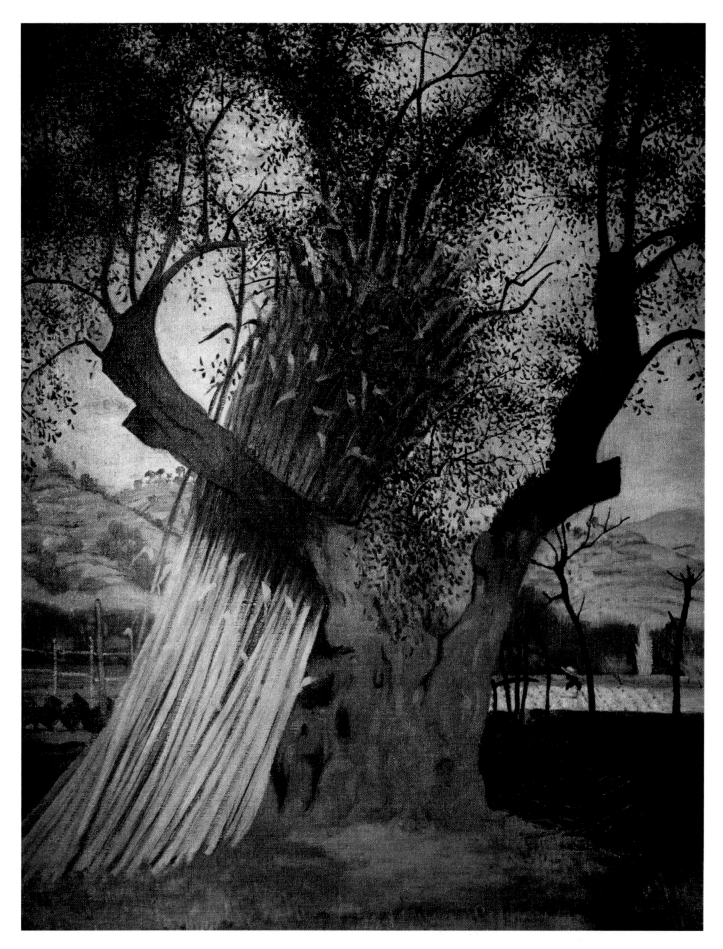

"The deception of the eye attracts me, at least as an aim," he wrote, "because above all I am convinced that I shall never attain it."

The cogency of the objects he now painted was no less staggering than in *The Invalid*, painted in his youth, and that authenticity remained within the bounds of that world full of poetry in which he lived while he was painting.

Félix Vallotton's life at the beginning of the 20th century apparently passed peacefully and at a steady pace. Accompanied by his wife and her children, he used to spend the summer either in his beloved Honfleur or in Switzerland. Now he could allow himself to travel, and he used to go to Belgium, Holland, and Germany. In 1906, Maurice Denis, advising him before a visit to Rome, added: "Don't forget to go and see the lovely portrait by Ingres at the Villa Medici, you will particularly like it – and just as much as the beautiful Poussin in the Colonna Gallery." Pierre Bonnard went to visit Vallotton in Normandy, accompanied by his future wife, Martha, and Vuillard, as always, remained his most trusted friend. All together, they helped Paul Ranson's widow by teaching at the Academic Ranson which they founded, and Vallotton was, in Thadée Natanson's words, "the most patient and the most earnest of the teachers".

In Paris in 1908, Vallotton and his wife were visited by Dr Hedy Hahnloser from Winterthur – Vallotton's future biographer. A friendship was struck up, the result of which was the assembly in Switzerland of one of the most important collections of Vallotton's works and those of other Nabis artists. In 1908 and 1909, Vallotton's pictures even travelled as far as Russia, where they were shown at the Moscow exhibitions organised by the magazine *The Golden Fleece*, alongside works by the best French masters of the 20th century. Vallotton's circle of closest friends was expanded by Henri Manguin, Charles Guérin, and Pierre Laprade, and he exhibited together with Matisse, Marquet, and other Fauves. The importance of his place in modern art is confirmed by the best critics. In his review of the Salon d'Automne in 1908, Louis Vauxcelles wrote: "Monsieur Henri Matisse and Monsieur Vallotton are exhibited directly opposite each other. It is impossible to imagine a bigger contrast. Two extremities ... This is a debate between David and Cézanne, if one may call it that."

Similarly, Louis Vauxcelles, invited to dinner in Honfleur by the artist, discovered the man behind the mask of cold aloofness. "I was immediately charmed," he wrote. "The reality turned out to be the opposite of the legend." Vauxcelles was fascinated by his intellectual subtlety and sincerity, and his refined culture. "That intimate Vallotton was the real Vallotton," he concludes. At that meeting, Louis Vauxcelles made one more

Part of the Town of Pont-Audemer, 1922.
Oil on canvas, 92 x 73 cm.
Private collection.

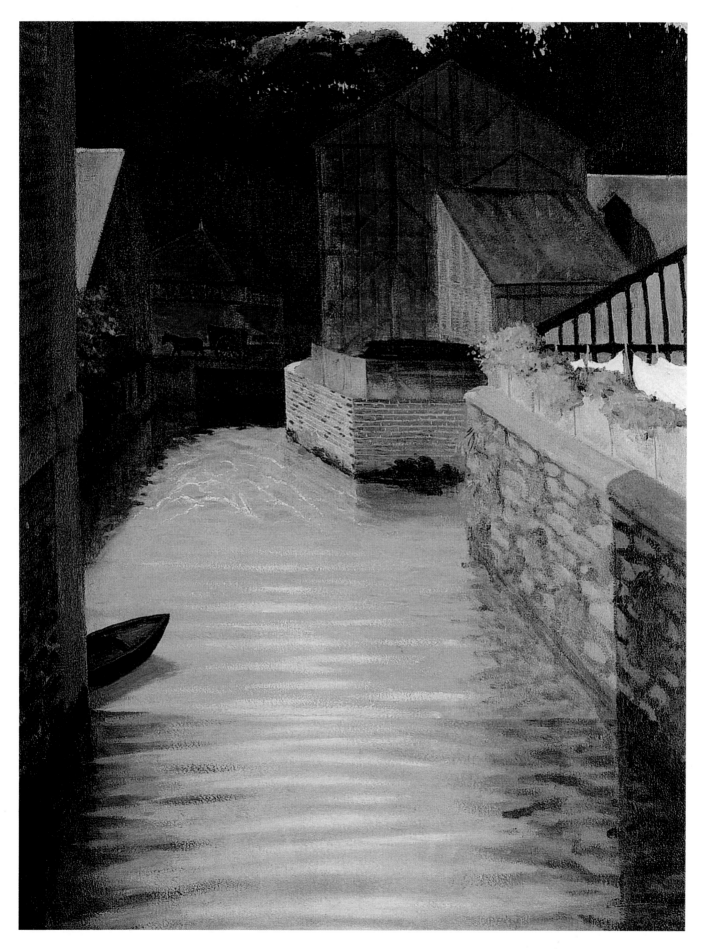

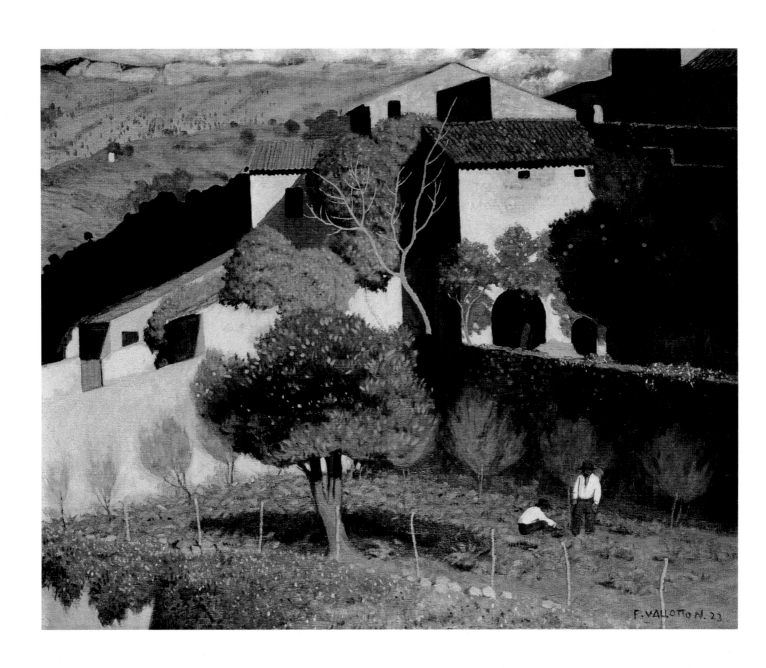

Cagnes, 1923. Oil on canvas, 65.3 x 80.5 cm. Musée d'Art et d'Histoire, Geneva.

Semur Landscape, 1923. Oil on canvas, 73 x 61 cm. Private collection, Zurich.

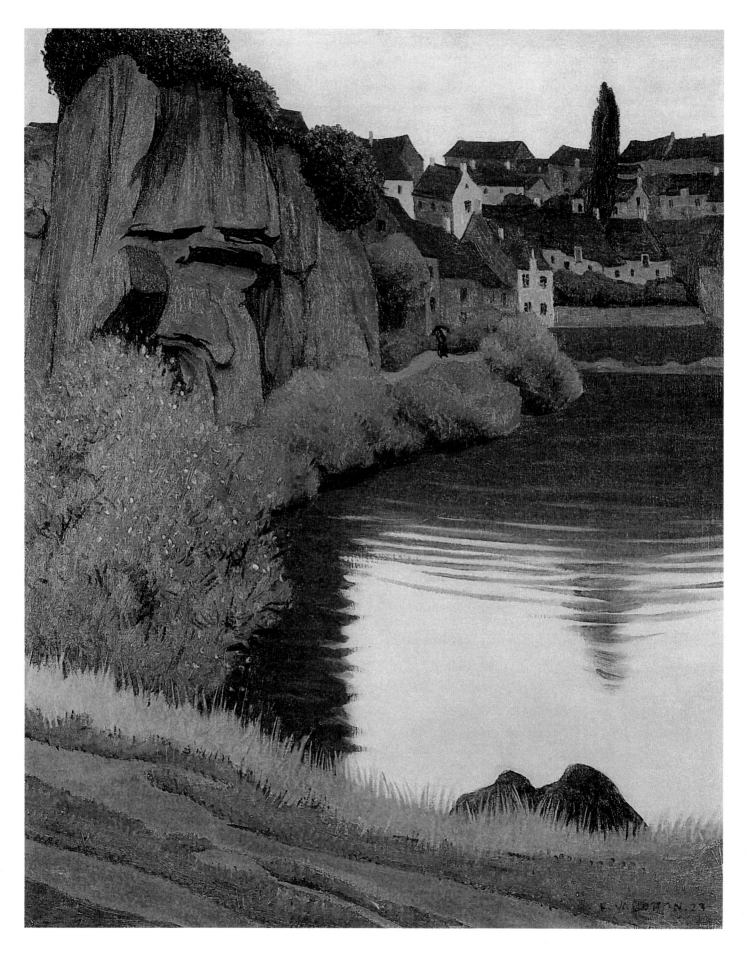

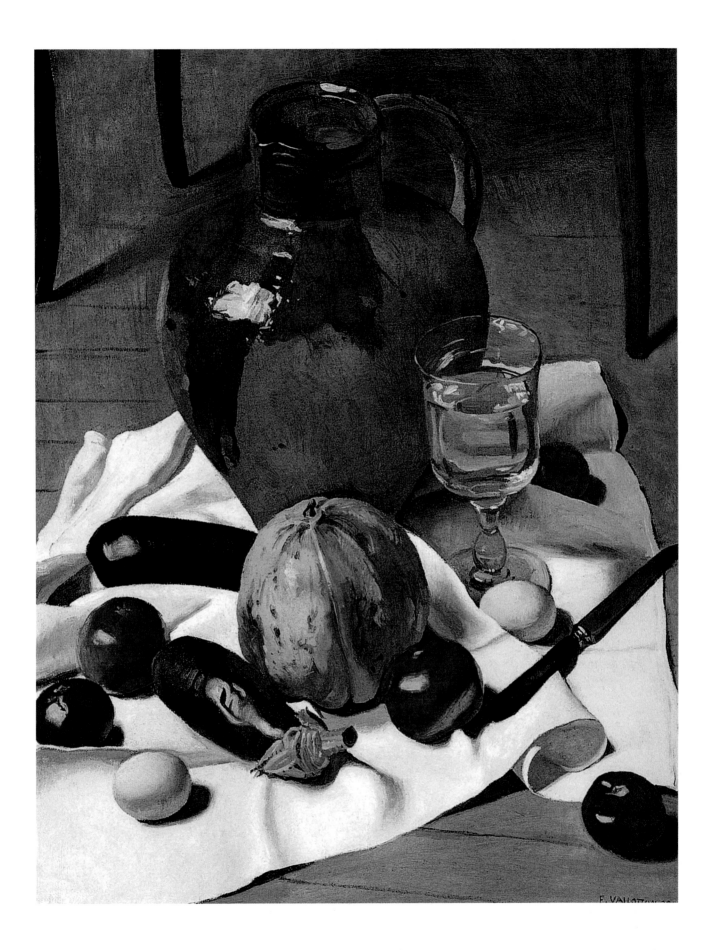

completely astonishing discovery: "Vallotton, an artist who is reputed to be cold, is, in fact, passion itself."

His Last Years

The greatest misfortune in his life was the fact that, due to his Vaudois character and Protestant upbringing, he always tried to hide his emotions, and always existed in contradiction with himself. That could be the reason for his constant melancholy and pessimism. In his youth, he used to complain to his brother of everyday inconveniences and difficulties in achieving success. Now, all that was in the past; however, only the first few years after his marriage turned out to be trouble-free. In 1905, Vallotton wrote: "However, it really is hard, now that I have reached the age of forty, to work so hard, just so that everything goes to rack and ruin ... I feel very depressed..." He was constantly burdened by financial worries. Apparently all was well with his painting, but Vallotton wanted to earn literary success as well. He wrote a few plays, but his attempts to have them published repeatedly ended in failure. Jules Claretie expressed an extremely unfavourable opinion of one of Vallotton's plays, and then lost the manuscript. We can imagine just how much this hurt Vallotton, as did the opinion of Jules Renard, with whom he had worked so much. "My dear Vallotton," Renard wrote, "I have just finished reading through your play *Without a Title*. There is much in it that is good and, I admit, I am surprised. This should not offend you: if you could see my drawings! But I do not think that the play can proceed in its present form." And when, at last, one of his Nabis friends, the director Lugne-Poë, presented a little play by Vallotton entitled *Un Rien* (Nothing) in his L'Oenvre Theatre, *L'Écho de Paris* commented in the most offensive tone: "The performance began with *Nothing*, a play by Monsieur Vallotton. This play completely justifies its title."

The Parisian literary milieu, whilst acknowledging Vallotton as an artist, was unwilling to accept him as a man of words. Not one of Vallotton's three novels was published during his lifetime. Despite all attempts by Vuillard and Guérin to give him encouragement and support, Vallotton lapsed further and further into gloomy pessimism.

"I am bored everywhere, wherever I may be." he wrote to his brother in 1906, "and I derived no pleasure from that visit to Nice, which could have been wonderful. So now I am back in Paris, but I am not exactly sure what to do here." With the passage of time, this condition only gets worse, and in 1908 he wrote: "...Unfortunately, I am in a state of melancholy and gloom ... and I feel more and more lonely." Of great

Still Life with a Large Earthen Jar, 1923.
Oil on canvas, 81 x 65.3 cm.
Private collection, Lausanne.

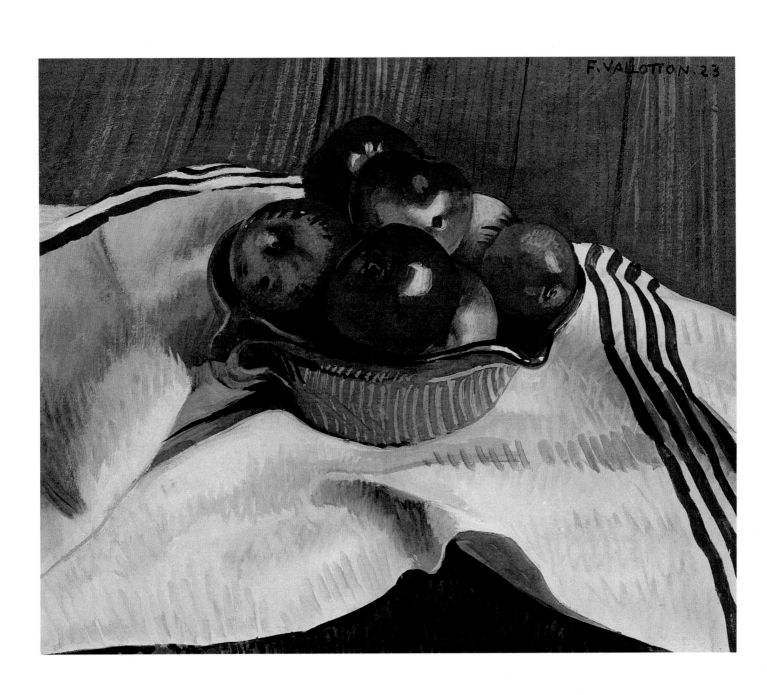

Still Life, Apples, 1923. Kustmuseum Winterthur, Winterthur (Switzerland).

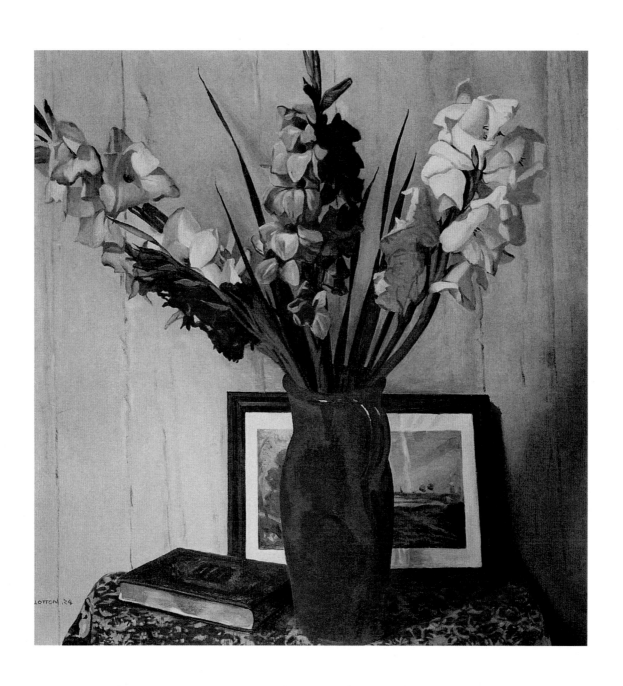

Still Life with Gladiolas, 1924. Oil on canvas, 86 x 82 cm. Musée cantonal des Beaux-Arts, Lausanne.

comfort was his friendship with the collectors from Winterthur. His letters to Madame Hedy Hahnloser-Bühler were confidential and candid, although also pierced with anguish: "I have lost my composure, and I actually see things through a black magnifying glass." Vallotton did not find the hoped-for harmony with his wife's family either. He did not like the children: their capriciousness exasperated him. He realised that art dealers, including his wife's relatives, were motivated by a love, not of art for its own sake, but of the money which it yields. In 1912, Vallotton published an article in the *Bibliotheque Universelle* magazine under the title "Artists, art critics, lovers of art and dealers". He bitterly refers to the fact that an artist is dependent on ignorant connoisseurs: "A man who has spent thirty years of his life manufacturing braces, and has never looked at a single picture, suddenly wakes up as an art lover."

In 1913, Vallotton gladly accepted an invitation from Georges Haasen, who represented the Swiss chocolate firm Cailler in St Petersburg, to go and visit him. As Haasen surmised, "the journey will be curative for anyone in whom there is no joy". To a certain extent, the journey fulfilled its purpose: the art collections at the Hermitage, the exotic character of the Russian Shrovetide with its pancakes and caviar, and the Moscow Kremlin, which he found "astonishing, wild, barbaric, and faintly ludicrous", enabled him to relax somewhat. The March weather in St Petersburg was too cold for him, and, being obliged to spend a few days indoors, Vallotton painted a portrait of Georges Haasen against a background of brightly-coloured Russian chintz curtains. Madame Haasen's portrait had been painted a few years earlier in Switzerland. But now, in St Petersburg, Vallotton did another drawing – of the Haasens' dachshund – and signed it: "To Monsieur Til-Til, my friend". After returning to Paris, he drew several Moscow and St Petersburg landscapes as pencil sketches.

But then the war started. Vallotton fervently desired to make some sort of contribution, but he was turned down by the army because of his age. His diary contains some notes on the unpredictability of what was happening, and the horrors of human sacrifice. "Whatever lies ahead of us," he wrote in July 1914, "everything thunders and smells of battle. Will this be the last crash, or the dawn of something new that we cannot imagine and cannot even surmise." He endured each defeat on the front hard, as well as rumours about the fate of the Hermitage in St Petersburg, and this certainly did not improve his emotional state. In 1915, he returned to engraving on wood, intending to put together a series entitled *This is War!* However, the artist himself, probably, felt that such engravings fell far short of their predecessors in expressiveness.

The Chateau-Gaillard in Andelys,
1924.
Oil on canvas, 100 x 73 cm.
Musée A.G. Poulain de Vernon,
Vernon.

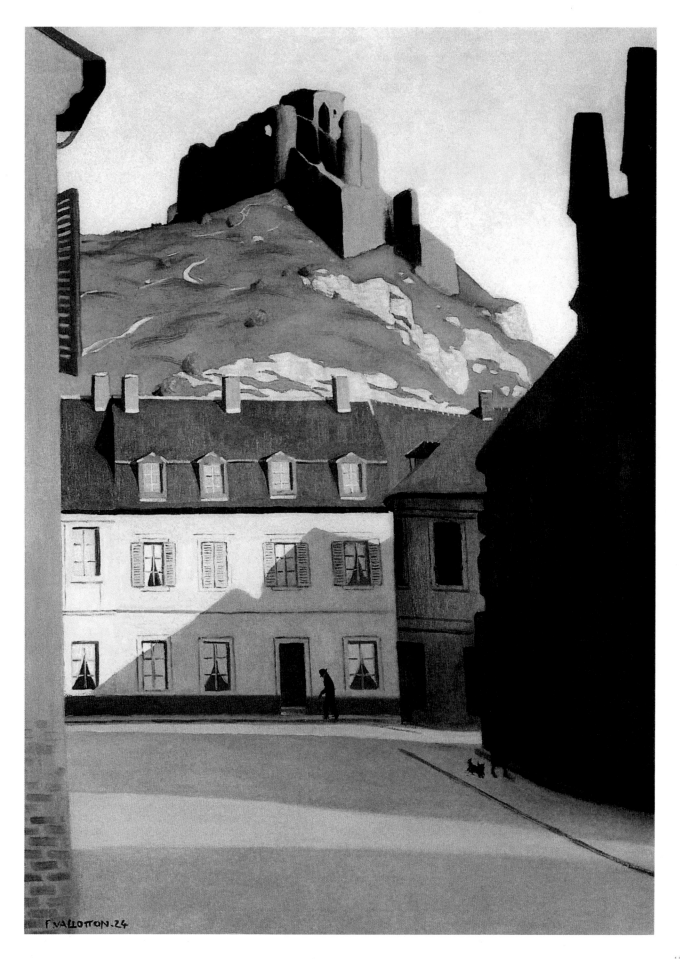

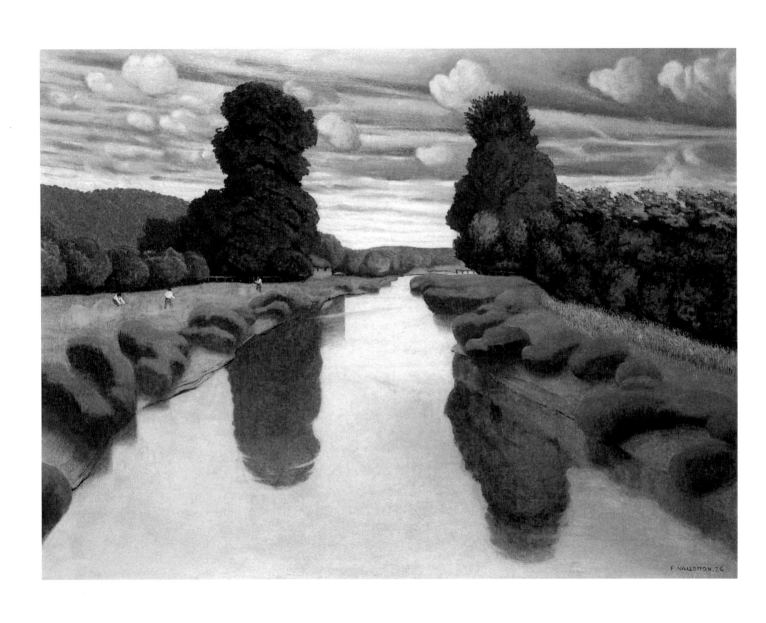

The Risle at Berville, 1924. Oil on canvas, 73.5 x 100 cm. Stiftung für Kunst, Kultur und Geschichte, Winterthur (Switzerland).

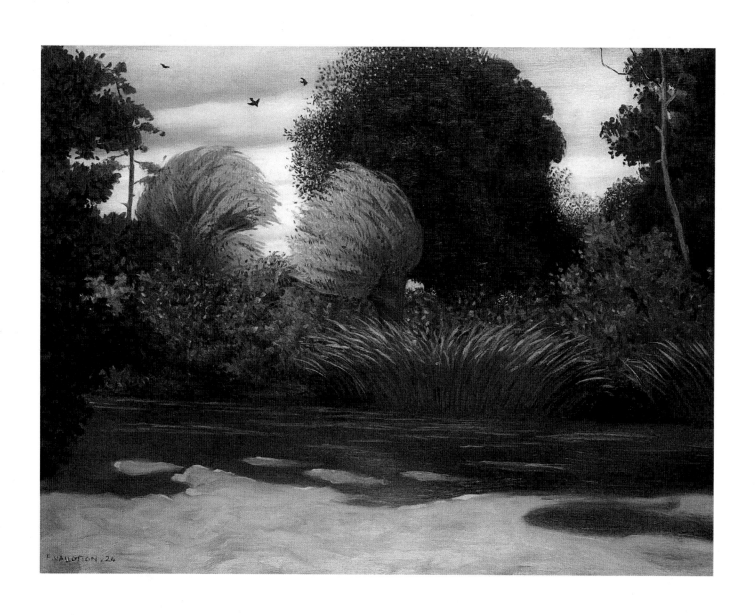

The Eure near Pacy-sur-Eure, 1924. Oil on canvas, 54 x 73 cm. Private collection, Lausanne.

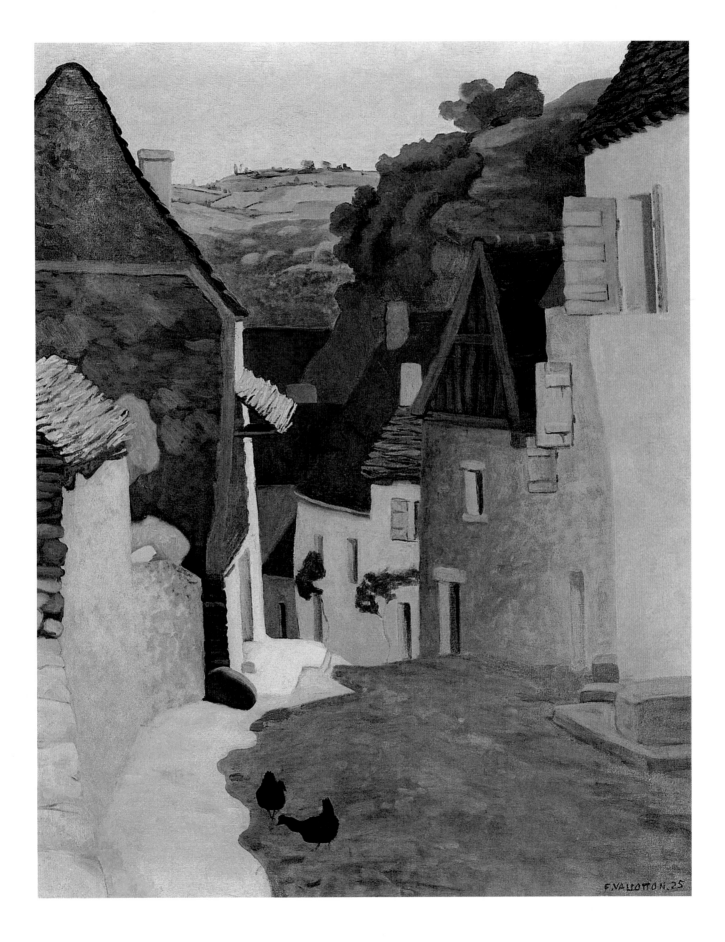

In 1917, Vallotton visited the front in Champagne with a group of other artists. As a result, he published an article entitled "Art and War" on 1 December in the magazine *Écrits Nouveaux*. This contained his thoughts on how an artist might find adequate expression for the sum total of the impressions and emotions caused by war. Vallotton himself made another attempt to reflect the war – he drew a few more decorative pictures, and in 1919 exhibited the large triptych: *Mourning*, *Punishment for the Crime*, and *Hope*. However, from the very outset, these attempts were doomed to failure, because it was too early to seek after a monumental reflection of war. In his own words: "War is not the explosions, nor this damaged tree with its crown hanging down, nor these gaping roofs, nor these unfortunate people who drag their stumps towards the illusory cover of the trenches, or rather it really is that, but only in the instant when the eye perceives all this, but its reverberations in space are so much more widespread!" Vallotton came to the conclusion that it was necessary to allow time for these impressions to sink in, and that time must elapse for art to be able to do its work.

On 22 December 1921, Vallotton wrote in his diary: "It seems as if only weeks have gone by since the time when I was called 'the Vallotton lad'. Life is a puff of smoke, you fight, surrender to illusions, clutch at apparitions which melt in your hand, and then it is time to die already." In the last years of his life, he retired into his shell completely. "Fortunately, there is still painting" – those are the last words in his diary. During his remaining span, he painted more than two hundred canvasses. These years were spent in apparent peace. He painted views of the Mediterranean and the Loire, Normandy to a lesser extent, because the house in Honfleur had been sold. In autumn and spring, he would go and visit his parents and brother in Lausanne, where they always expected him. Marianne Vallotton, the artist's niece, recalled:

> "It was the end of the year 1925 and the weather was grey and gloomy, but, in accordance with our old custom, we were getting ready to celebrate Christmas, when on 21 December my father received a letter, whose opening lines I quote: 'My dear Paul, after examining me twice, they have decided to operate. It has been arranged for next Saturday morning, the 26th. It would be nice if you could be here, for various reasons.'"

Before he left for the hospital, Vallotton sorted out his papers, destroyed manuscripts, finished the list of all his works and painted his last landscape – *The Bois de Boulogne in the Snow*. He died three days after the operation, on the morning of 29 December 1925, the day after his sixtieth birthday. Marianne relates that Vallotton remained true

Rocamadour Landscape, 1925.
Oil on canvas, 92 x 73 cm.
Private collection.

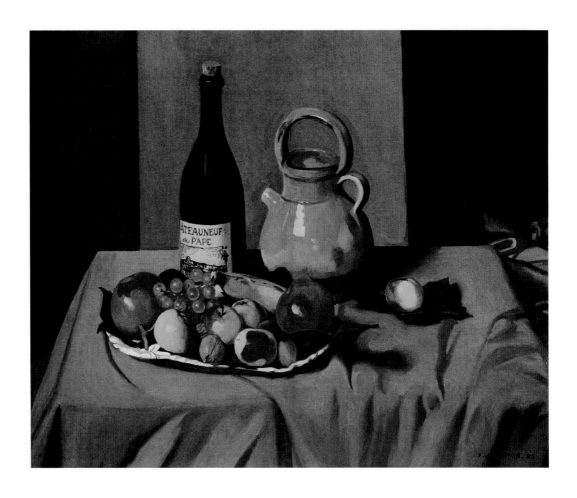

to himself right up to the end, and a few minutes before his death he told his brother Paul: "Don't you think this is an amusing way to celebrate the centenary of the death of the painter Jacques-Louis David?"

It would not be desirable, though, to finish the tale of Félix Vallotton on such a sad note. To many, he seemed a strange man and not everyone accepted his art, which differed too starkly from that of his contemporaries. He was talented in many ways, but was never conspicuous for his self-confidence. He always had doubts about everything, and did not allow himself to be happy. But, all the same, one of his last letters to his brother contained some words that are surprising for Vallotton. He wrote:

> "This is without a doubt the most beautiful and best attended [exhibition] that I have seen, and it makes me happy to see all the artists side by side who are not accustomed to mixing with each other, and whose value is enhanced thereby. I am exhibited next to Matisse, who has done some lovely things, but it appears to me that I shall stand up to the blow."

Still Life with a Bottle of Châteauneuf, 1925.
Oil on canvas, 60 x 73 cm.
Kustmuseum Bern, Bern.

Still Life with Onions, 1925.
Oil on canvas, 60 x 73 cm.
Private collection.

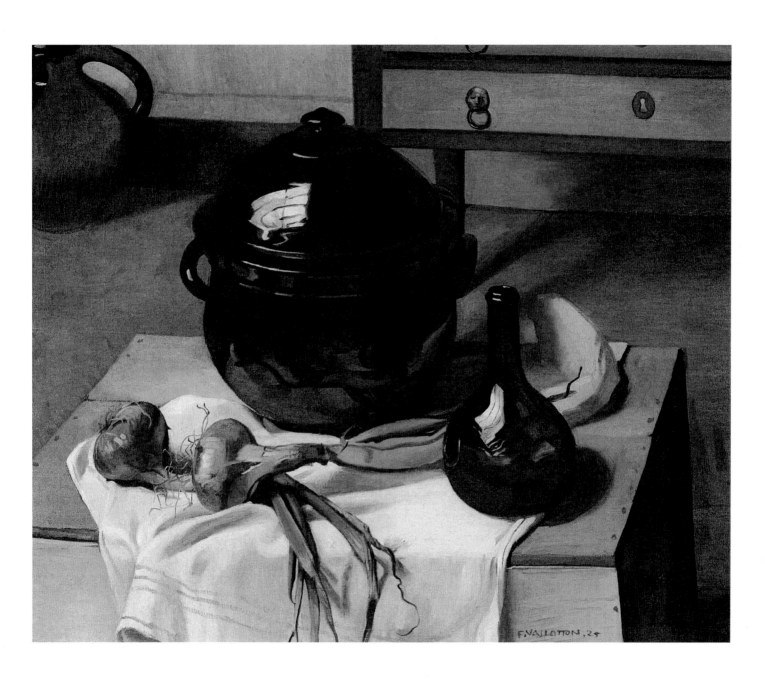

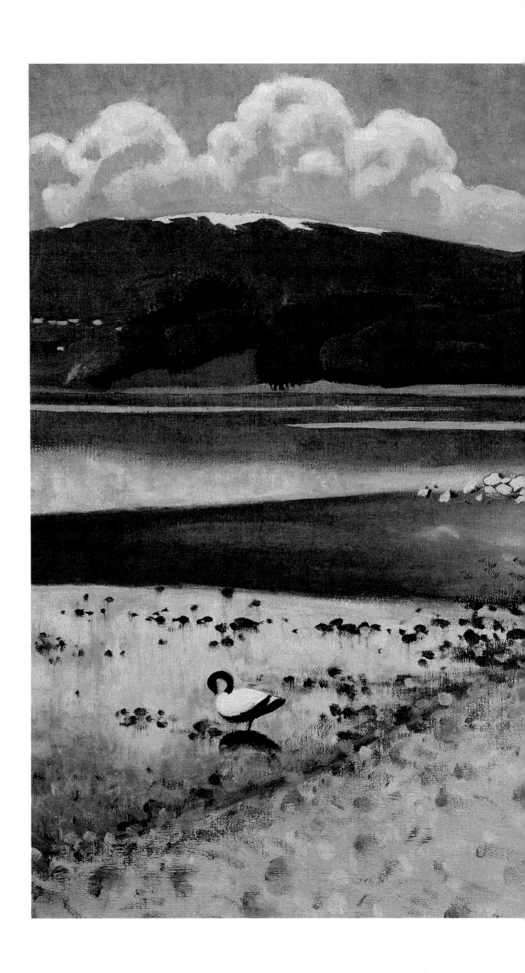

Vidy Beach, 1925.
Oil on canvas, 54 x 81 cm.
Musée cantonal des Beaux-Arts,
Lausanne.

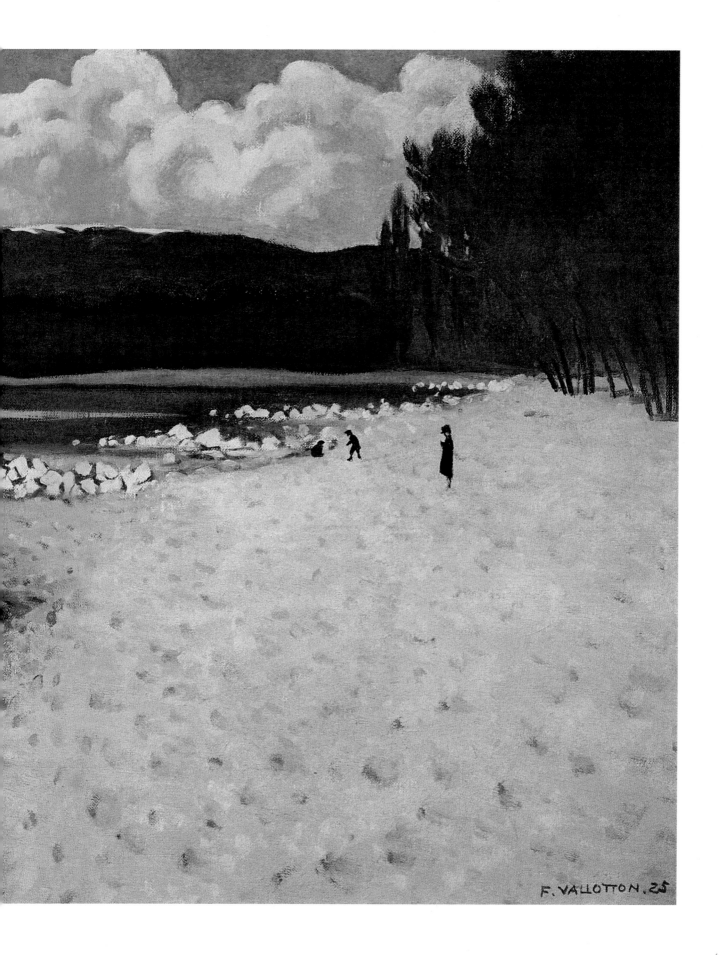

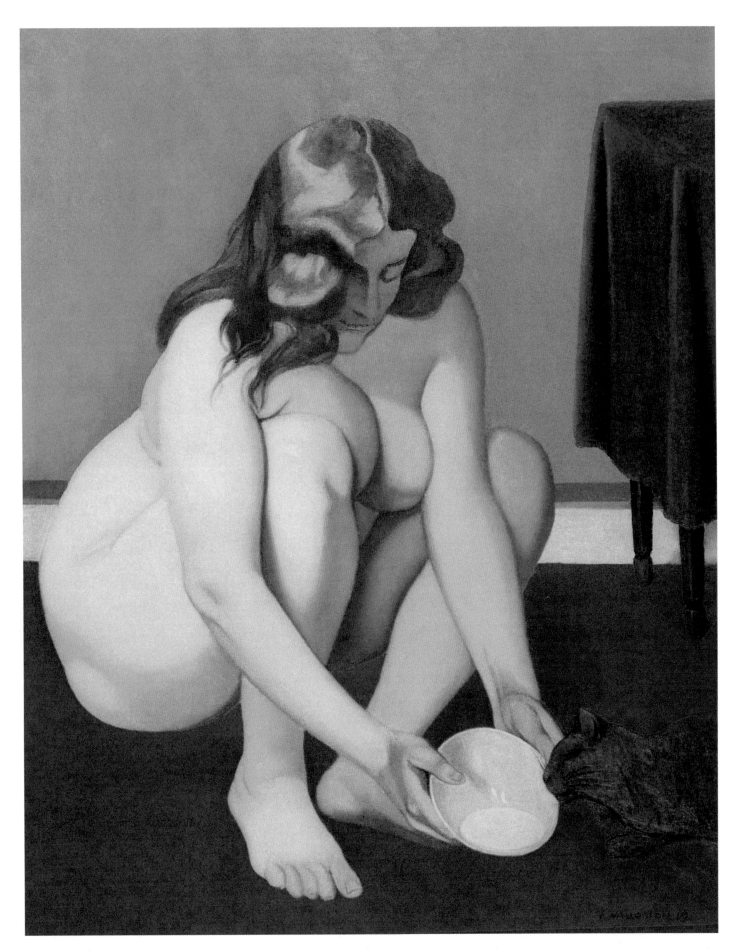

Vallotton's Women

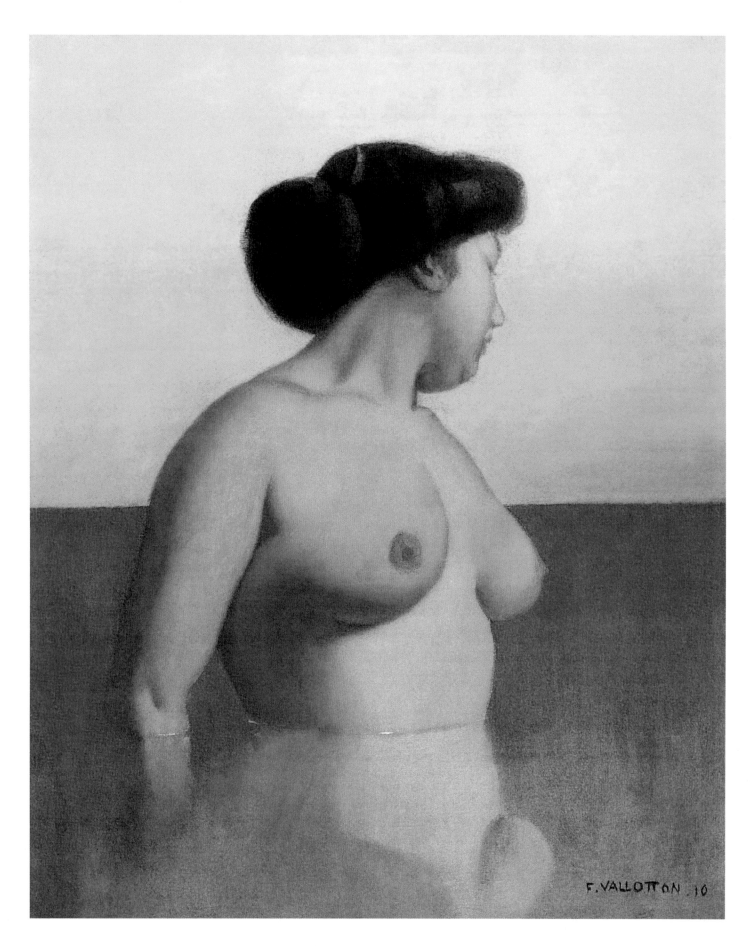

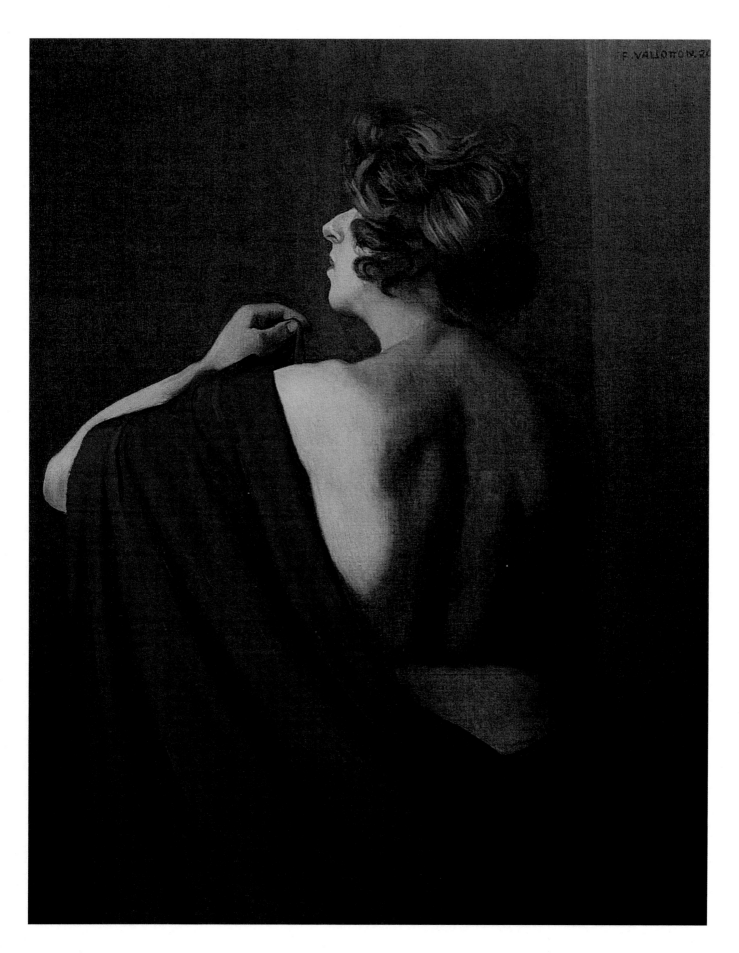

F. VALLOTTON. 2

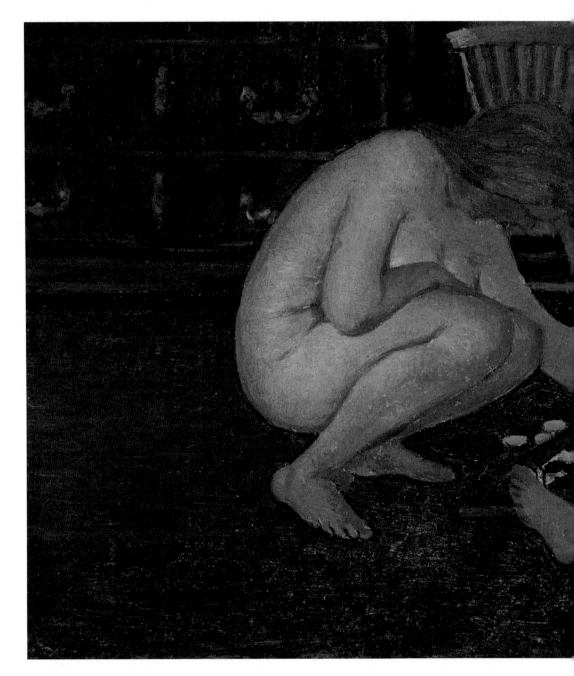

Squatting Woman Offering Milk to a Cat, 1919.
Oil on canvas, 100 x 81 cm.
Private collection. (p. 166)

Bather, Bust, 1910.
Oil on canvas, 61 x 51 cm.
On loan from a private
collection in Brussels,
Kunstmuseum Luzern Museum
of Art Lucerne, Lucerne.
(p. 168)

Woman in a Red Shawl, 1920.
Oil on canvas, 100 x 81 cm.
Musée cantonal des Beaux-Arts,
Lausanne. (p. 169)

Nude Women Playing Checkers,
1897.
Oil on pavatex, 25.5 x 52.5 cm.
Musée d'Art et d'Histoire, Geneva.

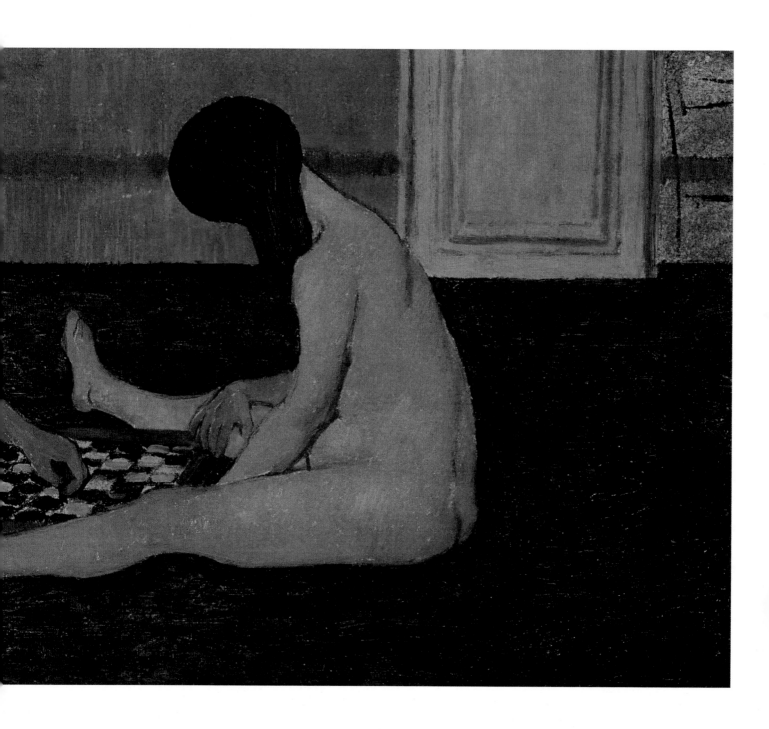

Woman Bathing, 1895. Oil on canvas, 98 x 130 cm. Private collection.

Nude Woman in an Armchair, 1897. Oil on cardboard, mounted on wood, 28 x 27.5 cm. Musée de Grenoble, Grenoble.

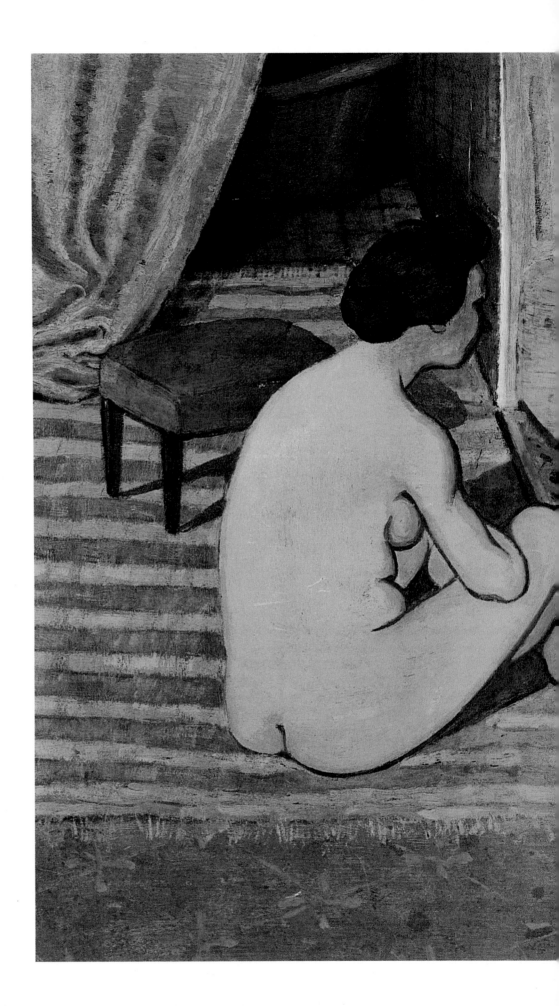

Nude Women with Cats,
c. 1897-1898.
Oil on cardboard, 41 x 52 cm.
Musée cantonal des Beaux-Arts,
Lausanne.

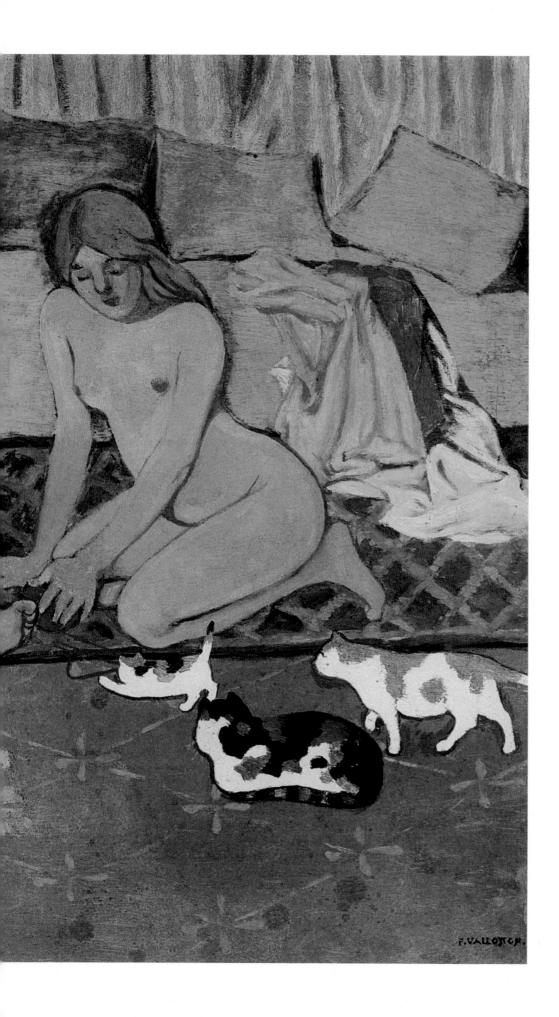

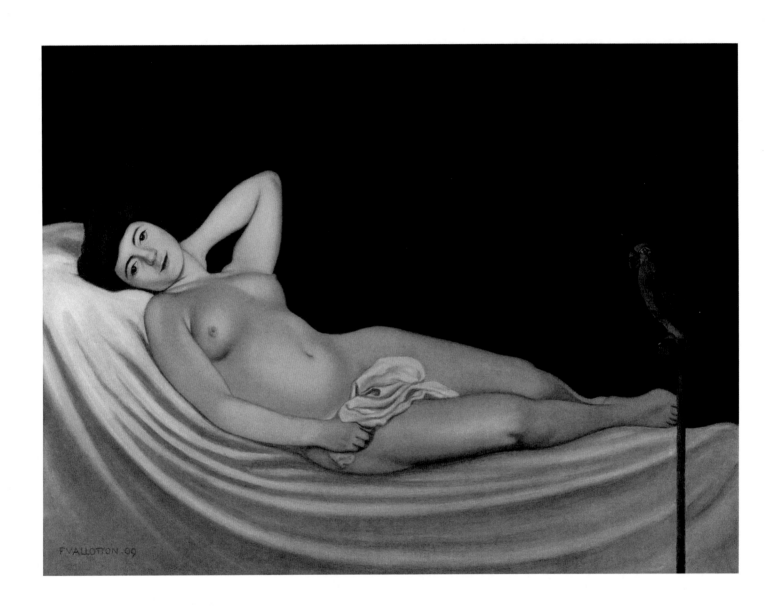

Woman with a Parrot, 1909. Oil on canvas, 114 x 163 cm. Private collection.

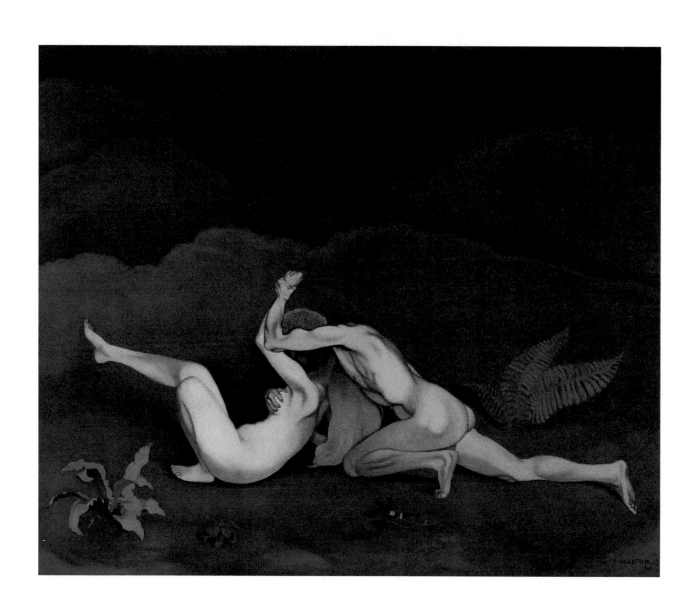

Man and Woman, 1913. Oil on canvas, 200 x 250 cm. Private collection.

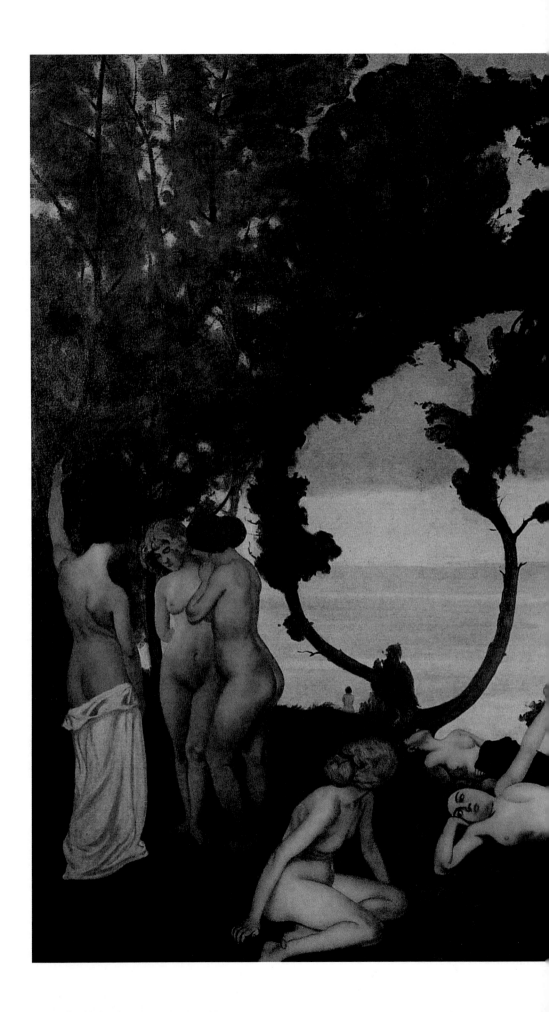

Summer, 1912.
Oil on canvas, 201 x 205.5 cm.
Musée cantonal des Beaux-Arts,
Lausanne.

In the Water, 1919.
Oil on canvas, 61 x 48 cm.
Private collection. (p. 180)

Spring, 1908.
Location unknown. (p. 181)

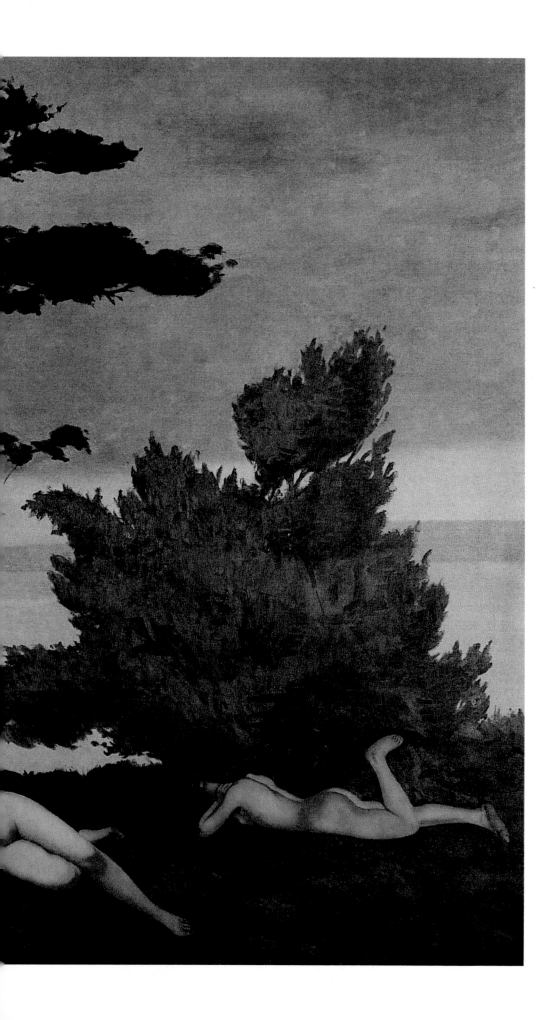

F. VALLOTTON . 08

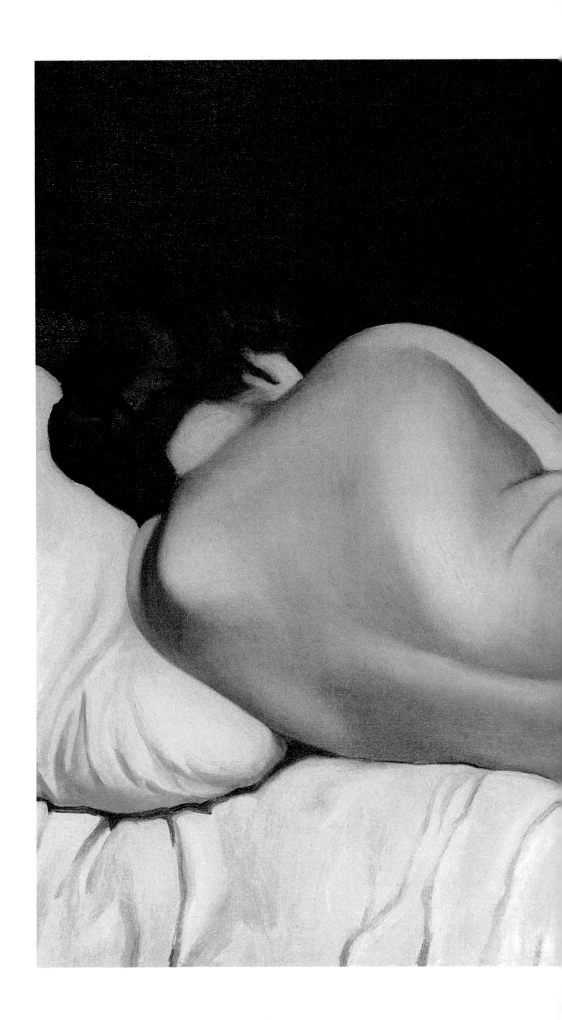

Nude Woman from Behind,
1921.
Oil on canvas, 73 x 92 cm.
Private collection.

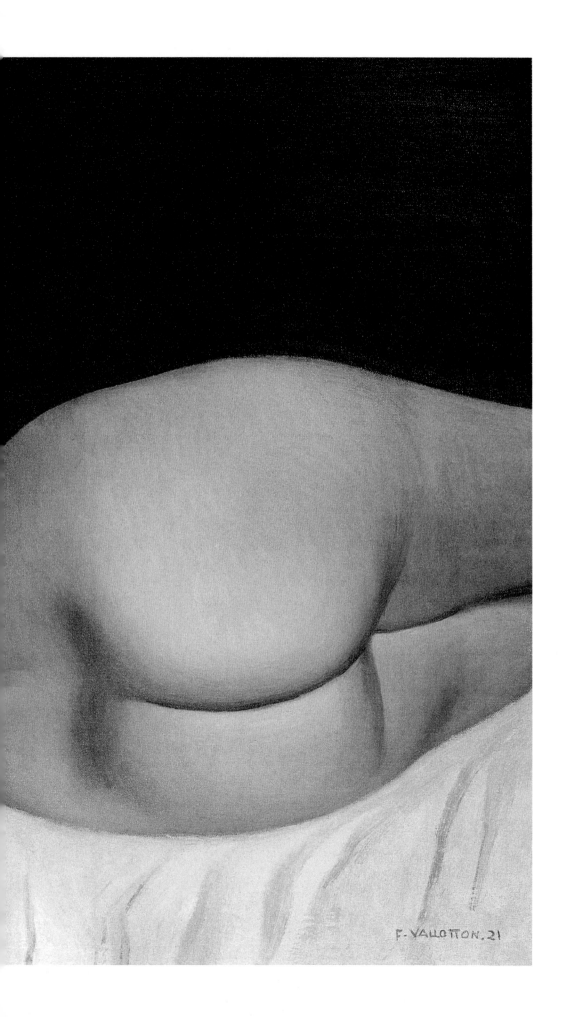

F. VALLOTTON. 21

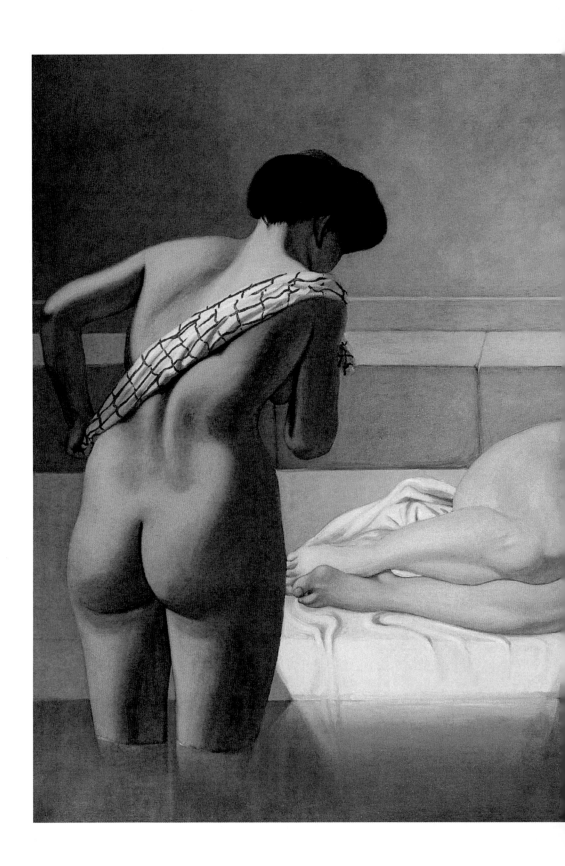

The Turkish Bath, 1907.
Oil on canvas, 130.5 x 195.5 cm.
Musée d'Art et d'Histoire, Geneva.

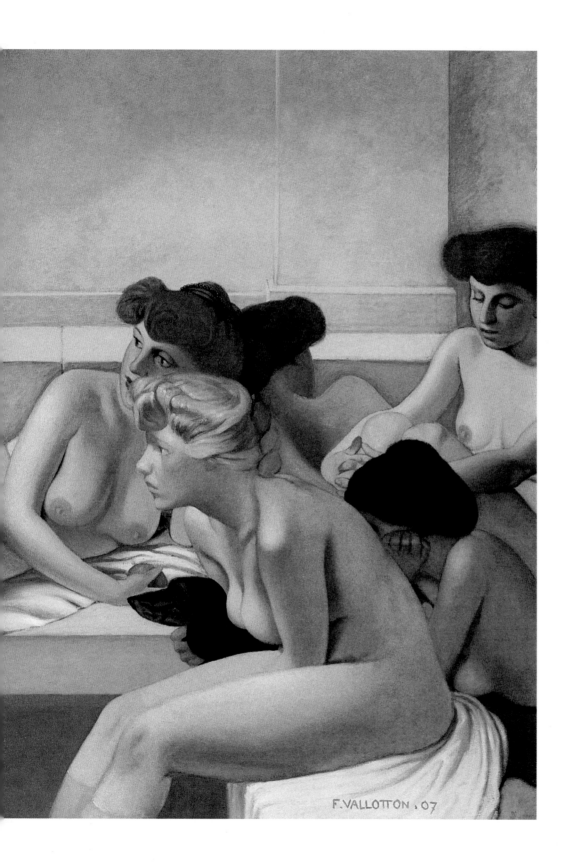

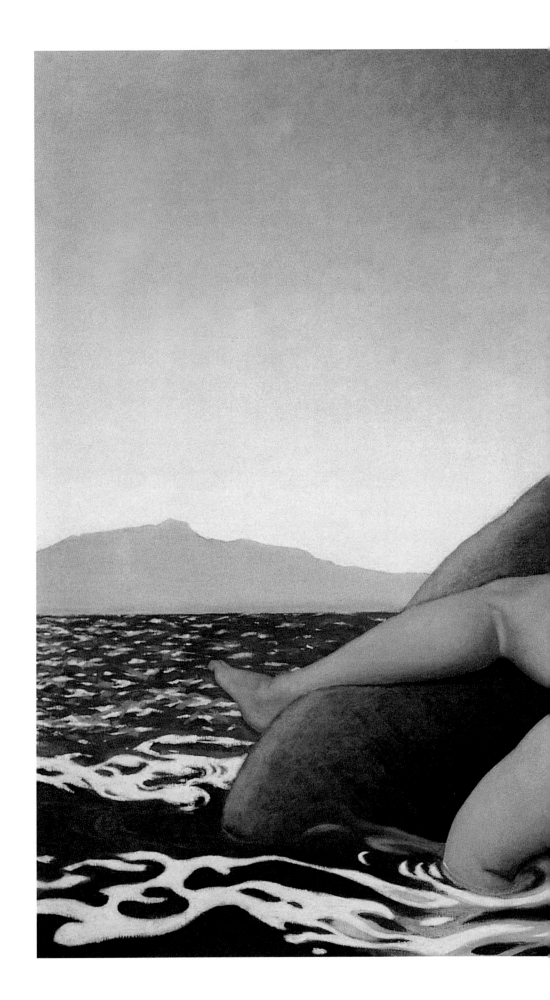

The Taking of Europe, 1908.
Oil on canvas, 130 x 162 cm.
Gift from Professor Hans R. Hahnloser,
Kunstmuseum Bern, Bern.

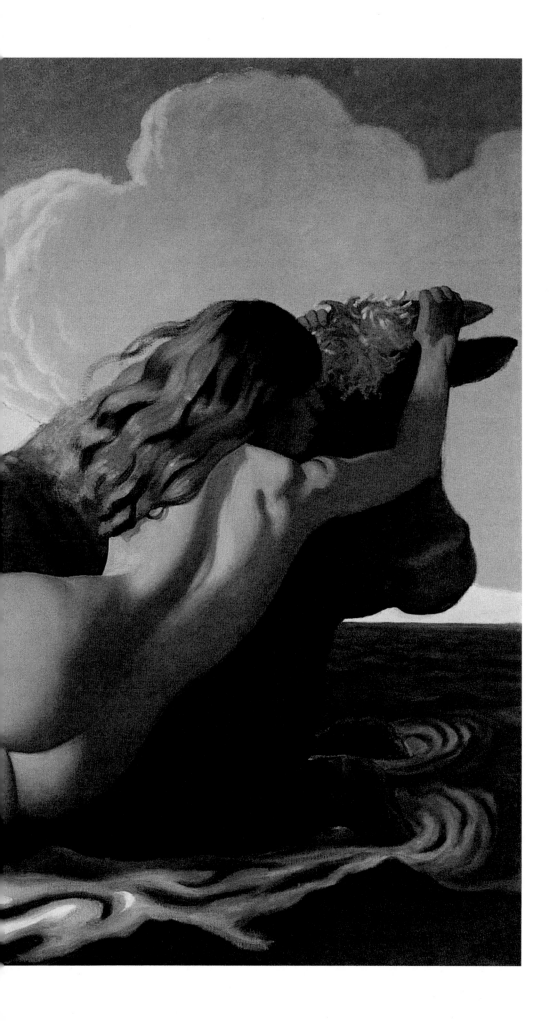

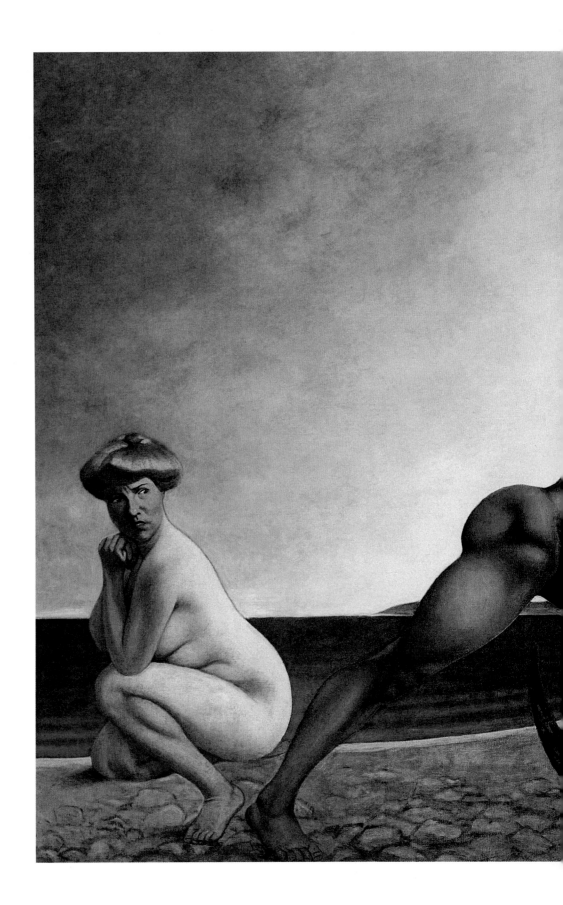

Perseus Slays the Dragon, 1910.
Oil on canvas, 160 x 225 cm.
Musée d'Art et d'Histoire, Geneva.

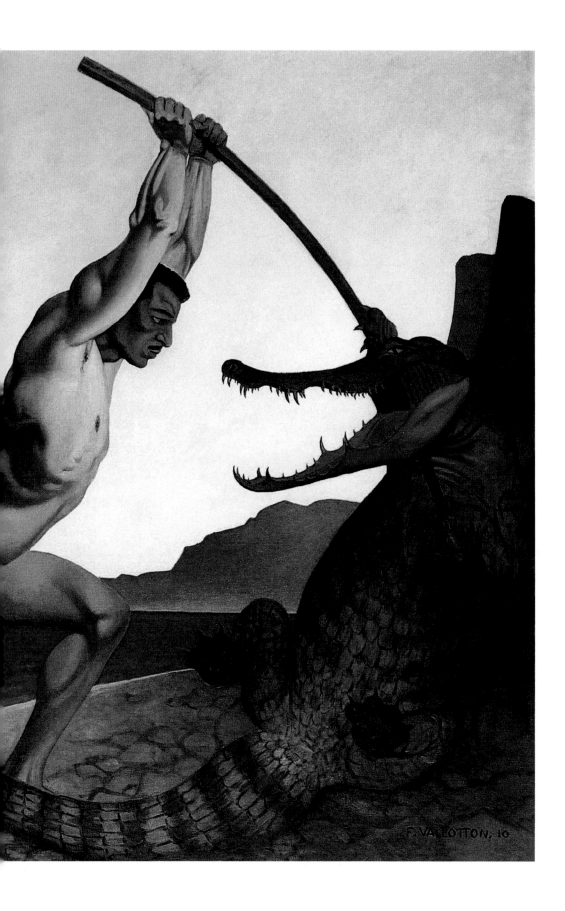

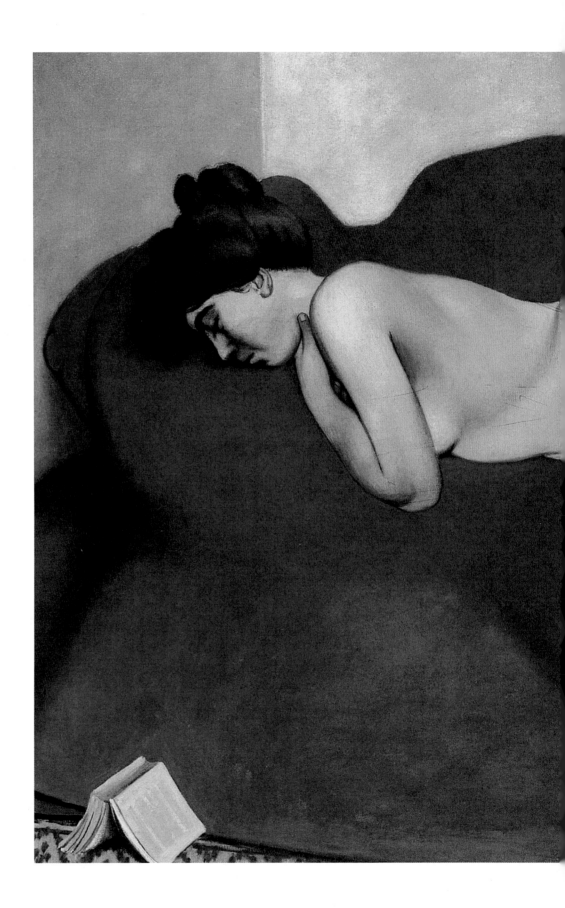

Sleep (detail), 1908.
Oil on canvas, 113.5 x 162.5 cm.
Musée d'Art et d'Histoire, Geneva.

Idleness, 1896.
Woodcut.
The Museum of Modern Art,
New York. (p. 192)

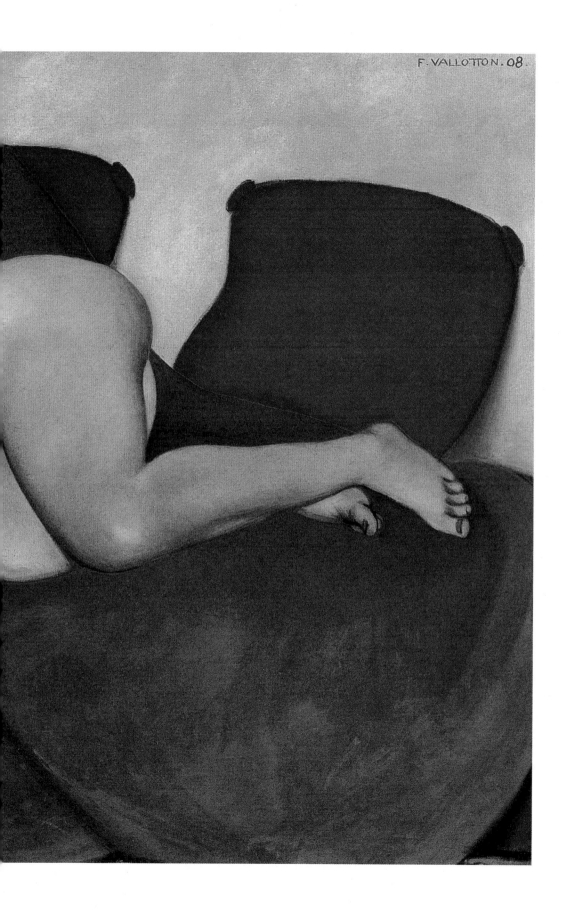

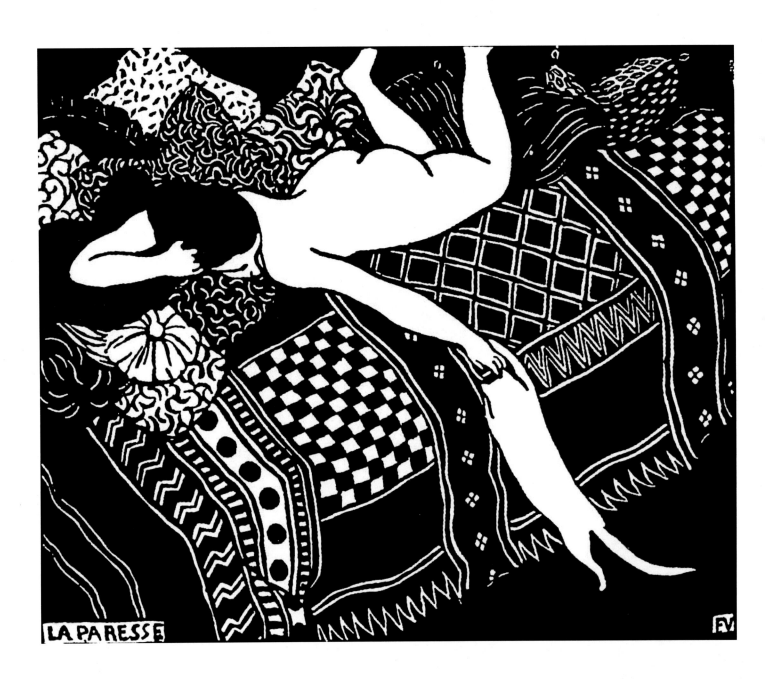

Engravings

The Letter, Vignette. Woodcut.
The State Hermitage Museum, St Petersburg.

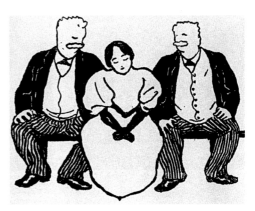

Untitled, 1893-1895. Woodcut.
Private collection.

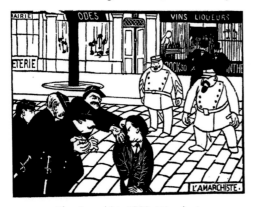

The Anarchist, 1892. Woodcut.
Private collection.

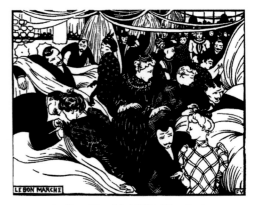

Le Bon Marché, 1893. Woodcut.
Private collection.

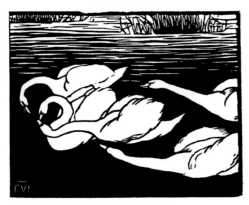

Swans, 1892. Woodcut.
The Museum of Modern Art, New York.

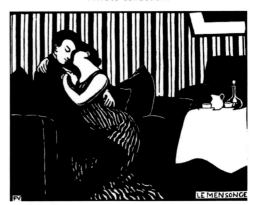

The Lie, 1897. Woodcut.
The Museum of Modern Art, New York.

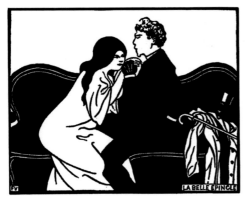

The Fine Pin, 1897. Woodcut.
Private collection.

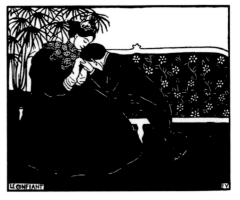

A Trusting Man, 1895. Woodcut.
The Museum of Modern Art, New York.

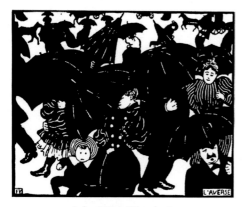

Rain, 1894. Woodcut.
Private collection.

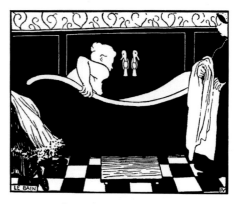

The Bath, 1894. Woodcut.
The Museum of Modern Art, New York.

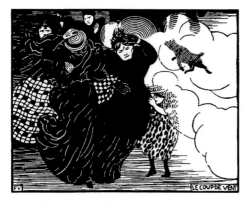

The Gust of Wind, 1894. Woodcut.
The Museum of Modern Art, New York.

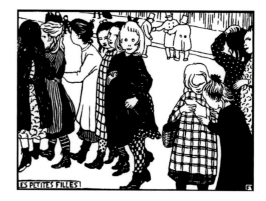

The Young Girls, 1893. Woodcut.
The State Hermitage Museum, St Petersburg.

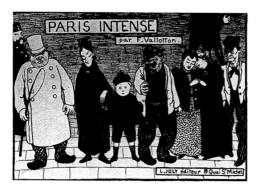

Paris Intense, 1894. Frontispiece of Paris Intense.
Engraving on zinc. 22 x 31.5 cm.
Baltimore Museum of Art, Baltimore.

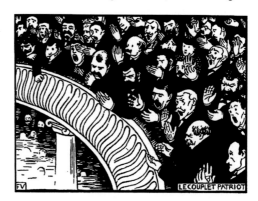

The Patriotic Ditty, 1893. Woodcut.
The Museum of Modern Art, New York.

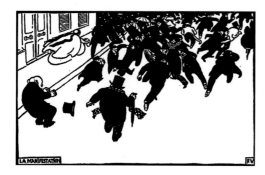

The Demonstration, 1893. Woodcut.
The Museum of Modern Art, New York.

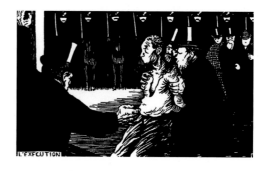

The Execution, 1894. Woodcut.
The Museum of Modern Art, New York.

Bibliography

De Gourmont, R. (1896). *Le Livre des masques*. Paris: Mercure de France.

Denis, Maurice. (1970). *Orangerie des Tuileries, 3 juin-31 août 1970*. Paris: Ministère d'État.

Guisan, G. and Jakubec, D. (1973-1975). *Félix Vallotton. Documents pour une biographie et pour l'histoire d'une oeuvre. Journal I, 1884-1889*. Lausanne-Paris: La Bibliothèque des Arts.

Guisan, G. and Jakubec, D. (1973-1975). *Félix Vallotton. Documents pour une biographie et pour l'histoire d'une oeuvre. Journal II, 1900-1914*. Lausanne-Paris: La Bibliothèque des Arts.

Guisan, G. and Jakubec, D. (1973-1975). *Félix Vallotton. Documents pour une biographie et pour l'histoire d'une oeuvre. Journal III, 1914-1921*. Lausanne-Paris: La Bibliothèque des Arts.

Guisan, G. and Jakubec, D. (1975). *Félix Vallotton, Édouard Vuillard et leurs amis de la Revue blanche. Études de lettres*. Lausanne.

Hahnloser-Bühler, H. (1936). *Félix Vallotton et ses Amis*. Paris.

Humbert, A. (1954). *Les Nabi et leur epoque 1888-1900*. Geneva: Pierre Callier.

Jourdain, F. (1953). *Félix Vallotton*. Geneva: Veb Verlag Der Kunst.

Karamzin, N. (1988). *Letters of a Russian Traveller*. Moscow.

Koella, R. (1969). *Félix Vallotton im Kunsthaus Zürich*. Zurich: Kunsthaus.

Meier-Graefe, J. (1898). *Félix Vallotton, Biography*. Paris-Berlin.

Natanson, T. (1948). *Peints à leur tour*. Paris: A. Michel.

Natanson, T. (1951). *Le Bonnard que je propose, 1867-1947*, Geneva: P. Cailler.

Roger-Marx, C. (1962). *La Gravure Originale En France de Manet à Nos Jours* (French Original Prints from Manet to the Present Time). Paris.

Shchekatikhin, N.N. (1920). *Feliks Vallotton*. Moscow.

Tolstoy, L. (1931). Extracts from the journal of 1857 (Notes from a journey through Switzerland). Moscow-Leningrad. Tome 5.

Vallotton, F. (1917). "Artists, critics, art-lovers and merchants". *Universal Library and Swiss Revue*, February.

Vallotton, F. (1946). *La Vie Meurtrie* (The Deadly Life). Geneva-Paris.

Vallotton, F. (1973). *Corbehaut*. Lausanne: Manesse-Verlag.

Vallotton, M.J. (1953). "My Uncle Félix Vallotton". *Perspectives*. Lausanne. June.

Vauxcelles, L. (1926). "Félix Vallotton" *Le Figaro artistique*. February 4.

Index

Made in the USA
Columbia, SC
11 June 2022